BUILDING WITH WOOD

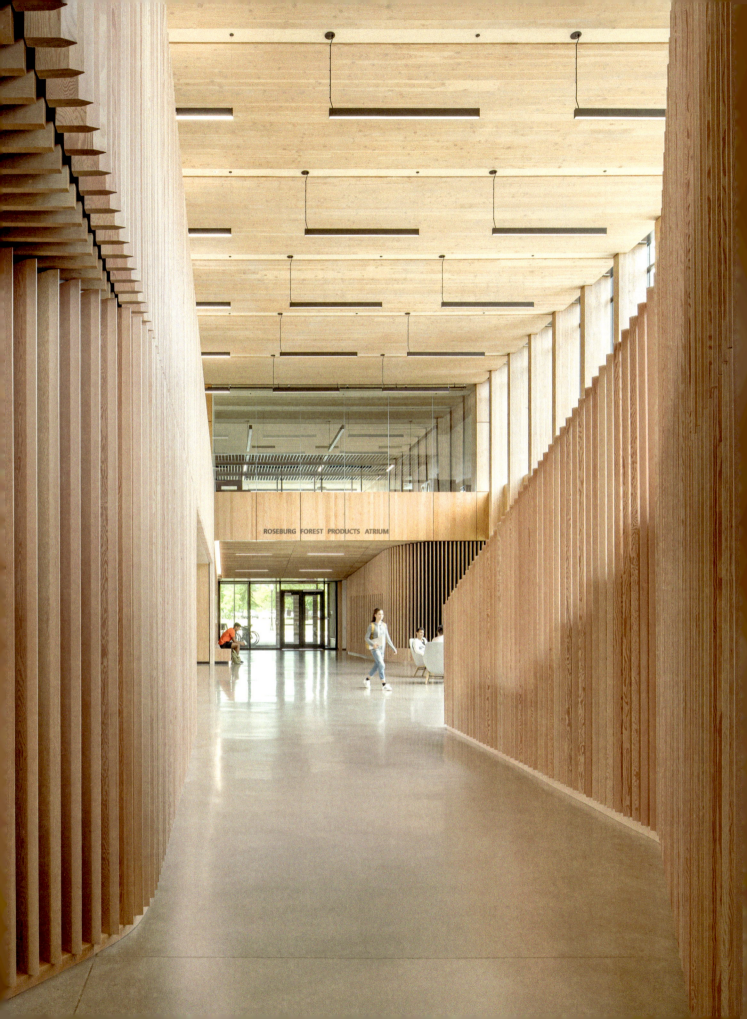

Agata Toromanoff

BUILDING WITH WOOD

THE NEW TIMBER ARCHITECTURE

PRESTEL

MUNICH · LONDON · NEW YORK

TABLE OF CONTENTS

INTRODUCTION — 6

IN CONVERSATION WITH KENGO KUMA — 8

RESIDENTIAL ARCHITECTURE

14 LOGEMENTS HOUSING COMPLEX / MARS ARCHITECTES Paris, France — 16

VILLA VUGHT/ MECANOO Vught, The Netherlands — 22

FREEBOOTER / GG-LOOP Amsterdam, The Netherlands — 28

MTR / ALAIN CARLE ARCHITECTE Mont-Tremblant, Québec, Canada — 34

TIMBER HOUSE 670 UNION STREET / MESH ARCHITECTURES New York, USA — 40

LATHHOUSE / BIRDSEYE Sagaponack, USA — 44

PUBLIC BUILDINGS

MAGGIE'S LEEDS CENTRE / HEATHERWICK STUDIO Leeds, United Kingdom — 52

ALTO TÂMEGA TOURIST INFORMATION POINT / AND-RÉ ARQUITECTURA Chaves, Portugal — 58

TAVERNY MEDICAL CENTRE / MAAJ ARCHITECTES Taverny, France — 62

MICROLIBRARY WARAK KAYU / SHAU INDONESIA Semarang, Indonesia — 66

COMMUNITY LIFE CENTER TRINITAT / HAZ ARQUITECTURA Barcelona, Spain — 72

CULTURAL VENUES

TOHO GAKUEN MUNETSUGU HALL / KENGO KUMA Tokyo, Japan — 80

YABULI ENTREPRENEURS' CONGRESS CENTRE / MAD ARCHITECTS Yabuli, China — 84

SARA CULTURAL CENTRE / WHITE ARKITEKTER Skellefteå, Sweden — 90

SAMLING / HELEN & HARD Nord-Odal, Norway — 96

EDUCATION & SPORT FACILITIES

KITA IM PARK / BIRK HEILMEYER UND FRENZEL ARCHITEKTEN Stuttgart, Germany — 104

THE ARC AT GREEN SCHOOL / IBUKU Bali, Indonesia — 110

CANTEEN AND MEDIA CENTRE / WULF ARCHITEKTEN Darmstadt, Germany — 114

HOMERTON COLLEGE DINING HALL / FEILDEN FOWLES Cambridge, United Kingdom 118

THE ARIAKE GYMNASTICS CENTRE /
 NIKKEN SEKKEI LTD+ SHIMIZU CORPORATION Tokyo, Japan 122

OREGON FOREST SCIENCE COMPLEX /
 MGA | MICHAEL GREEN ARCHITECTURE Corvallis, USA 128

HOSPITALITY PROJECTS

GRAND WORLD PHU QUOC WELCOME CENTRE /
 VO TRONG NGHIA ARCHITECTS Phu Quoc, Vietnam 136

MJØSTÅRNET / VOLL ARKITEKTER Brumunddal, Norway 140

HOTEL MILLA MONTIS / PETER PICHLER ARCHITECTURE Maranza, Italy 146

COEDA HOUSE / KENGO KUMA Shizuoka, Japan 150

FUCHSEGG LODGE HOTEL / LUDESCHER + LUTZ ARCHITEKTEN Amagmach, Austria 154

ZEN WELLNESS SEINEI / SHIGERU BAN Awaji, Japan 160

COMMERCIAL & OFFICE SPACES

THE FINANCIAL PARK / HELEN & HARD Bjergsted, Norway 168

6 ORSMAN ROAD / WAUGH THISTLETON ARCHITECTS London, United Kingdom 174

CATALYST BUILDING / MGA | MICHAEL GREEN ARCHITECTURE Spokane, USA 180

TE WHARE NUI O TUTEATA, THE SCION INNOVATION HUB /
 RTA STUDIO + IRVING SMITH ARCHITECTS Rotorua, New Zealand 186

SWALES / RYUICHI ASHIZAWA ARCHITECT, ARCARI + IOVINO ARCHITECTS Harrisburg, USA 192

ANNEX – PLANS 196

INDEX 230

PHOTO CREDITS 237

INTRODUCTION

Associated with centuries-old architecture and traditions rooted deeply in the cultures of the world's various regions, wood is now one of the most utilised materials today and offers us genuine hope for the future. Unjustly forgotten over the last two centuries, wood is back with an impact stronger than ever. Facing the numerous troubling challenges of today's world, architects around the world have re-invented wood with the use of digital technologies. They are taking part in a fascinating race to compete in cutting-edge solutions and to constantly break height and scale records. What was unthinkable in the past, like a wooden skyscraper, is becoming a norm. Computers have made this possible. Even if design processes are defined by the aid of digital technologies, the art of building in wood continues to strike a good balance between drawing from traditions and infusing old techniques with novel ways of fabricating wood structures. These new methods are driven by extensive studies of the structure of wood that have led to digital wood processing.

Environmentally, as a material, wood is absolutely unrivalled while providing excellent structural performance. Wood offers comparable strength to the widely used concrete or steel, yet with incomparably less expense in terms of production. Wood is easily available, often locally, which simplifies the construction stage just as much as the fact that wooden structures are much easier and faster to erect, and allow for no-waste building sites. Renewable and durable, wood's sustainable qualities are enhanced by its ability to extract carbon from the atmosphere rather than emitting it. Last but not least, its aesthetic values are difficult to beat. Ideal for serene and atmospheric spaces, wood, even in an urban setting, can bring us closer to nature. Whether used in a public, educational, or residential building, wood is a guarantee of a healthy environment. Regardless of the scale, it can perfectly insulate sound or heat, and can be used without being mixed with other, less friendly, materials. It also has a soothing visual impact.

I am truly honoured to begin this book with a conversation with the acclaimed Kengo Kuma, a pioneer and master of wood architecture, whose role in the material's revival is significant. The architect embraces traditional techniques and modern advancements to imagine a better future, but also operates with carefully crafted structural solutions to create special visual effects that influence the particular way we experience a space.

The following overview of contemporary wooden buildings presents the most ground-breaking and sophisticated concepts. Each project is a powerful demonstration of the structural power and aesthetic beauty of wood, which is illustrated in numerous striking images, while at the end of the book readers can find more technical details, including plans and sketches of the featured buildings. Wood is always at the heart of the examples selected for this volume; it is used not merely as an addition or decoration but also to create a solid and innovative structural base. Architects from around the world are using the well-known yet entirely re-invented material in a visionary and often unprecedented way. The panorama of various typologies proves that the possibilities of wood are now limitless. I would like to thank all architects presented in this book for their enthusiastic participation and for sharing their precious experiences that have steered the discipline into a very promising direction.

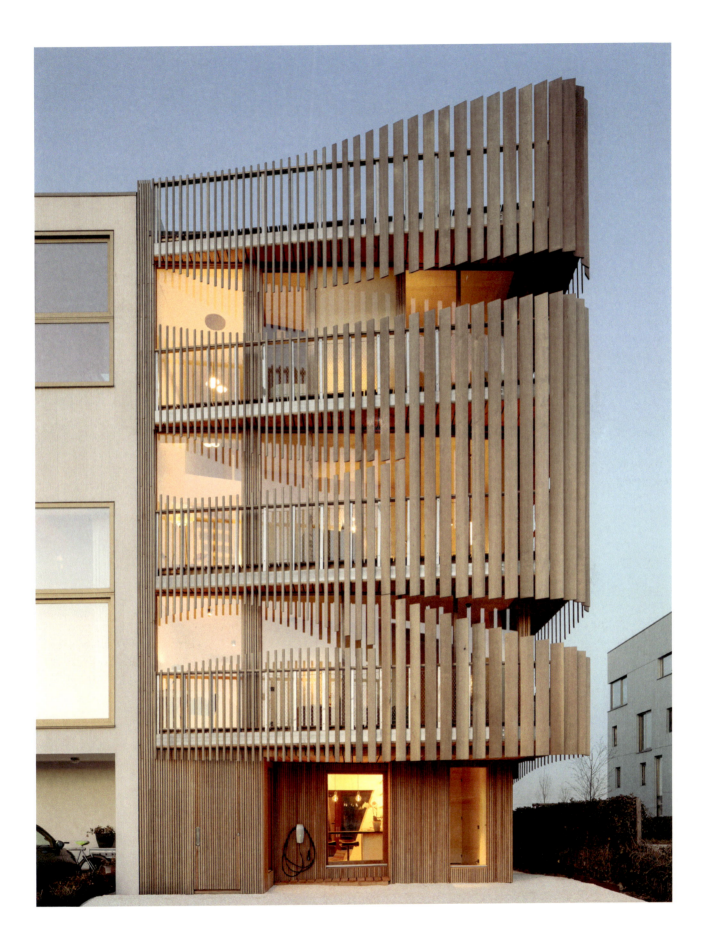

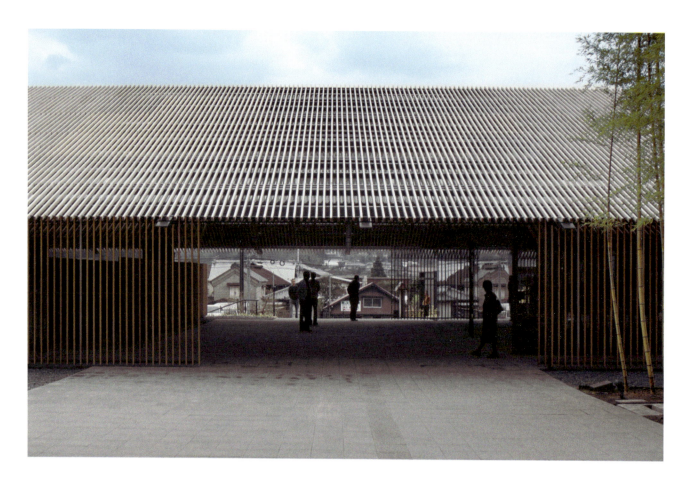

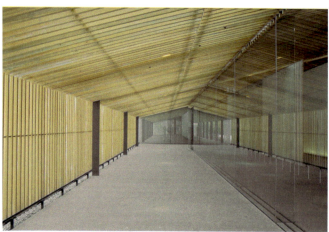

Museum of Hiroshige Ando
Batou, Nasu-gun, Tochigi Prefecture, Japan, 2000
Designed to celebrate the oeuvre of Hiroshige Ando, the building aims to translate into architecture the revolutionary perspective that the artist created in his woodblock prints. A superposition of layers was used to show the three-dimensional space, which Kengo Kuma recreates with wooden louvers made of local cedar. This meticulously arranged structure, which defines both the rectangular volume and gabled roof, creates an original shell that interacts with the natural light inside as well as naturally blending the outside into the surroundings.

IN CONVERSATION WITH KENGO KUMA

In many buildings designed by Japanese architect Kengo Kuma, wood plays a leading role. The natural character of the material is masterly used to create highly original shapes and a pleasant atmosphere. Each aspect of wood is carefully taken into account — both the structure and texture, as well as the ways these affect the play of light and air circulation. With a great sense of all the nuances that the use of wood brings to each project, Kuma draws from old techniques and brings contemporary architecture back closer to nature. The architect has compared it with music, while his designs are aimed at reflecting rhythm and tones to arrive at pure harmony with the landscape. Inspired by the most traditional approaches, Kuma treats wood as a remedy to many contemporary challenges. He often emphasises that the role of architects should not be limited to inventing forms but that they also should suggest a new way of living, where past solutions enhanced by the latest technologies could be built better in the future.

You have often mentioned that the house you grew up in (made of wood) was a kind space. One of your inspirations is the inviting form of a bird's nest. Is wooden architecture a guarantee for obtaining welcoming and warm spaces?

Yes, indeed. The house I grew up in was wooden, but what made it even more welcoming and comforting I think was that it also had tatami and washi, which were essential materials for old Japanese houses. All those elements contributed to my idea of a gentle space for people.

As opposed to the modernist tradition, with Le Corbusier playing a leading role, you insist that a building cannot be an isolated object, cut off from the land around it. Is using natural and local materials the best way to harmoniously connect architecture with its context and cherish the surroundings, especially the natural environment? And why is it so important to consider the context in the process of designing new buildings?

Why don't we look back to the life of our ancestors? Human beings had been walking directly on the earth for a long time. This is because doing so felt more stable and secure as a living creature — the sense of being tied to the ground means much more than one might think. Therefore, it is only natural for me to design architecture that is both technically and psychologically connected to its location.

In your vision, light and shadow play an important role to often create a forest-like experience. Could you talk more about using wood in this context?

A forest-like experience is not at all special, considering that human beings have long been inhabitants of forests. We somehow feel relaxed and comfortable in wooden architecture because of this. The texture of wood works as a filter and can reflect light and shadow and create a forest-like air in a building, which is one of many reasons we tend to use lots of wooden materials in our designs.

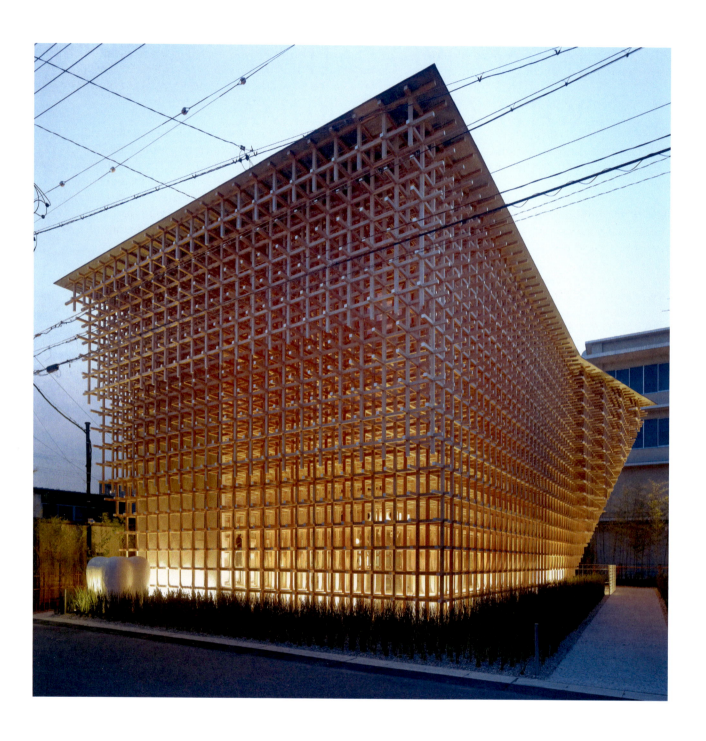

What are the most inspiring lessons you have learnt from traditional Japanese architecture?

There are certain techniques and methods that I've learnt from Japanese traditional architecture, but the number one lesson for me was a sense of unity with the garden — or that architecture should be a part of the garden (or the landscape).

How do you approach the challenging task of combining new technologies with the use of natural materials?

Applying new technologies does not conflict with using natural materials. Advanced technologies can only enhance or draw out the potentials of natural materials. Our studio is constantly searching for new ways to use them and is trying to be wired into any new technologies.

In one of your interviews you said, referring to Kenzo Tange's work, that you want to create architecture that is currently in demand — what do you think is in demand now?

The demand of the age I feel now is "returning to nature," to which I try to be responsive through our projects.

In the book I focus on buildings that are structurally made of wood. How far can architects push the limits of wooden architecture thanks to advanced technologies at the moment?

I don't think one specific wooden building with cutting-edge techniques can change the future of architecture. It's not about designing technically elaborated buildings of wood — architects should care about changing the "texture" of big cities — from covering them with hard and cold industrial materials to weaving them with more natural, human-friendly materials.

What do you dream of when thinking about wooden architecture? Do you have any particular goal or wish for the future?

My dream is to create a workspace where I myself can feel the utmost comfort. I'm already nearing this — our studio now has several "satellite" offices scattered around Japan, from Okinawa in the south to Hokkaido in the north, all humbly situated in nature.

GC Prostho Museum Research Center
Torii Matsu Machi, Kasugai-shi, Aichi Prefecture, Japan, 2010
The lightweight, semi-transparent structure of one of the most iconic buildings designed by Kengo Kuma was informed by Cidori, a traditional Japanese toy made of a system of wooden sticks with joints allowing free combinations with a simple twist. This technique, devoid of any fittings, is boldly transferred into architecture to create a unique spatial atmosphere with a play of light and shadow reminiscent of walking across a forest. Proving the structural flexibility of wood on a large scale, Kuma's design also looks back to the times when architecture was purely a hand-made discipline.

Yusuhara Wooden Bridge Museum
Minami Aoyama, Minato-ku, Tokyo, Japan, 2010
The Yusuhara Wooden Bridge Museum is a peculiar kind of structure that is a passage between two public buildings on two sides of a road but also offers space for an artists' workshop and accommodation for artist-in-residence programmes. At the heart of the design of the gallery, suspended in the air, is a special technique from traditional Japanese and Chinese architecture. A grid of wooden cantilevered beams uses small structural elements to create a solid volume that is also sustainable.

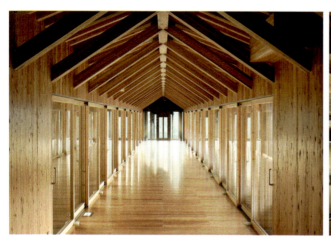
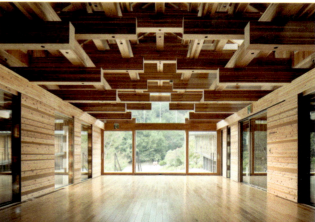
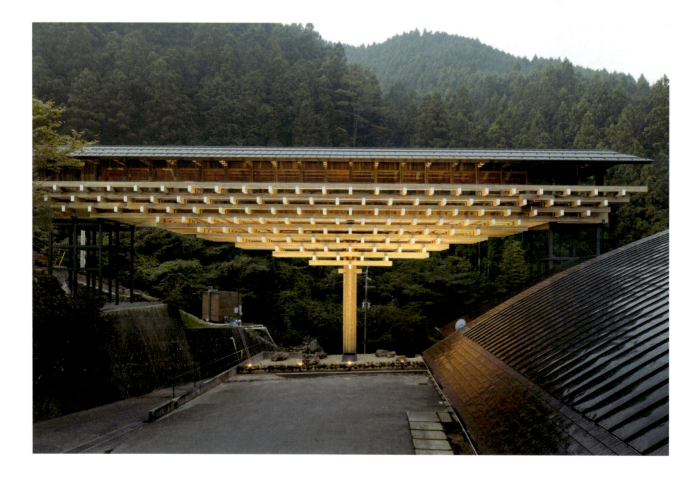

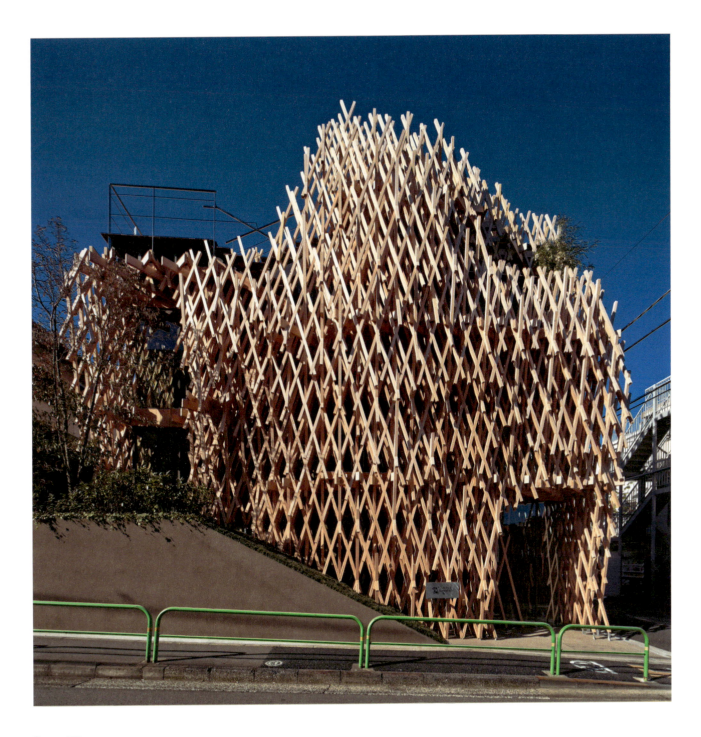

Sunny Hills
Minami Aoyama, Tokyo, Japan, 2013
Kuma's idea when designing Sunny Hills was to invent a subtle volume that would resonate well with the residential context of the Aoyama district. The inspiration was once again a traditional Japanese method, based on a joint system called Jigoku-Gumi, where intertwined wooden laths of the same width create a complex grid without the need to use glue or nails. The way they intersect creates a cloud-like structure that is distinctive yet soft. As a result, the shop takes on the intriguing shape of a bamboo basket and invites customers into its equally atmospheric interior. The nuanced structure is impressive during the day but is even more striking after sunset when the building is lit from inside.

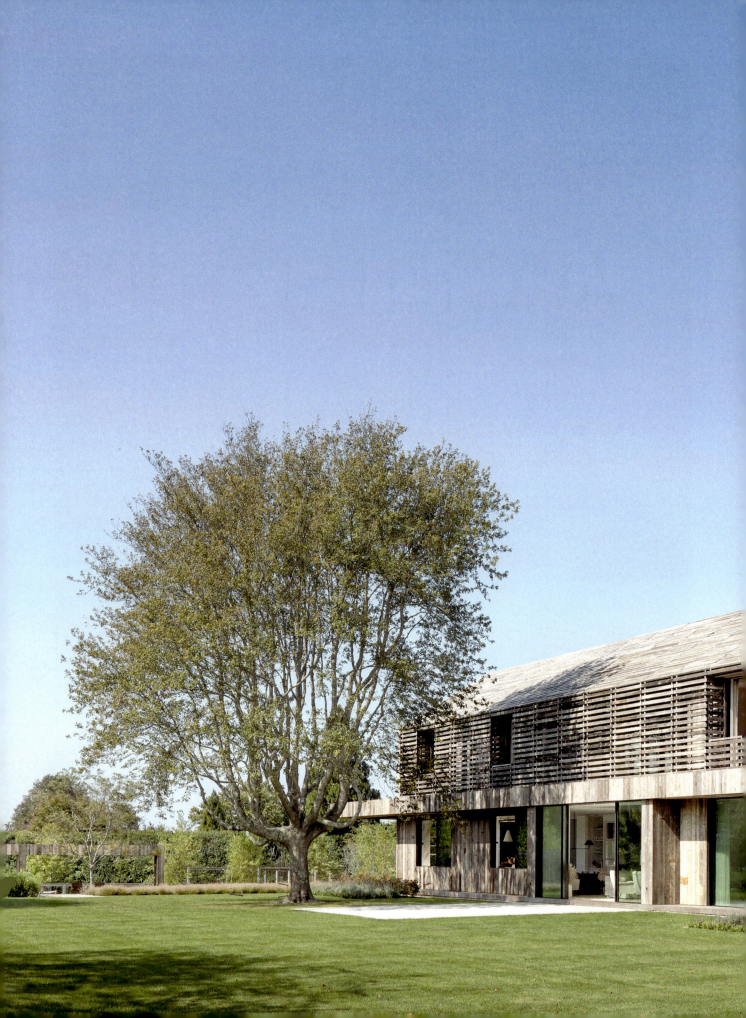

RESIDENTIAL ARCHITECTURE

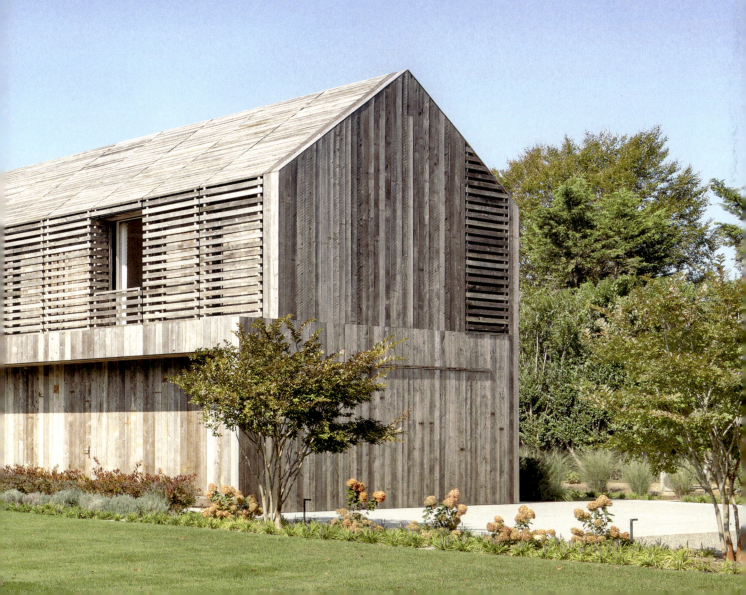

14 LOGEMENTS HOUSING COMPLEX

PARIS, FRANCE, 2020 // MARS ARCHITECTES

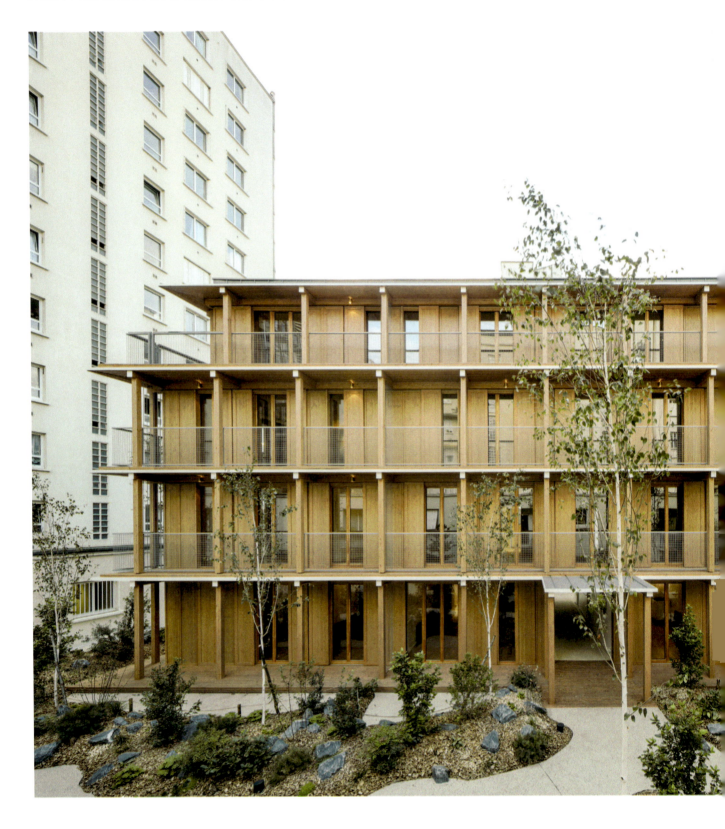

RESIDENTIAL ARCHITECTURE

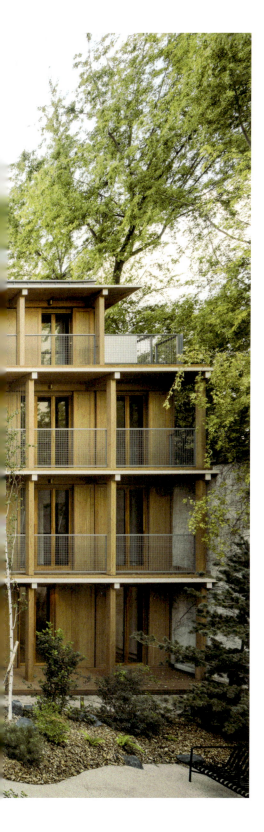

This wooden gem hidden at the heart of a block apartment in the capital of France, designed by MARS Architectes, has created an exceptional ambiance that brings architecture closer to nature and achieves a sense of privacy in the middle of a big city.

What is initially the most striking in the development, commissioned by the real estate company GECINA in the 12th district of Paris, is its atmosphere of intimacy and its very natural style, both of which starkly contrast with the character and pace of the metropolis. "Walking in Paris, we sometimes catch a glimpse of its hidden side, when a partially opened porch unveils an unexpected richness, a calm and peaceful atmosphere, precious and vegetal, which gives a particular relish to Parisian heart of blocks," muse the architects, who have so successfully transformed one of these types of spots. Surrounded by an apartment complex from the 1970s, the wooden building, evoking Japanese temples, is enveloped by a subtly arranged garden.

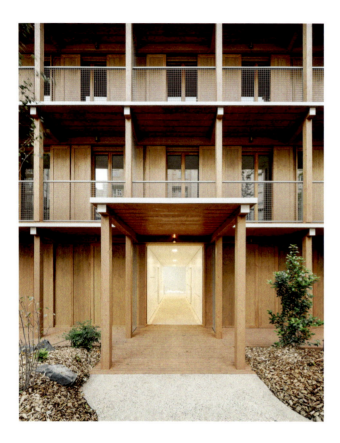

"One of the major challenges of the project lies in the entry sequence, creating a smooth transition between the urban universe of the city and the intimate universe of the home," state the architects, whose final choice was a canopy blending into the rhythm of the façade.

Due to this specific location, the architects were challenged with various constraints on the construction. Not only did the eleven-storey block separating the site from street, and not allowing any lifting installation, have to remain fully operational, but there were also strict weight constraints, as the new construction had to span an existing parking lot. Combining traditional techniques and contemporary aesthetics, this project required both innovative methodology and cutting-edge engineering, as well as quality craftsmanship. The wooden construction and façade proved to be the most practical solution, while the rigorous arrangement of the structure was determined by the scale of the windows. The wood selected for this housing complex had to be durable and weather-proof, and was additionally reinforced by the white protective paint used at the ends of the wooden beams, which also enhances the rhythm of the façade.

The regularly scheduled balconies also function as a protection for the woodwork as well as the shutters. The space obtained through these balconies, and the recessed wall of windows and shutters, smooths the transition between the inside and outside. MARS Architectes aimed at an architectural style that would be simple yet original and in harmony with the garden, which is why they decided to leave the structure exposed and the assemblies visible. Interestingly, the shutters are made of a system of sliding panels that further adds variety to the façade, yet in a strict manner, by leaving the windows completely hidden or entirely prominent.

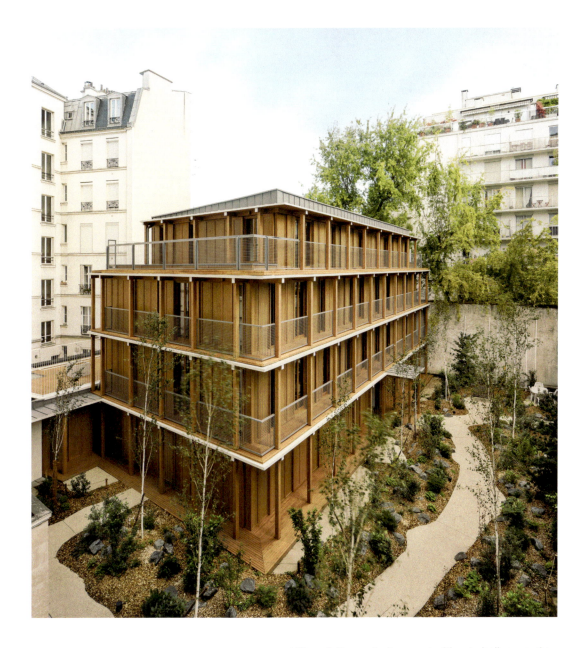

Although the project was not without challenges, they successfully implemented sustainable solutions into a collective housing design amid the dense, old urban fabric.

14 LOGEMENTS HOUSING COMPLEX

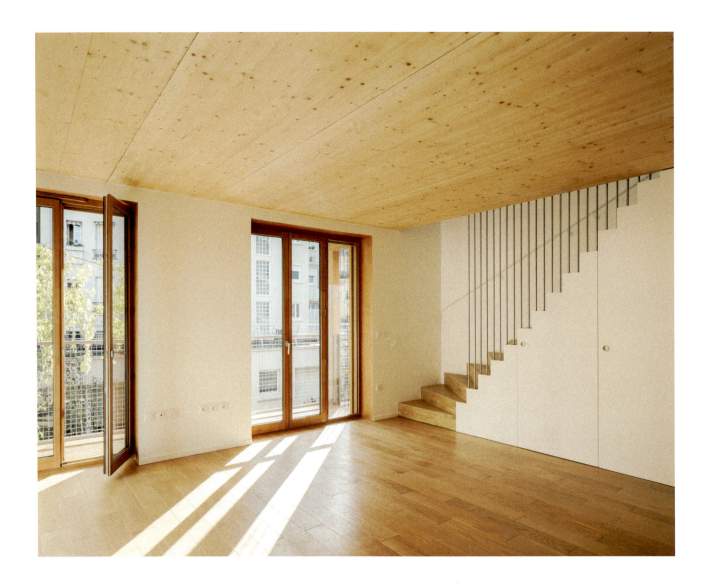

There are two interesting contrasts in the building. The meticulously elaborated outer shell is somehow counterbalanced by the minimalist all-white courtyard with a series of footbridges and balconies accessing the apartments. The passage between them is a canopy entrance followed by a long white corridor, reflecting the transition between the outside and inside as well as between entirely different styles. Another difference is the freedom with which the interiors have been designed, which is in perfect opposition to the rigor of the outer shell. The architects used an open gallery strategy to make it possible to offer run-through plan configurations, which are equal for all flats and, as they emphasise, allow for "space expansion, clearance of corridors, as well as a simple and effective natural ventilation." Organised into strips, the apartments are situated with one of two orientations — toward the garden there are the living room and bedroom connected with double sliding panels and access to the balcony, while on the courtyard side, the architects located the entrance and the rooms are filled with lots of natural light.

The use of sliding doors connecting all interiors enhances fluidity and makes the living space much more practical to arrange; the doors are also parallel to the system of outside shutters. Just like the outer shell, the inside of the building offers a warm and natural embrace created by wood.

VILLA VUGHT

VUGHT, THE NETHERLANDS, 2019 // MECANOO

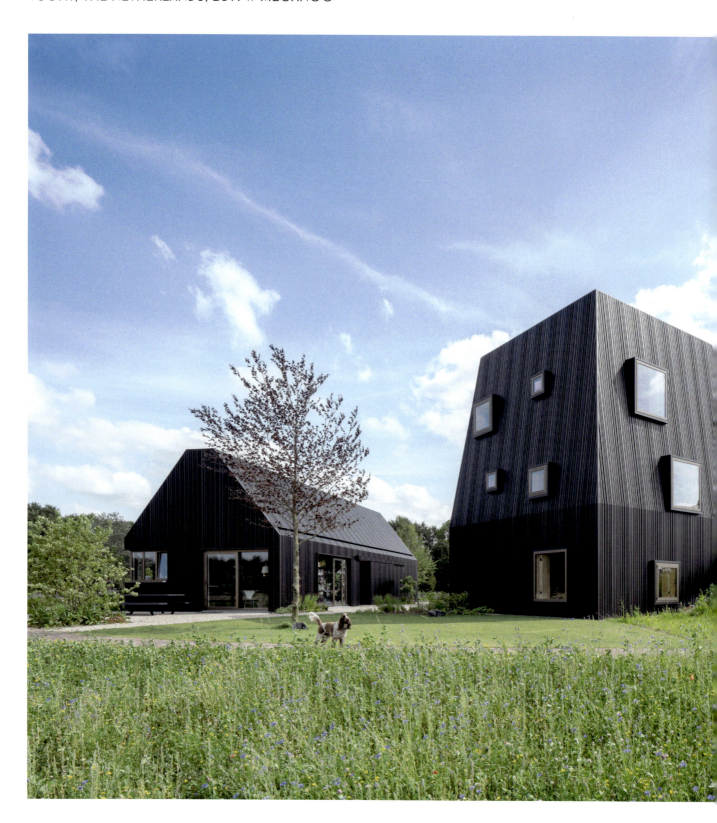

RESIDENTIAL ARCHITECTURE

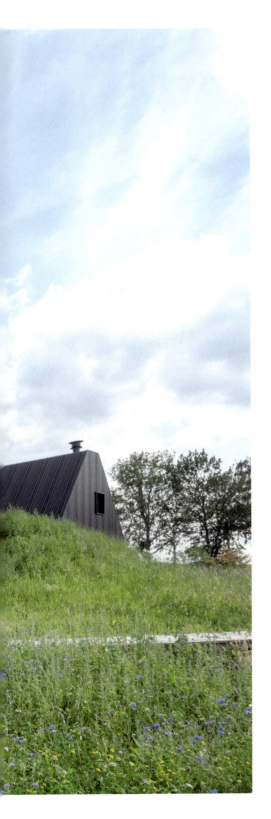

Inspired by local farmstead typology, the Mecanoo architecture firm envisioned a contemporary version of the Dutch "hoeve" as an ensemble of farmhouses and living quarters arranged around a courtyard that provides a central open space, partly protected yet not disconnected from the surroundings.

The tallest of the volumes creating a picturesque composition is a tower-like structure, which connects the villa with the landscape. The placement of the square openings in various sizes has been carefully chosen in order to frame the best views of the neighbouring farmlands across all façades.

The original cluster of volumes designed by Mecanoo consists of three buildings — a tall tower-like structure with a long-distance view and the contrasting two lower volumes covered in gabled roofs, mimicking a simple barn. All draw from the shapes of the vernacular architecture. The two barns open onto adjacent gardens. The architects protectively embraced the common space in between these three parts, but in a balanced way, which leaves it open to the surroundings. Connecting the spaces with the landscape is realised through numerous openings, which are planned in strategic positions in order to frame particular views. The "windows are placed like picture frames, adorning the walls with selected images of the surrounding farmlands," remark the architects. This well-planned open—close or inside—outside relation is enhanced by the materials, and thus their particular colours, that empower the original shapes of the ensemble. The outer shell of all three buildings is made of dark bronze anodised aluminium cladding, which the architects chose with the goal of a seamless extension beyond the façade up to the roof top.

As much as their profiles are intended to mimic the iron roofs of local farm buildings, the effect also turns the volumes into curious monoliths. The corrugated exterior somehow breaks the contrast between the cladding and the main material of the ensemble — wood, drawing from its texture. Cross-laminated timber is used for the structure, and European silver fir for all interior finishings. The architects selected wood to obtain a visually warm effect as well as for its sustainable qualities. "Compared to other solid construction methods, relatively little energy is needed for the production and processing of cross-laminated timber," the studio explains. They add that "it contributes to sustainable CO_2 storage as well."

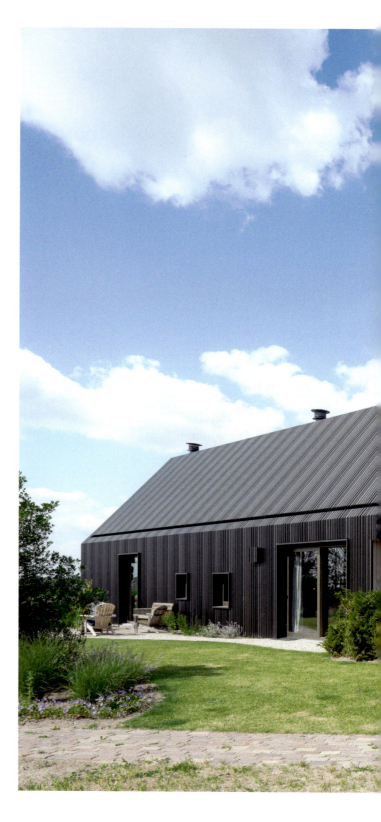

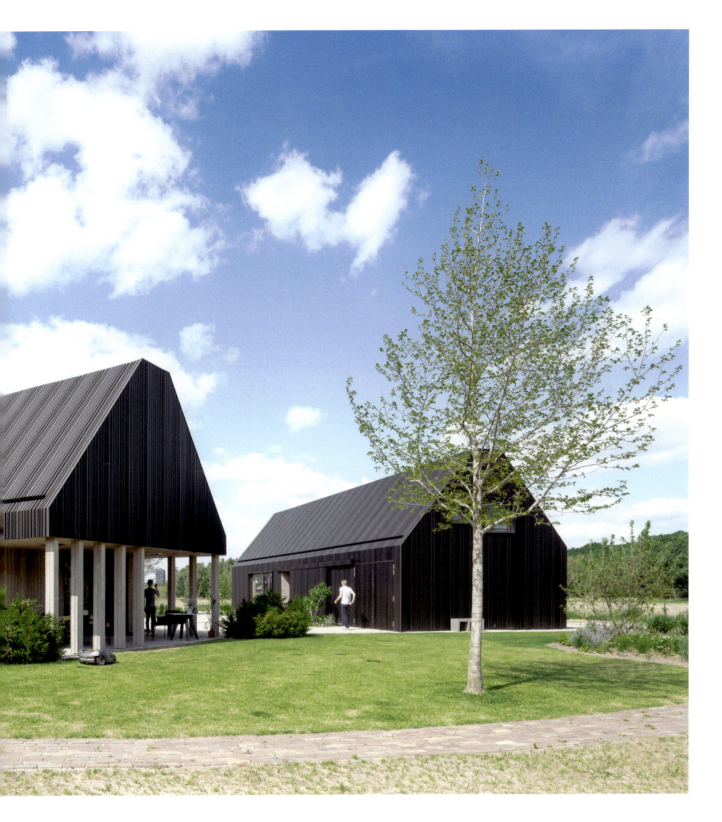

To make the villa even more energy efficient, it is heated and cooled with electric heat pumps.

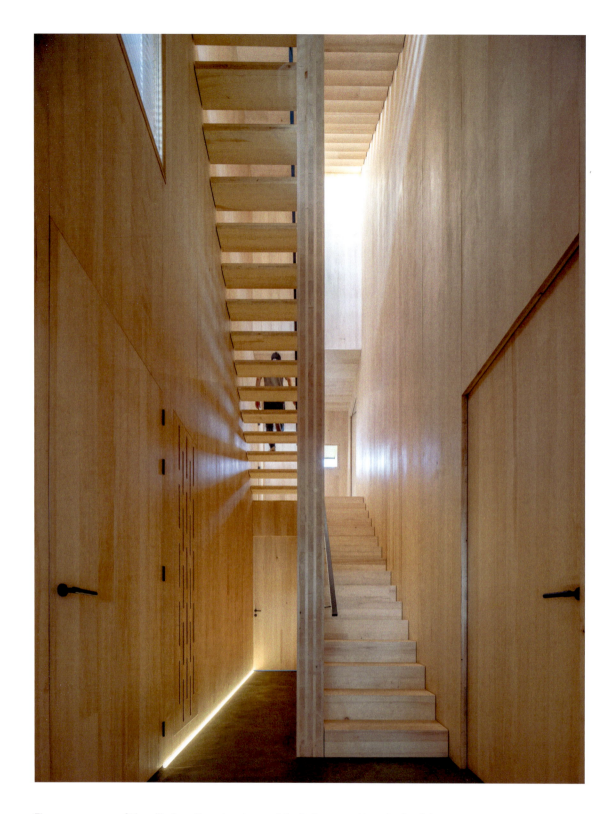

The programme of the villa is quite extensive, as it includes a cooking studio, living and dining rooms, kitchen, one main and two children's bedrooms, a bathroom, workspace, and playroom, as well as car and bicycle parking and a guest suite. All interiors are defined by European silver fir wood, chosen for its exceptional smoothness and uniform texture.

The biggest challenge in the setting informed by the typology of the "hoeve", a traditional Dutch ensemble of farmhouses, was the connection between the residential functions throughout the detached structures. Private quarters are located in the most intimate, tallest volume — the main bedroom on the ground floor and two children's room on the upper floors. The roof terrace on the top allows the inhabitants to enjoy extensive vistas. A half-sunken corridor that is hidden beneath a mound covered with grass connects this private part with one of the barn-style volumes. Here the architects designed a living room with a kitchen and dining area opening onto a large veranda on the ground floor, as well as a workspace and a playroom on a higher level.

The second low building remains entirely detached, as it houses a cooking studio for culinary classes and workshops run by the house's owner and a guesthouse on the top floor. All interiors are spacious and filled with natural light throughout the day thanks to carefully placed openings. The natural colour of the wooden finish contributes to this brightness and creates a cosy atmosphere perfect for the rural location. As such, the interiors form a surprising, stark contrast to the dark monolithic exterior look.

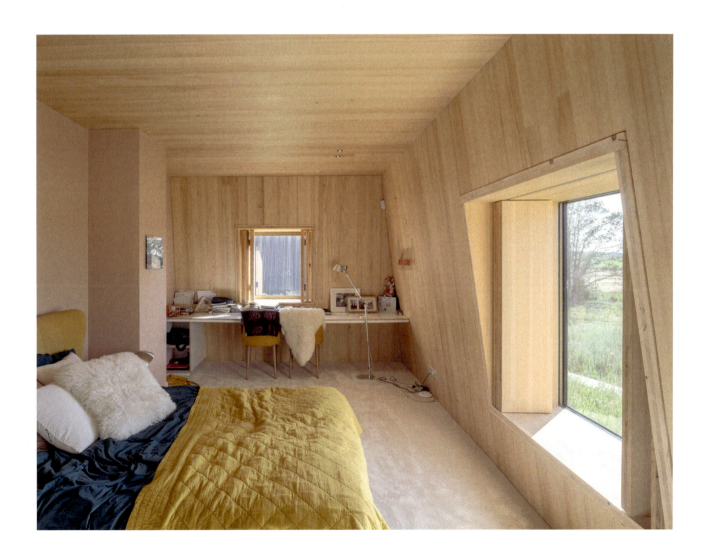

FREEBOOTER

AMSTERDAM, THE NETHERLANDS, 2019 // GG-LOOP

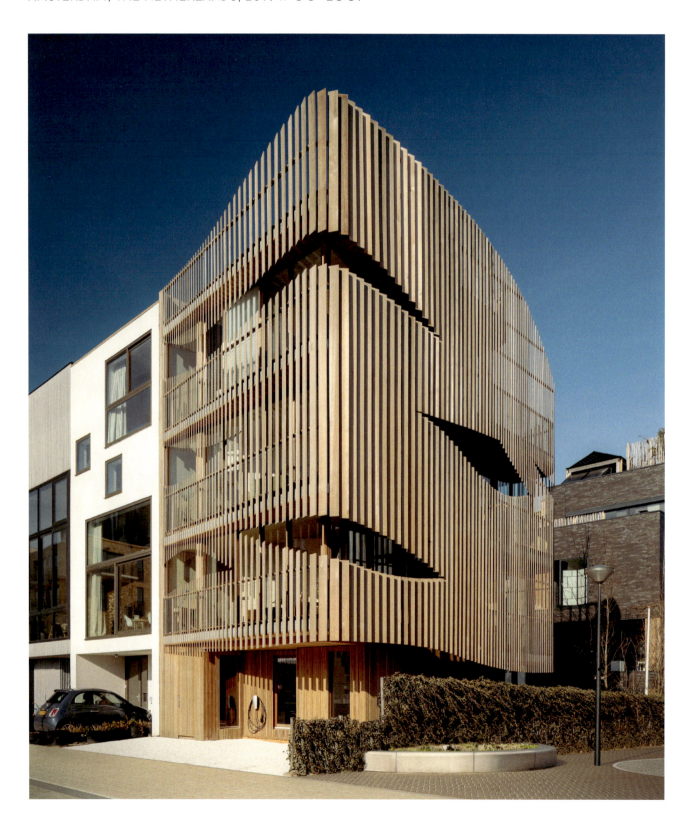

Envisioned in the spirit of biophilic design,
which combines sustainable materials, construction,
and energy efficiency with aspects of healthy
spaces that foster well-being, Freebooter celebrates
wood in a very complex and elaborated form.

Giacomo Garziano, the founder of GG-loop architecture studio, is a pioneer in developing projects that, as he emphasises, not only have "green" structures but also create healthy spaces that help the residents reconnect with nature. "I see biophilic design as the key to truly innovative design, balancing the technical aspects of environmentally conscious construction with the qualitative, lived-in experience of an organic and natural space," the architects states.

In Amsterdam, his holistic approach resulted in this unique two-apartment house, the design of which draws from Dutch history, culture, and the specific Dutch sense of light. Driven by the fact that this particular district of Amsterdam used to be the main throughfare for ships docking into the city, back at the beginning of the 20th century, the architect followed a maritime inspiration. Freebooters at that time were intrepid freelancers who created ship's crews and explored broad waters. Naming the building after these, the architect aims at a "ship on land" effect and highlights references to the water, wind, and sails by also using materials typical of ship-building.

Freebooter is a hybrid structure combining cross-laminated timber (CLT) and steel, with all elements prefabricated to facilitate the construction time. All four floors were erected in only three weeks, while finishing the apartment block took six months, proving how time-saving the material is in terms of construction time. The use of wood also highlights the notable craftmanship in combining form and function, both inside and outside. Each apartment is distinctively made of three main materials — western red cedar, pine, and steel, all typically known in ship constructions. The floor plans were also envisioned to reference those of a ship. The free-flowing layout of the interiors has been designed as an open plan, embraced by curvaceous lines. While the kitchen features are located centrally, they open onto the living room, which together with the dining and casual spaces has been planned to provide flexibility. "The spaces are very fluid and organic, and 'unfold' as you move through the home," explain the architects, who treat the design as an "extension" of the user.

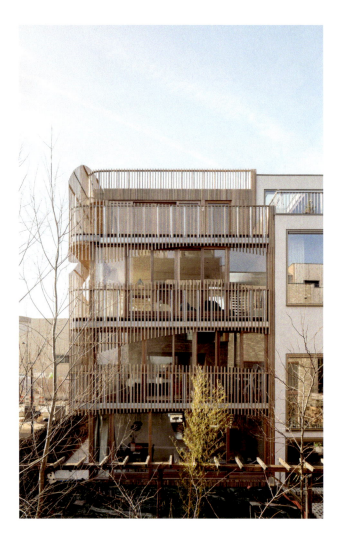

This was also achieved through mostly glass walls, which together with the numerous balconies open the interiors to the surroundings. The house's structure, with its impressive system of beams and all-wood spaces, is beautifully visible. To maintain the balance between providing light and views and privacy, the architect designed a meticulously crafted louvered façade, which is another highlight of the building. Its precise structure is based on a computer algorithm that the architect used to study the flow of sunlight throughout the year. The goal was to obtain optimal light for all interiors, with an optimal shape and positioning of each element. While the wood creates the compact core of the house, the transparent glass envelope appears ephemeral, and the louvered outer shell, although also executed in wood, indeed resembles a sail in the wind. This delightful juxtaposition of materials and the way they are used, creates a multi-sensory experience, and thus influences the atmosphere of the interiors.

In his work, Giacomo Garziano is inspired by both nature and music — the architect actually believes that architecture is a form of "frozen music," as he calls it, with all its attendant rhythms, poetry, and feeling, which his biophilic apartment house definitely conveys. According to the architect, a building should also tell a story, and Freebooter, with its maritime references, perfectly fulfils the task.

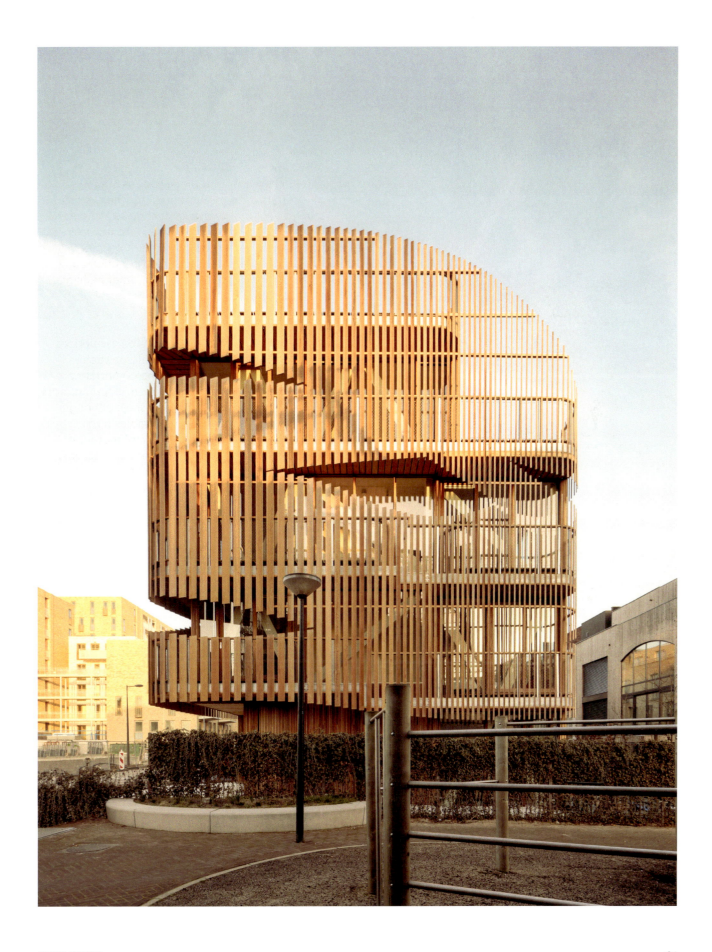

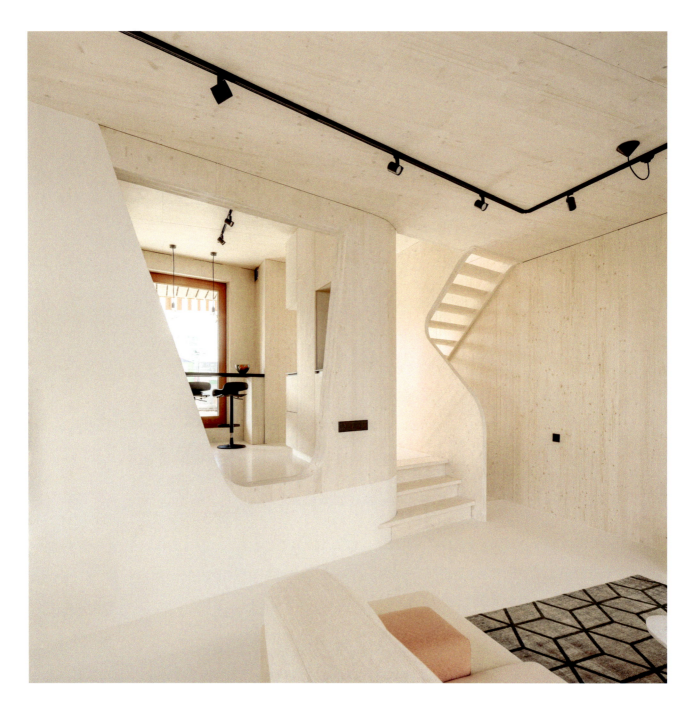

Employing a biophilic living concept, the GG-loop architectural studio created a house offering a multi-sensory experience through its materials, shapes, and layout. Its spaces were meant to be flexible and to become a comfortable retreat for its residents.

The subtle use of light, characteristic of Dutch culture, is achieved through a system of meticulously positioned louvers, wrapping the building in soft curves. Based on a year-long study of the trajectory of light on site, the design illustrates the way wood can be used on a large scale yet very subtly.

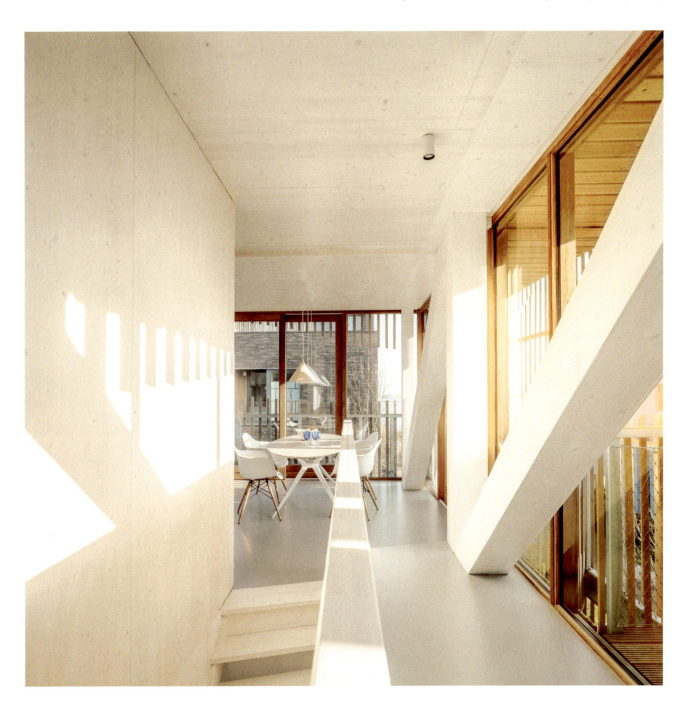

FREEBOOTER

MTR

MONT-TREMBLANT, QUÉBEC, CANADA, 2020 // ALAIN CARLE ARCHITECTE

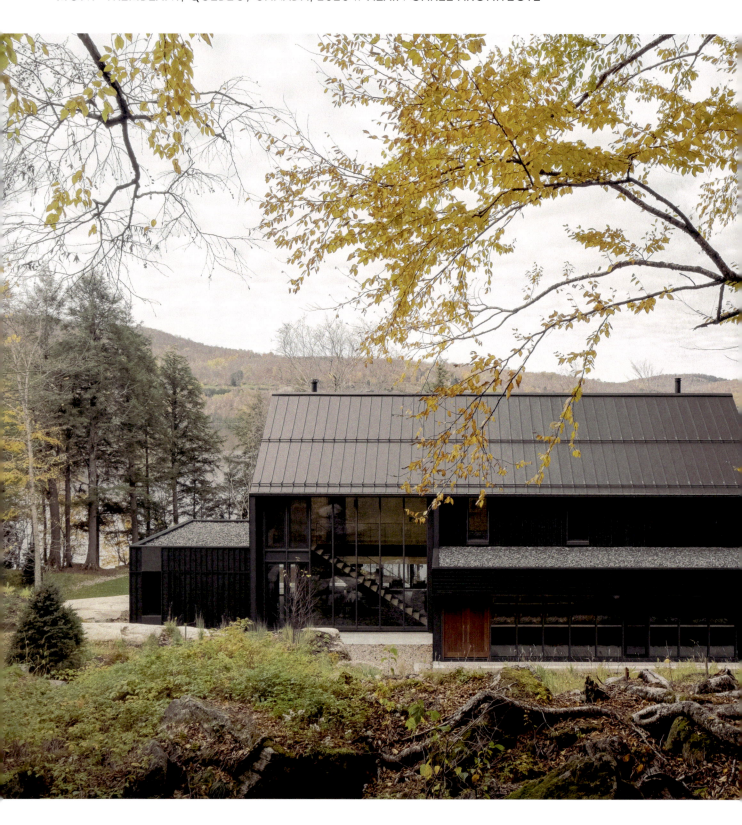

This monolithic two-volume residence sits on Lac Tremblant, one of Québec's natural wonders. With an interestingly stained black exterior siding, it sinks into the natural landscape, while the gable roof structure reinterprets local vernacular traditions.

Alain Carle Architecte designed the house on a very steep slope with high rocky cliffs overlooking the picturesque lake scenery. This spectacular setting created a restrictive frame for the architects, both structurally and aesthetically. "A very large flat rock cap on the edge of the lake was chosen as 'level 0' and allowed the creation of the architectural project's anchoring identity," they explain. The plateau acts like a terrace and brings the house as close to nature as possible. In the interiors, this proximity is enhanced by large windows in the main living space that benefit from the lake view and literally invite the surrounding landscape inside. Based on a mainly wood-frame construction, the house takes a simple shape. On the one hand it is the architects' reinterpretation of the board and batten traditional method used locally, and on the other, a way to limit the impact of the architecture on the landscape.

The organisation of MTR is informed by the surroundings — it comprises two volumes, which follow the horizontal orientation of the site. The main one, covered with the gable roof that also acts as a connection with the rocky cliff at the rear, displays a stained black exterior shell. Here, the architects suggested an original solution — the dense batten grid, made in an exaggerated size, creates an increased shadow effect on the façade. "The resulting façades are a layering of grids evolving at different scales — roof grid, board and batten grid, punched windows grid, glazed wall grid," comments the studio. In contrast with this distinctive relief stands the second volume, realised with horizontal cedar plank. Not only lower and covered with a flat roof, it also displays a much smoother exterior surface. The architects decided to blacken the wood for aesthetic reasons, as it helps to fuse the structure with the natural context, but there was also a practical aspect to this decision — some elements that were available only in black become invisible in this configuration, which gives the house an expressive, monolithic look.

Also envisioned around the landscape are the interiors, organised across three levels. The first floor is dedicated to all social functions and common spaces, and the second one comprises four bedrooms with ensuite bathrooms. A smaller, basement level completes the programme. Just as on the façade, wood is the dominant material and defines the character of the spaces. Black or white painted pine paneling, solid wood steps, an engineered wood floor, and white and grey oak or solid wood doors, both swinging and sliding, demonstrate the importance of the material and the large scope of carpentry work also inside the house. The cabinetry elements, made mainly of wood, also harmonise with these elements, as does the selection of furniture determined by the presence of wood to suit the coherent concept of the design.

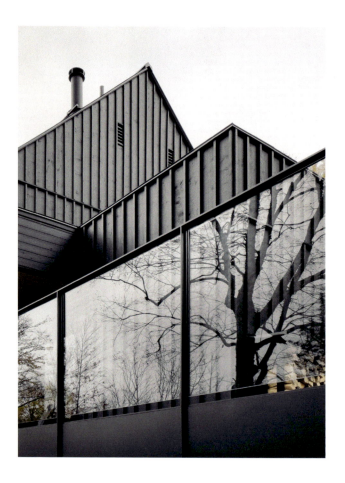

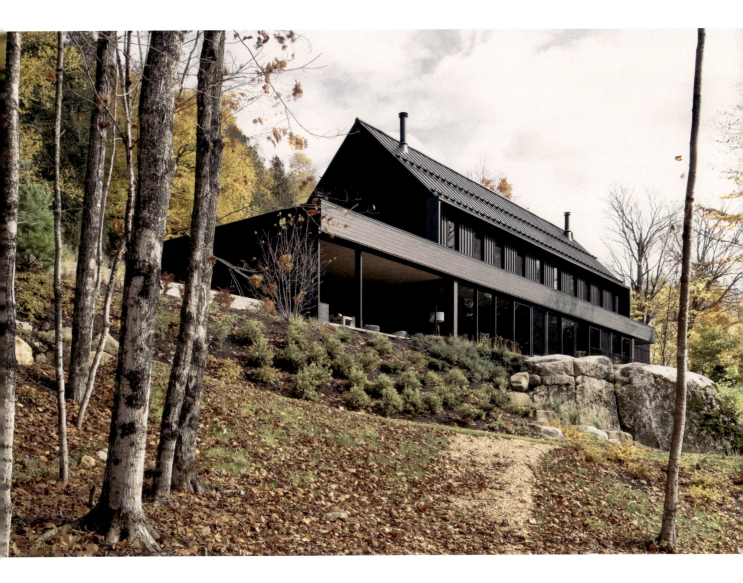

Two elements settle the house into the context — the gable roof that draws from the traditionally used local board and batten method as well as the blackened timber cladding that acts as a camouflage and integrates the volume in the natural surroundings.

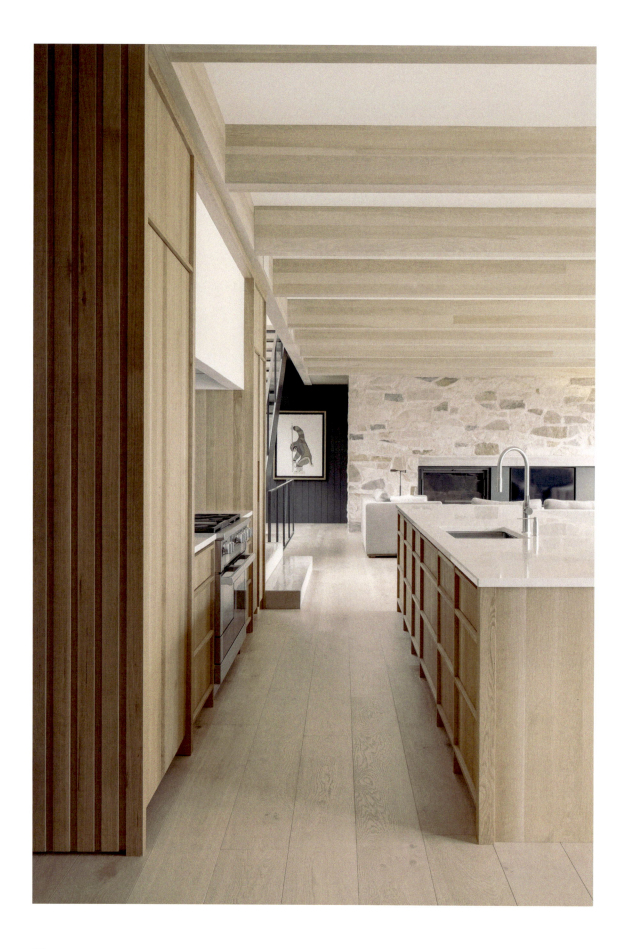

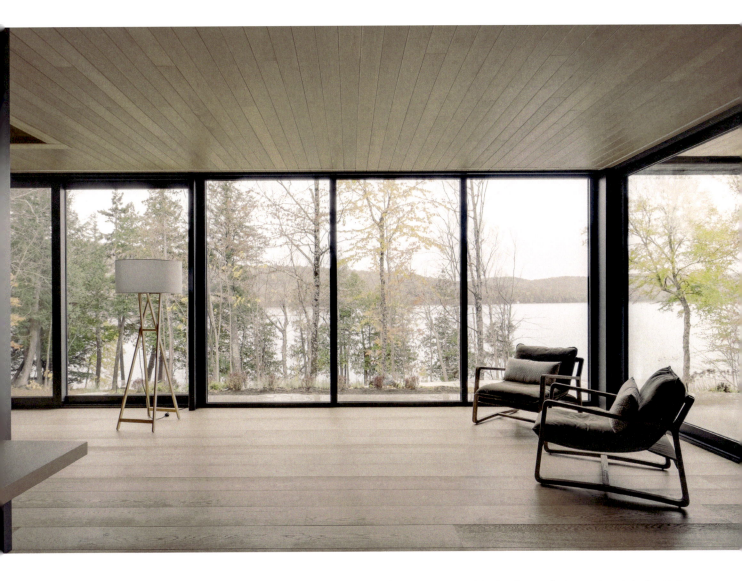

The house becomes part of the landscape just as nature is invited into the interiors, especially in the main living area, where extensive south-facing windows open to a lake view.

TIMBER HOUSE 670 UNION STREET

BROOKLYN, NY, USA, 2022 // MESH ARCHITECTURES

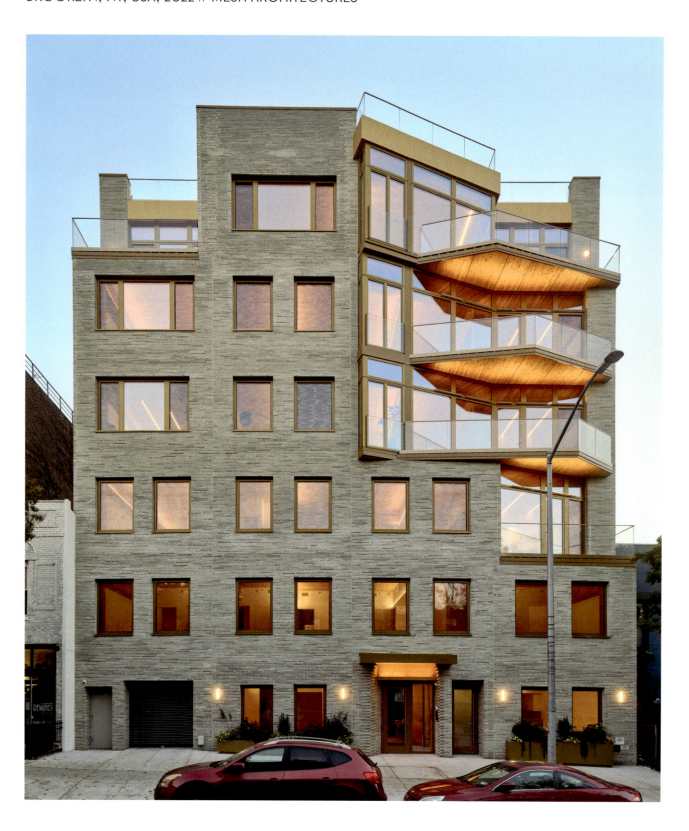

The newly completed Union Street Homes is proudly named by its architects as the first mass-timber condominium in the New York region. The MESH architectures studio has been introducing new technologies on an unprecedented scale.

Housing fourteen apartments across six levels, the Timber House in Park Slope, Brooklyn, is based on glue-laminated timber columns, beams, and floorplates. The MESH Architectures studio has been a pioneer in introducing mass-timber constructions in the U.S. They compare the system to ready-to-assemble furniture on a large scale. The large components of the building, possible thanks to a computer-controlled fabrication processes, are made of fast-growing standard lumber and are pre-made, which allows for rapid construction, which reduces the amount of waste and typical local environmental disruptions. Moreover wooden constructions sequester carbon and are demountable at any point with recyclable elements. At the same time, the structural elements are extremely durable and entirely fire resistant. Wood's aesthetic and its natural beauty, which remains largely exposed in this case, as well as its efficient environmental footprint are clearly other important factors that make wood a good alternative to traditionally erected steel and concrete buildings. "Timber House's generously sized residencies feel like modern-day treehouses," reflect the architects.

The atmosphere in the abundantly scaled rooms is created by the exposed structure, with the impressive wood-beam ceilings as a highlight, as well as by the expansive glass windows that fill the spaces with natural light, enhancing the bright hues of the wood, also used in many rooms for the floors. The visual warmth is accentuated after dark by energy-efficient lighting, sleekly integrated into the ceilings.

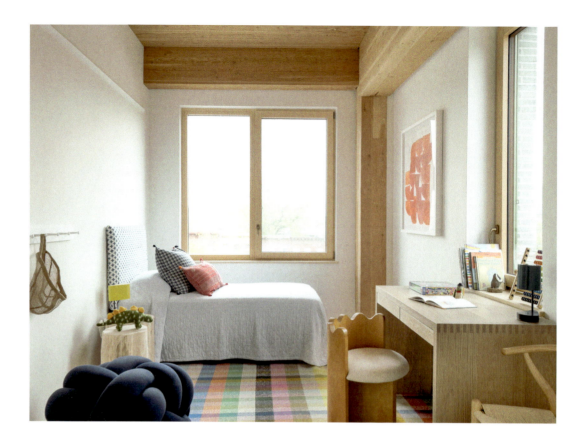

The generously sized rooms with tall wood-beam ceilings are impressive in combination with the fully glazed façade offering a panoramic view of New York City. The building functions as a typical urban condominium and employs some significant environmental advantages.

The living areas combine spacious open kitchens and bright living rooms. The layout of the interiors is quite practical and even the corridors have been planned on a grand scale, making all apartments very functional. Half of the units also have private outdoor spaces in the form of balconies and a huge private roof deck for the inhabitants, offering vistas of downtown Brooklyn and Manhattan.

The sustainable solutions for the Timber House do not conclude with the material or structure. The heating functions use high-efficiency heat pumps, cooking is via induction, and electricity is generated by solar photovoltaic panels on the roof. The architects note that "passive-house-level performance is achieved with generous insulation, air sealing, triple-glazed windows, and energy-recovering ventilation." Planned to use the minimal amount of energy and with an eye toward renewable energy sources, the architects have excluded features requiring fossil fuels. Even the parking slots are all equipped with electric charging stations. While the striking, wood-beamed ceilings of the structure are exposed inside, on the outer shell the building is clad in brick, which creates a visual connection with the urban context and refers to the early façades of Brooklyn brownstones.

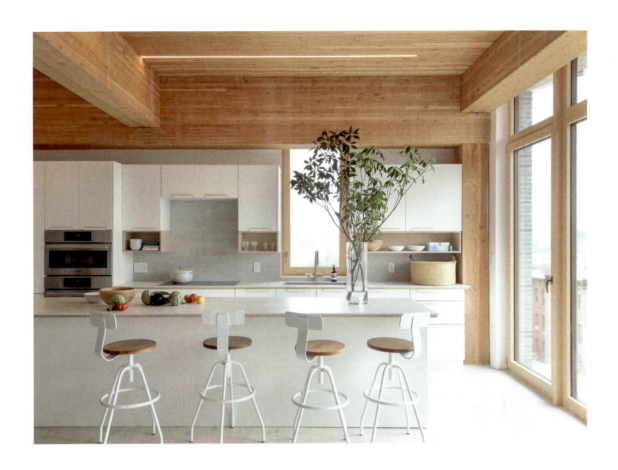
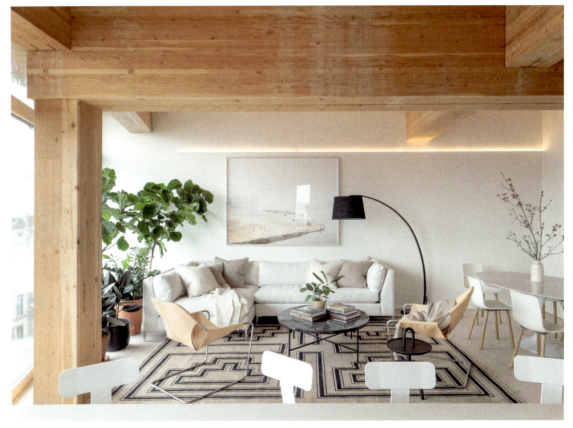

TIMBER HOUSE 670 UNION STREET

LATHHOUSE

SAGAPONACK, NEW YORK, USA, 2020 // BIRDSEYE

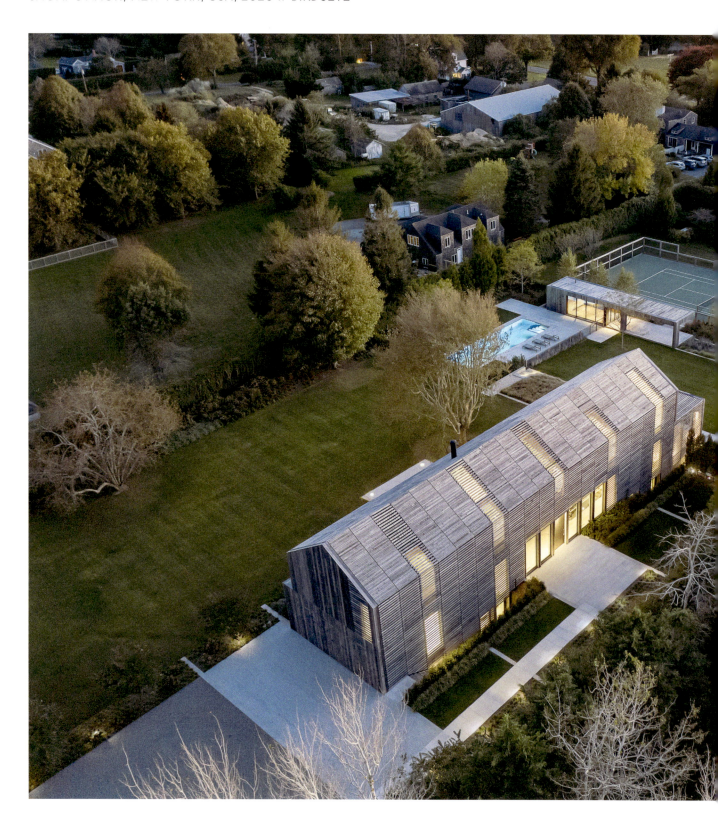

RESIDENTIAL ARCHITECTURE

This Hamptons retreat is a perfect combination of contemporary minimalist chic and a traditional silhouette. The use of wood is one of the architects' many sustainable decisions but wood also plays an important aestheticising role.

Birdseye, an American architecture firm known for ingenious interpretations of traditional architecture, designed this comfortable, large holiday home referring to the local mélange of modernist, historical, and rural farmland buildings, with an emphasis on the last one. "The architecture of Lathhouse is conceptually inspired by the eponymous lath house; a traditional gabled farm structure made primarily of wood laths or slats spaced to reduce sunlight while permitting ventilation," explains the studio. The arrangement of slats, which for this project were repurposed from old fences, creates a meticulous skin enveloping the gable structure on all sides. As the architects emphasise, the slats are both contextual and purposeful. Their varied textures and hues animate the simply shaped volume, while the glass elements on the walls and ceilings allow an inspiring play of light and shadow in between the slats. In a practical sense, the slat system provides privacy and helps in filtering the sunlight (the plot has some mature greenery, yet not close enough to the house to offer sufficient shade). This interesting reference to the vernacular form highlights the natural beauty of wood and its charm.

With this structural solution, the architects have also gained a good relation with the surroundings — the gable double-height volume overlooks an extensive lawn, with the south façade largely glazed to create a smooth inside—outside transition (operable walls in the living room open to a large stone terrace, while the kitchen opens to a wood-slatted, pergola-covered porch with a comfortable and shaded outdoor dining area). The generous openings visually enlarge the already impressive floor area and are an excellent source of light for the interiors.

Lathhouse, with its barn-style design, may refer to the local agrarian context but the programming of the house as well as the interior design are purely contemporary. The spaces of the main house are organised across three levels. The lower floor includes a spacious bunk space and play room as well as a gym, guest suite, and wine storage. The ground level with the main entry and welcoming hall has all of the common spaces — the interconnected living and dining areas, together with a large kitchen (extended by the large outdoor terrace), as well as another guest room and a garage. The primary bedroom with an extensive view over the estate and three other bedroom suites, as well as the laundry room, are located on the second floor. On the higher level, the outdoor slats system wraps around to each bedroom window to create inset Juliet balconies, which fill the spaces with natural light. The interiors, designed by Brooke Michelsen, are characterised by a clean aesthetic — bespoke pieces of furniture are complemented by custom-made cabinetry in a way that resonates with the strongly present craft aspect of the architecture. The estate, located on a gently sloping plot, also includes a pool and a tennis court with a minimalist pool house in between. In addition to the global use of wood, the architects employed other sustainable solutions, like geothermal heating and cooling, rainwater collection, and high-efficiency windows.

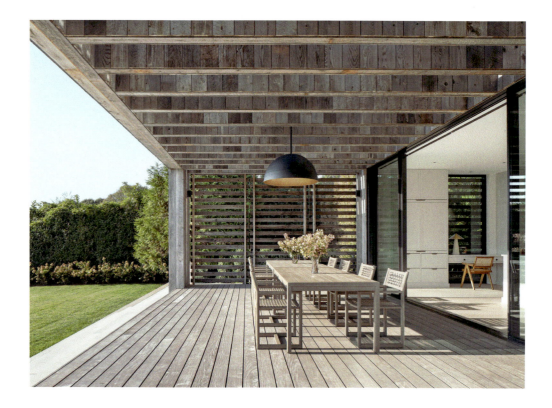

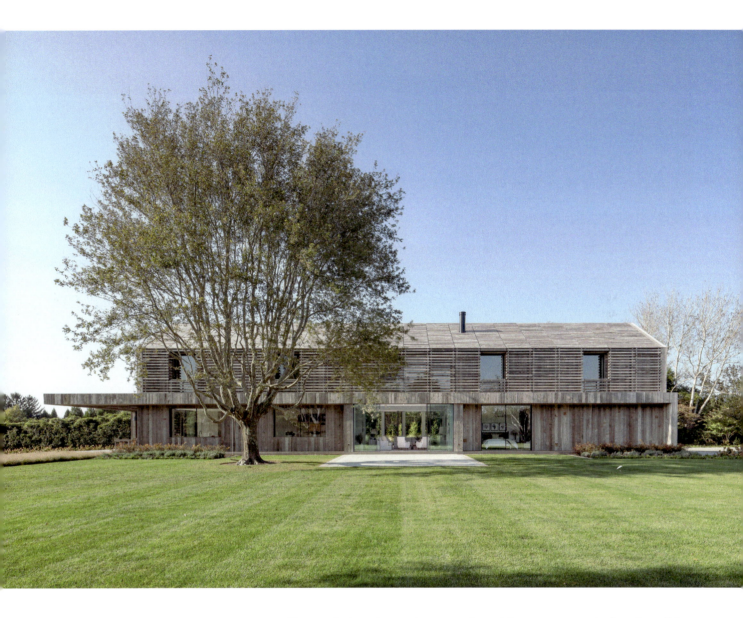

The wood-slatted, pergola-covered porch becomes a practical outdoor dining space, while the south façade is equipped with operable walls that open the living room to a large terrace and further to the large garden.

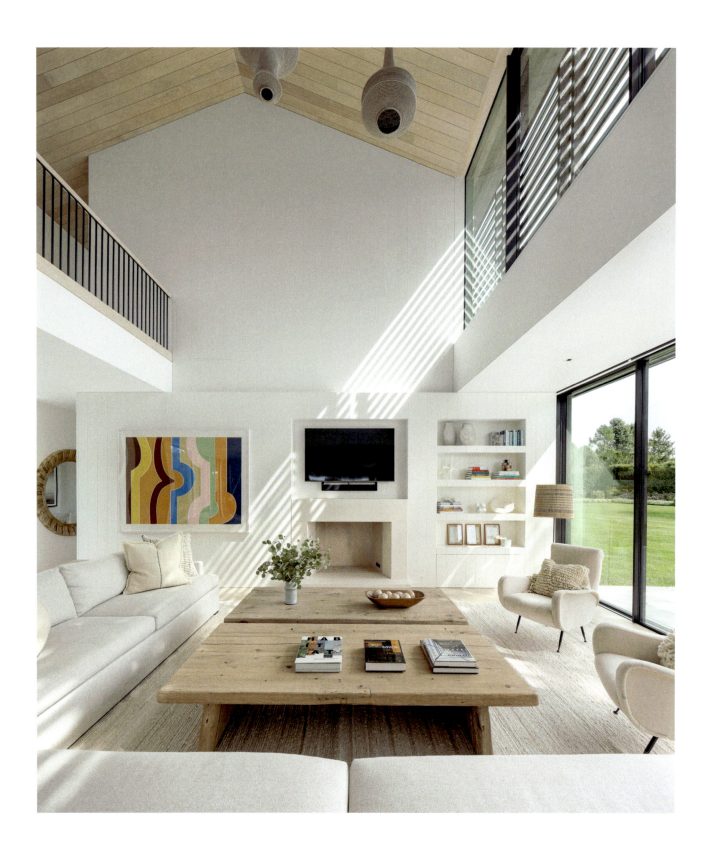

The main living area benefits from a double-height ceiling and the beauty of the exposed gable roof structure. On the upper level, the slats over the glass skylight and walls create a lovely play of light and shadow that animates the interiors.

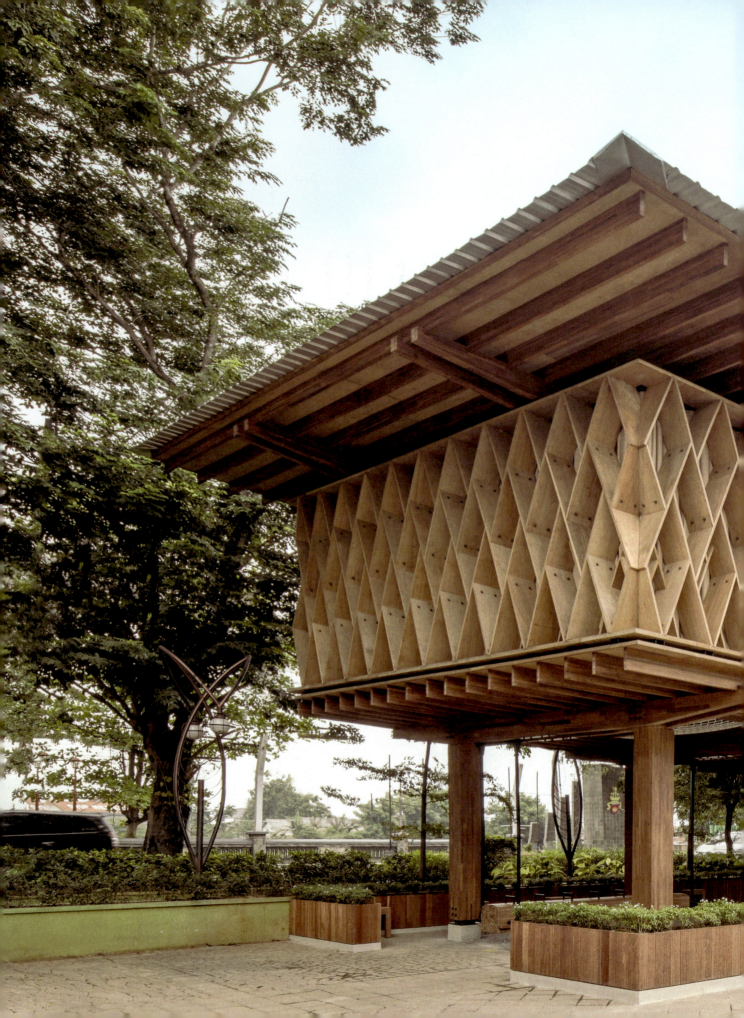

PUBLIC BUILDINGS

MAGGIE'S LEEDS CENTRE

LEEDS, UNITED KINGDOM, 2020 // HEATHERWICK STUDIO

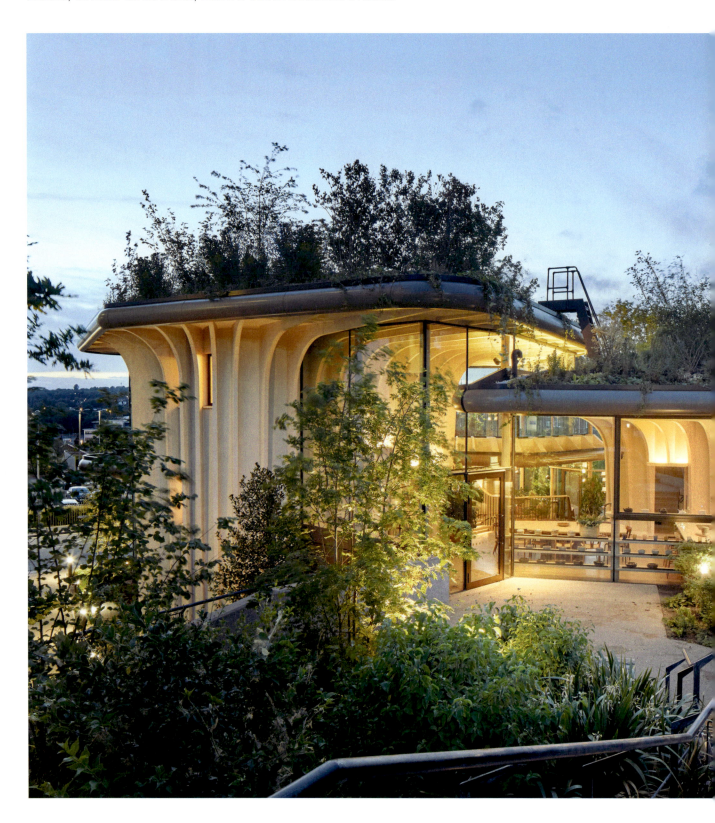

Made entirely with a prefabricated and sustainably sourced spruce timber system, this design was envisioned as a group of three large-scale planters. The ingenious combination of wood and organic shapes creates a unique space for a very special use.

One of the most recognisable charities in the United Kingdom, Maggie's provides practical and emotional supports for cancer patients. Its Leeds Centre is located on the campus of St. James's University Hospital and occupies a steep slope. The site was, as the studio points out, a grassy hill and the last patch of greenery at the hospital. While envisioning the inventive structure of Maggie's Centre, the architects faced several challenges. Not only was the plot sloped, but building there would deprive the complex of its last green space. It was also framed by roads that happened to be the hospital's main ambulance route, which could not be blocked by the construction. The use of wood brought with it effective solutions to all these issues.

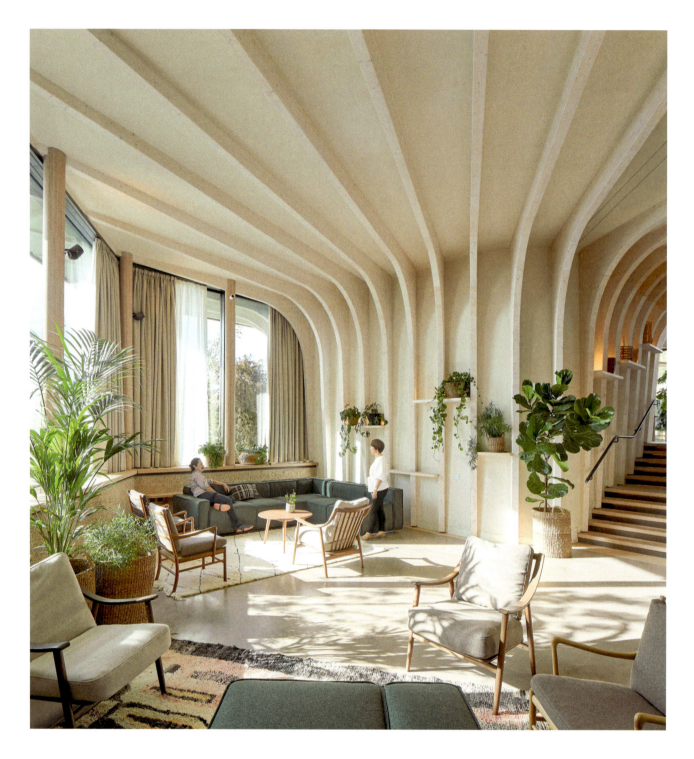

The impressive organic structure shows wood's flexibility and creates a dynamic spatial experience enhanced by the skilfully installed lighting system that makes the curvaceous wooden cores glow. Aesthetics meet functionality and sustainability in a most striking way.

The centre is designed as a group of three large planters, which each house a counselling room and envelop the centrally located areas, including the kitchen space, library, and an exercise room. The structure is supported by modulated glulam fins, which evoke the shapes of trunks protectively spreading over various interior spaces. The plan is a perfectly balanced combination of private areas and common spaces where people can meet and spend time together. Adapting this dynamic structure to the level changes was not realised by digging into the slope but by following the plot's natural contours. The six-metre difference is visually counterbalanced by the multi-level shape. "Instead of a single monolithic canopy, the roof is composed of three overlapping gardens, which step down and overhang to shelter communal areas," comment the architects. This intervention provides far-reaching panoramic views of the Yorkshire Dales and enabled the architects to preserve the greenery on the site. The impressive, lush rooftop garden, designed by Balston Agius, celebrates native English species of plants and draws from the local woodlands. Here Maggie's visitors can find a calming environment, a visual perspective that symbolically creates a connection with the space beyond the hospital limits, and even some activity if they like gardening.

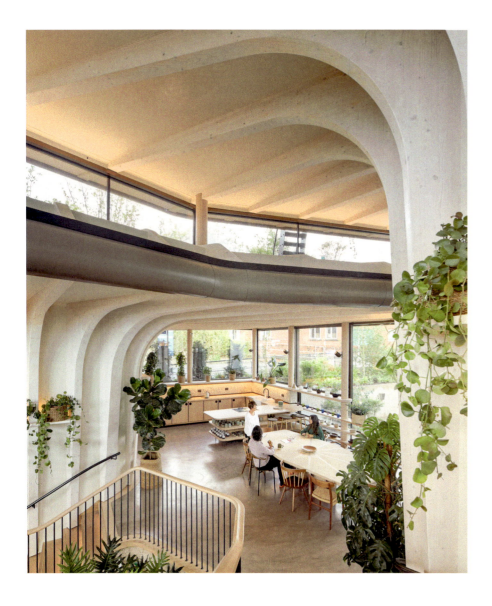

Due to the specific function of the building as well as Maggie's philosophy, the interior required a particular approach and design that would make visitors feel comforted. "The interior of the centre explores everything that is often missed in healing environments: natural and tactile aterials, soft lighting, and a variety of spaces designed to encourage social opportunities as well as quiet contemplation," explain the architects. Wood, once again, proved to be the transmitter of a home-like ambiance supported by a very considerate and subtle lighting system integrated within the shelves and the interior edges of the roofs. As a result, the wooden cores look as if they are emitting light, which makes the striking curvaceous surfaces even more flexible and dynamic. Wood was also the perfect choice due to the road obstructions and limited construction time. Made mostly of prefabricated sustainably forested spruce, the volume could be built off-site and rapidly assembled on a concrete slab and retaining wall

"By only using natural, sustainable materials and immersing the building in thousands of plants, there was a chance for us to make an extraordinary environment capable of inspiring visitors with hope and perseverance during their difficult health journeys," reflects Thomas Heatherwick.

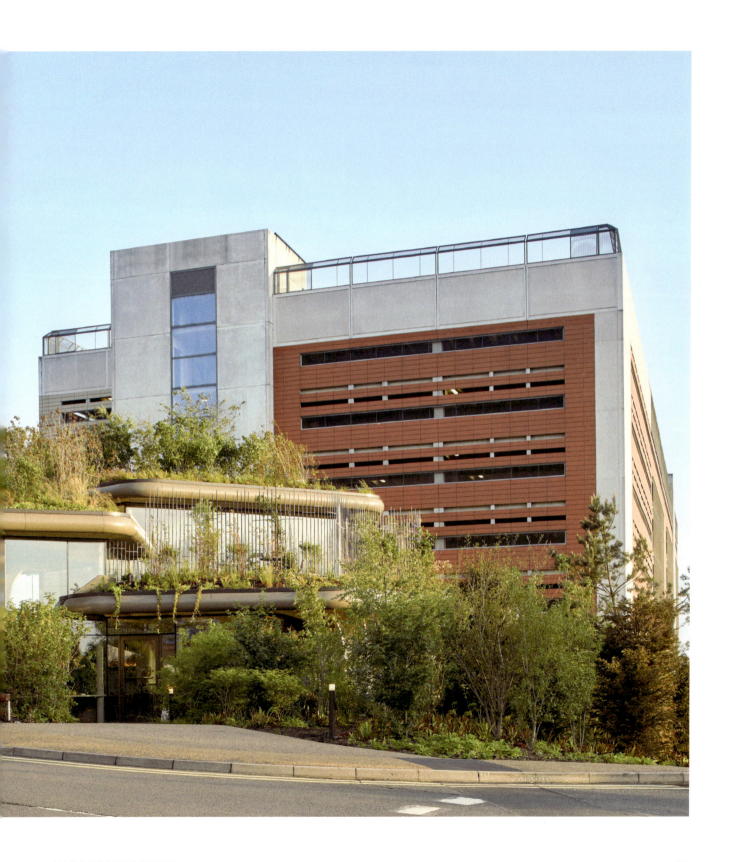

ALTO TÂMEGA
TOURIST INFORMATION POINT

CHAVES, PORTUGAL, 2020 // AND-RÉ ARQUITECTURA

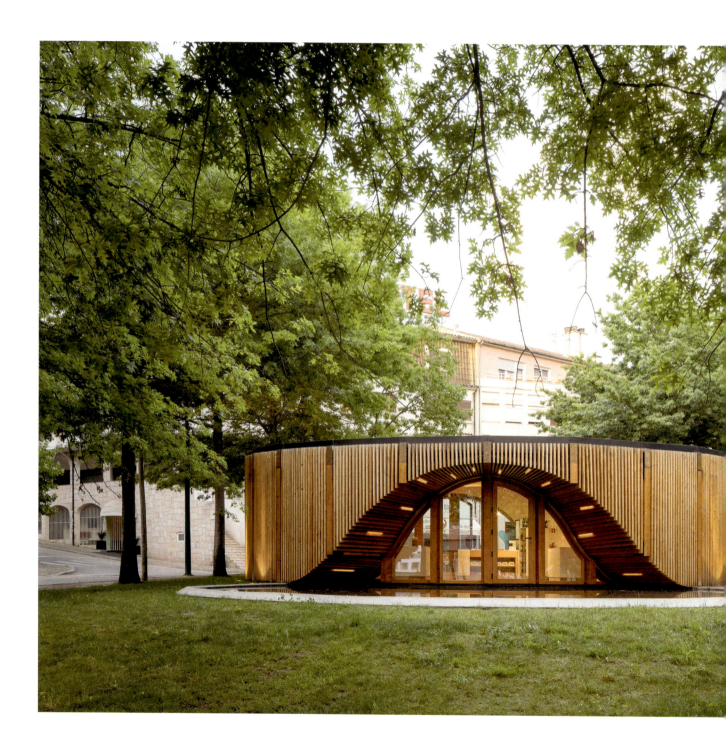

The beautifully shaped timber construction for this playful tourism information point uses wood as a symbol of the region it represents, with nature as its main attraction. The circular building has a meticulously arranged structure highlighting the flexibility of the material.

Alto Tâmega Tourist Information Point, designed by AND-RÉ Arquitectura, represents six local municipalities — Boticas, Chaves, Montalegre, Ribeira de Pena, Valpaços, and Vila Pouca de Aguiar. As the region's main attraction is nature, the architects decided to reflect this in the material chosen for the structure. Timber, together with the very organic shape, defined by fluid curves and reminiscent of a tree trunk, create a harmonious relation with the natural context. The building, located in the middle of the Tabolado Garden, visually sinks into the surroundings with a natural charm. The dynamic shape creates an interesting visual effect, as do the originally roofed outdoor spaces. Not only is the thick wooden outer shell impressively sculpted, but the sinusoid waves on both sides also enhance the connection with the outside. Two distinctive folds mark the entrance on one side, while a large viewing window opens toward the park on the opposite. By placing the pool next to the building, the architects point symbolically at two aspects — the Tâmega River, essential for the region, and the fact that Chaves is Portugal's most famous thermal area.

The structure is very clear, based on a circular plan and a system of timber pillars and beams covered with wooden battens, which are beautifully exposed and crowning the open space. The architects perfectly adjusted the plan to the function and focused on practicality, which is also why the main emphasis is placed on the structural beauty. "The simplicity of the program mirrors itself in the shape of the building, resulting in a clarity of functions and a clear reading of the touristic contents," the studio comments. The Information Point's interior is an open plan, to be able to welcome a large number of guests, and is organised along the main axis to make both visiting and displaying essential information as practical as possible.

The rest rooms and technical spaces, in contrast, are hidden in the thickness of the walls. Although timber was appropriately selected due to a strong sense of symbolism with the building representing the character of the region, the architects' sustainable solutions were not limited to the material. They note that many of their "technical and building choices aim to answer the rigorous sustainability and durability principles," including "the solar orientation of the main room, location and shading of the windows, double glazed wood window frames, solar panels, zinc roof, water reuse, the use of high levels of insulation, and the preferential use of wood both as structure and façade."

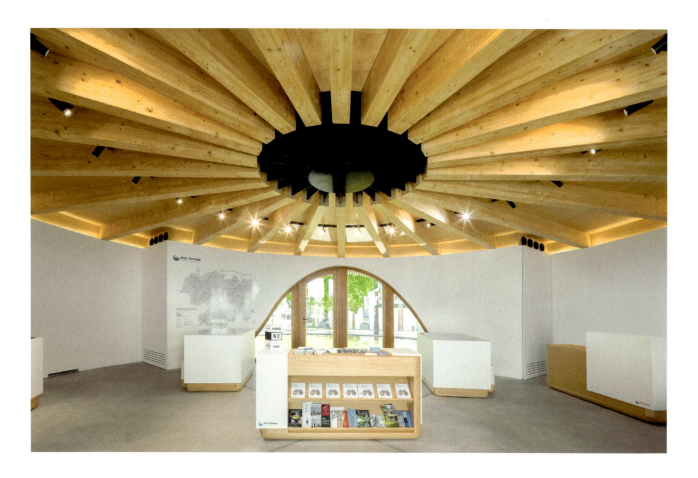

The impressive ceiling covered in timber battens is a highlight of the open-space room, planned to welcome a large number of visitors at once. Designed with functionality as the main objective, the interior reflects the harmonic, circular shape of the building.

60 PUBLIC BUILDINGS

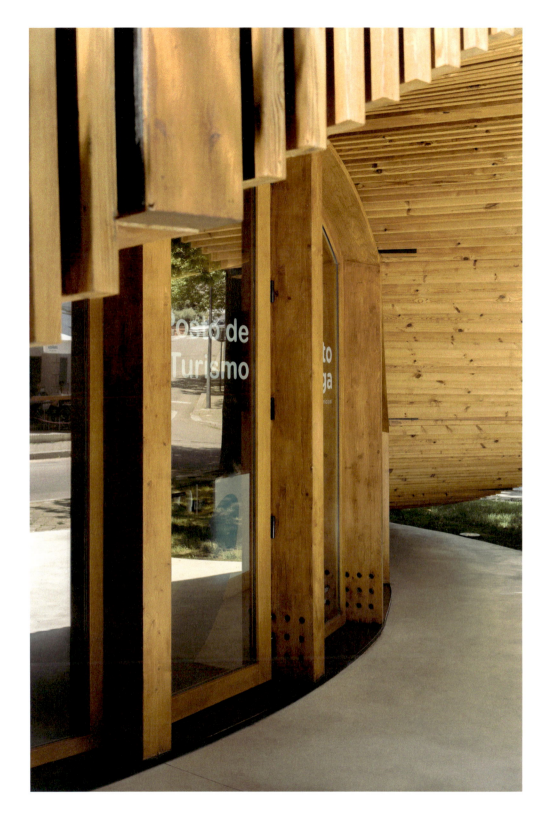

The timber structure is executed with an excellent eye for details. The rhythmic texture and fluid shape perfectly express the organic character of the material.

TAVERNY MEDICAL CENTRE

TAVERNY, FRANCE, 2020 // MAAJ ARCHITECTES

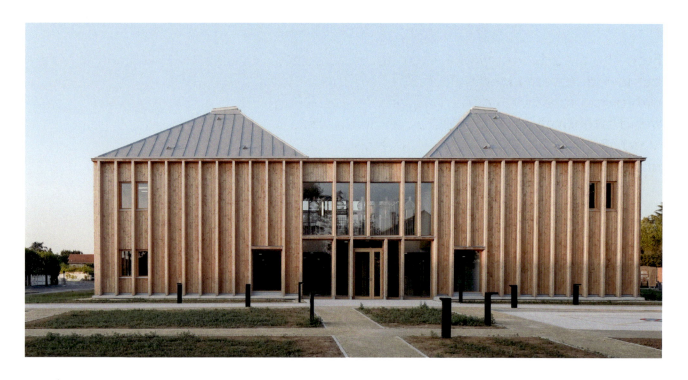

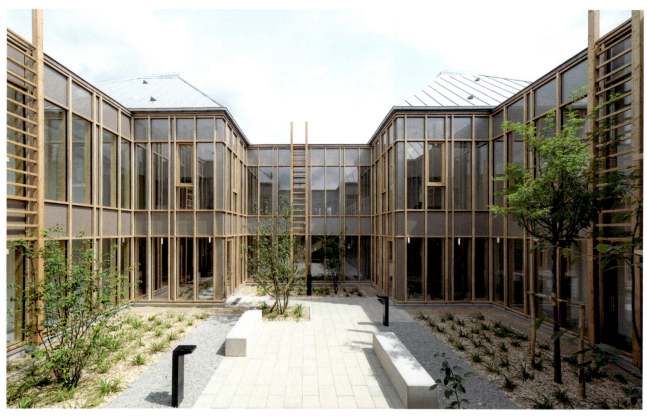

From the outside it may look like a fortified castle, but inside, Taverny Medical Centre surprises visitors with a spacious patio and transparent walls. Using wood extensively and inspired by ancient cloisters, MAAJ ARCHITECTES has created an embracing and atmospheric care facility.

The patio, as the architects emphasise, "acts as an intimate and sensory place where medicinal plants are grown, a reminder of the health and curative purpose of the Centre."

The monolithic volume is visually striking with its rhythmically arranged wooden structure, yet the material effectively softens its rather massive scale. This timber façade is reminiscent of a forest, and as a natural outer layer it creates an ambient climate, both externally in terms of perceiving the buildings as well as internally, providing well-being for the patients. Built for a multidisciplinary medical team, the architects' main objective for the building was to create spaces well adapted to care facilities. Its original structure, enveloping a central patio, is reminiscent of ancient cloisters in the architects' vision. This arrangement creates much-needed intimacy and offers a protective atmosphere. In a stark contrast to the solid outer shell, the walls that open to the patio are fully glazed with soft wooden elements framing geometric windows. It is a very functional solution for letting in natural lighting across the building and allowing ventilation of the interiors, but it also has psychological benefits. This outdoor space can be used as an extension of the waiting rooms, and as it is overgrown with plants, patients can feel calm and reconnected to nature in the middle of the city. To enhance this warm atmosphere, light wood has also been used in many spaces throughout the interiors.

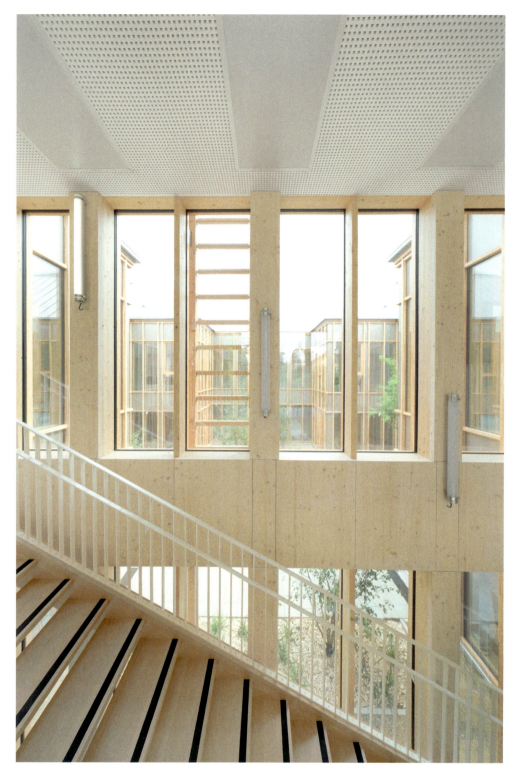

Playing with wood, the architects created a stark contrast between the solid monolithic outer shell and the generously glazed inside walls that open to a central patio, also defined by wood, but used in an entirely different manner. This is true of the interiors as well, where wooden elements enhance the warm atmosphere.

PUBLIC BUILDINGS

The architects' goal in using wood extensively — in all possible elements including the structure, façade cladding, and the interiors — was very clear: to provide the city a sustainable building that would have the capacity to capture CO_2. Moreover, wood's abilities to ensure an ambient climate were not without an additional meaning. The architects had also carefully considered the urban context of the Taverny Medical Centre. As they note, the plot is situated in a fragmented townscape and bordered by a motorway, which may be another reason for the "fortified" character of the building. At the same time, the pre-existing buildings were taken into account. The studio's aim was "to integrate it harmoniously in the surrounding urban environment, with balanced proportions between filled and empty spaces, mineral and vegetal components, buildings and green areas." The unusually shaped centre is covered with four-sided roofs, which soften the scale of the building and provide an additional source of natural light and ventilation.

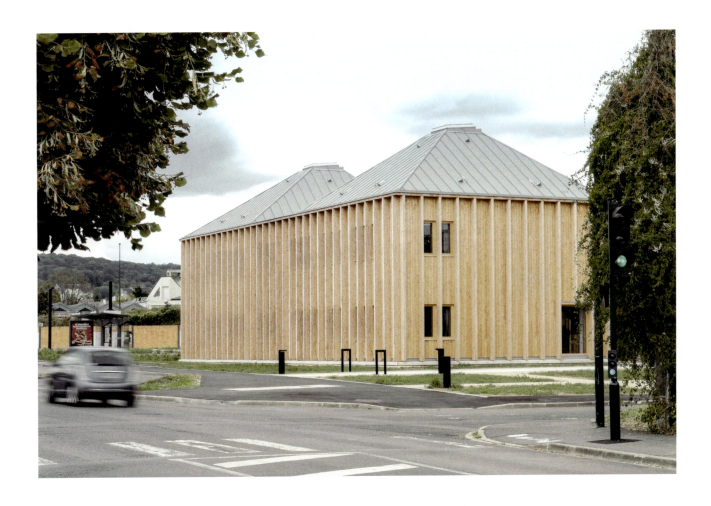

MICROLIBRARY WARAK KAYU

SEMARANG, INDONESIA, 2020 // SHAU INDONESIA

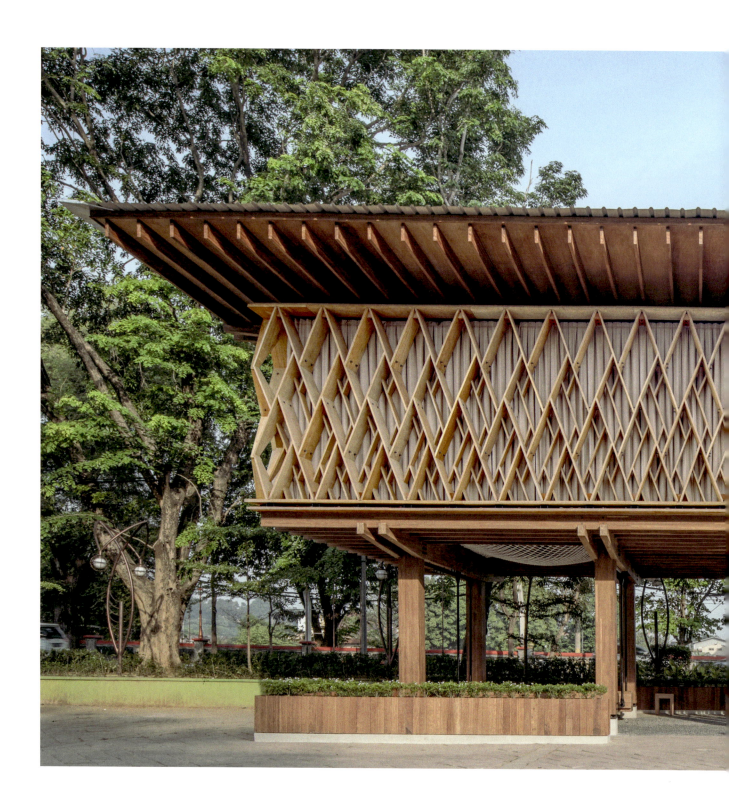

PUBLIC BUILDINGS

The tropical climate conditions were the architects' main reference for the selection of materials and forms. Lightness and sophistication define the Microlibrary Warak Kayu, which seems to be carved out of a wooden block.

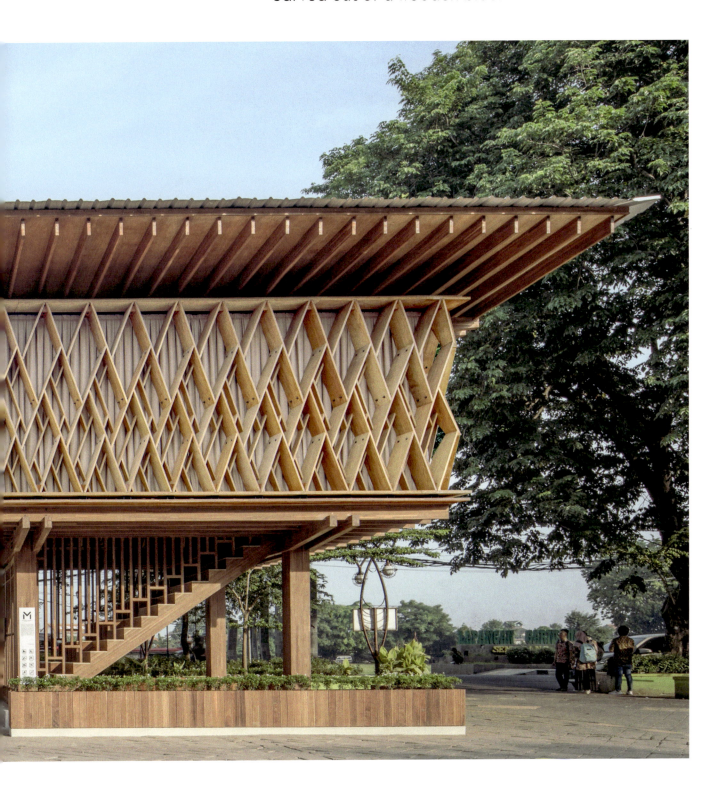

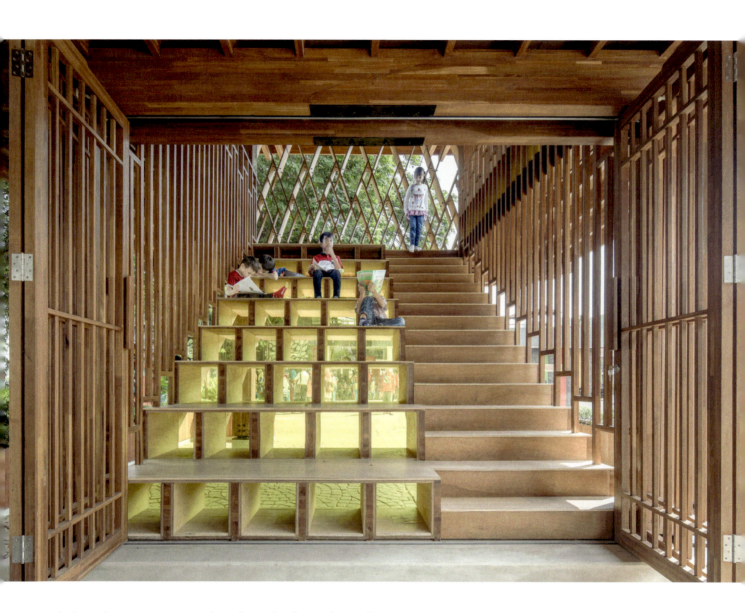

At the main entrance, next to the staircase leading to the top floor, the semi-transparent steps can be also used as seats for an audience to watch presentations or movies. It is also a playful space for children to sit together with books.

Florian Heinzelmann & Daliana Suryawinata of SHAU Indonesia designed this intriguing and elegant structure, built as a part of the Microlibrary project, which aims to popularise reading through a series of multi-functional community spaces. Situated in the heart of Semarang, the capital of Central Java in Indonesia, the library is run by a local charity group and is open to everyone for free. With a cafeteria, small vendors, and a local school nearby, the location is a busy spot. Sitting in the middle of a square, it is easy accessible, while the open space is perfect for showcasing the library's distinctively sculptured shape. The decorative structure of the brise soleil is based on German construction system from the 1920s called "Zollinger Bauweise," and with its diamond-like pattern it happens to resemble the dragon-like skin of Warak Ngendog, a local mythical creature.

Made of locally prefabricated wood, this beautiful elevated construction relates to traditional homes built on stilts called rumah panggung. This solution is also highly practical, as the architects gained a roofed area on the ground floor that can be used for gatherings or social activities, like workshops or presentations, as the venue was planned from the outset with a multi-programmatic approach. Thanks to an inventive wooden swing, children can even use this space as a playground. To create a pleasant and cosy atmosphere, the ground area has been surrounded by boxes with plants, which enhance the volume's natural character. The upper level is dedicated to the library space with numerous benches for sitting and a big common table for flipping through books. But the most fanciful element for young readers is probably the net suspended in the air, where they can bounce or lie down to read.

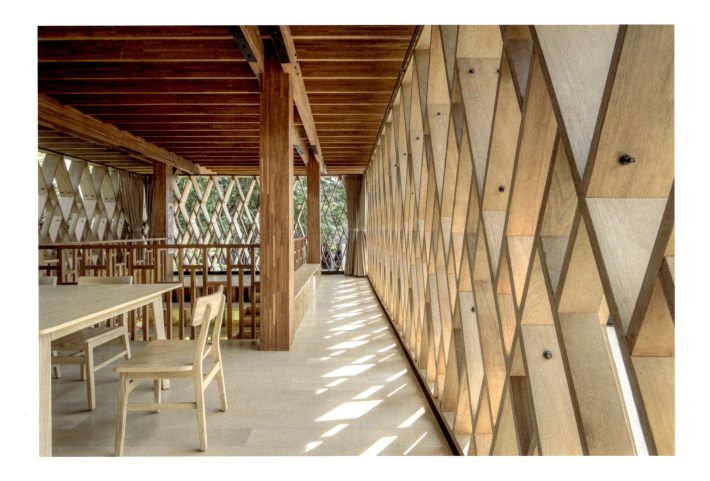

MICROLIBRARY WARAK KAYU

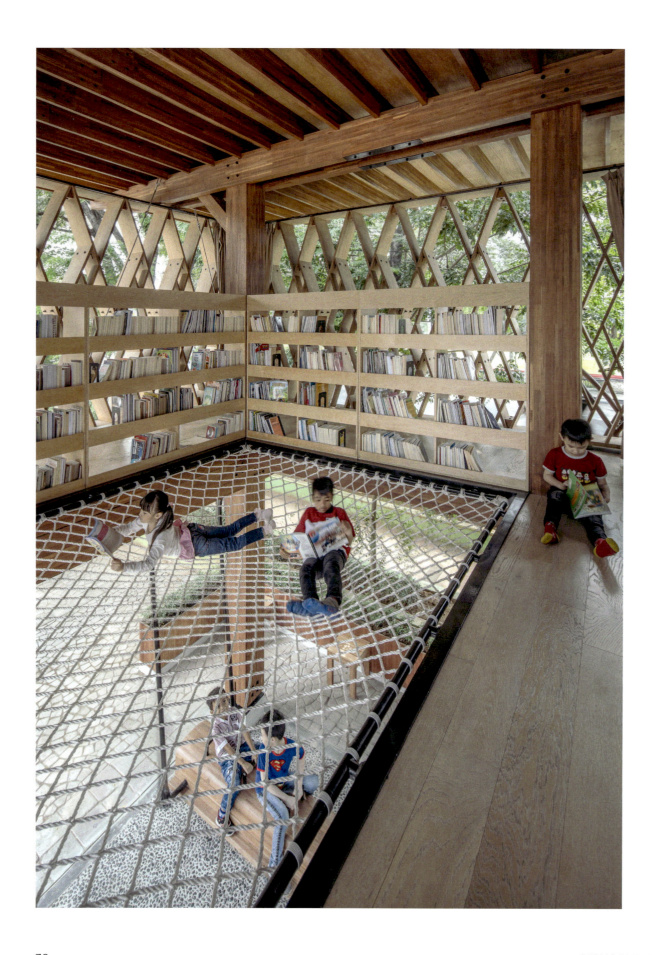

At the heart of SHAU's architectural practice is sustainability with a focus on socially and environmentally responsible architecture that is also aesthetically pleasing. This particular project was an experimental case in exploring the best solutions for tropical contexts. And, as the architects proudly emphasise, it is Indonesia's first Forest Stewardship Council—certified building building. For the construction they used various wood species including Bangkirai, a hard tropical wood with high weather resistance, for the main structural elements like beams and columns. Decking and the geometric brise soleil were crafted of different Meranti-based plywood types in various thicknesses.

All components were locally manufactured to minimise the transportation. "The Microlibrary Warak Kayu is designed around passive climatic design aspects: no air conditioning is used therefore no energy is spent," explains the studio. While cross ventilation cools down the space and prevents humidity, shading elements effectively limit the access of solar heat. Additionally, the decorative pattern is also a functional element, as it blocks the lower altitude sun angles in the mornings and afternoons, yet there is still enough natural light inside to read books. To also block the wind, the architects installed a special curtain that can be stretched along the length of the walls.

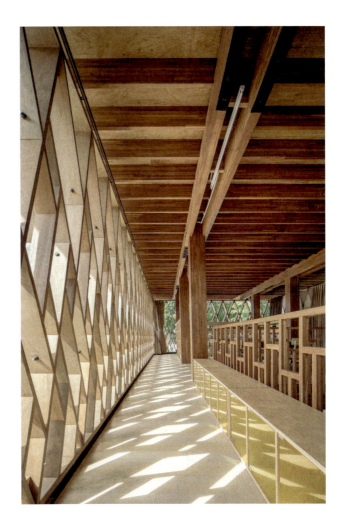

The heart of the upper floor is the bouncing net, where kids can lie down, relax, and read, but also directly communicate with parents and friends underneath. To reduce the wind and entirely block the access of natural light, the interior can be enveloped with a special curtain in a natural colour.

COMMUNITY LIFE CENTER TRINITAT

BARCELONA, SPAIN, 2021 // HAZ ARQUITECTURA

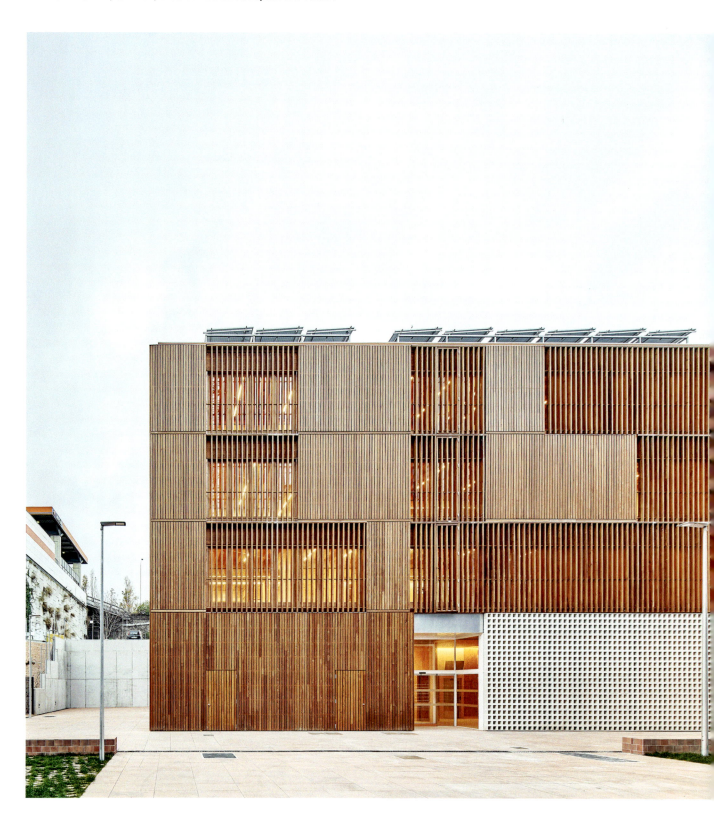

Wood, selected here in order to enhance the welcoming character of the Community Life Center Trinitat building, transforms a minimalist volume into a curious cube with a striking textural façade.

Manuel Sánchez-Villanueva and Carol Beuter of Haz Arquitectura have inaugurated a multifunctional community facility hub dedicated to a couple of districts at an entrance to Barcelona. As Community Life Center Trinitat is the first building, the architects employed a simple form so that in the future, it can visually match the next elements of the complex, which will be interconnected through an interior plaza. The building's geometric minimalism is far from boring or obvious, however, due to the inventive way the architects work with wood, which they chose as the structural material.

The main goal was to create a public space that would make people feel at home. Another important aspect was the location, near one of the busy traffic hubs on the outskirts of the city, considering wood's ability to absorb CO_2 and thus the low environmental impact. The wooden structure also visually reduces the relatively large scale of the four-storey building. Its interior is planned around two courtyards, with a centrally located staircase to provide both light and ventilation. The ground floor houses the reception, a canteen, and the entrance hall, which functions as a foyer for events and exhibitions. The second level is devoted to social services and women's centres, while the two top floors offer office spaces. All interiors showcase the visually striking exposed structure. Wood is literally everywhere, with the small exception of a metal framework of girders and pillars. The load-bearing system is made of radiata pine cross-laminated wood panels with beautifully elaborated rhythmic ceilings. The construction is solid, yet through the use of light colours, does not seem heavy. The wall claddings of plywood skirting allowed for the swift distribution of electrical and data connections, which are all invisible. All other elements of the very precise wooden structure are made of CLT. Independent of the kind of spaces, whether the expansive entrance hall, an office space, or a staircase, wood introduces a very special ambiance that is welcoming and not intimidating. The tactile qualities of wood and its natural hues are pivotal in creating this effect.

Both the spatial arrangement and the wooden structure work well with the inventive ventilation system, which is based on ancient Mediterranean traditions. "The air that circulates through the buried tubes, once tempered by the subsoil, is released into the two covered patios, which function as large air ducts," explain the architects. As a result, the air becomes cool in summer and warm in winter, which limits the use of air conditioning to the absolute minimum. This solution was possible thanks to the lightness of the wooden structure. "Due to its low weight, it has no thermal inertia, which is why we mobilise the inertia of the ground," states the studio. "We took advantage of the land clearing of the excavation on the hillside to bury tubes through which clean air circulates before erecting the building." Last but not least, the photovoltaic panels installed on the roof generate nearly all of the yearly electrical power consumed by the building, which makes it truly sustainable.

Not only the layout but also the specific design of the walls and doors foster the innovative ventilation system, allowing air to circulate across the building and reducing the need for any energy-supported ways of controlling the temperature.

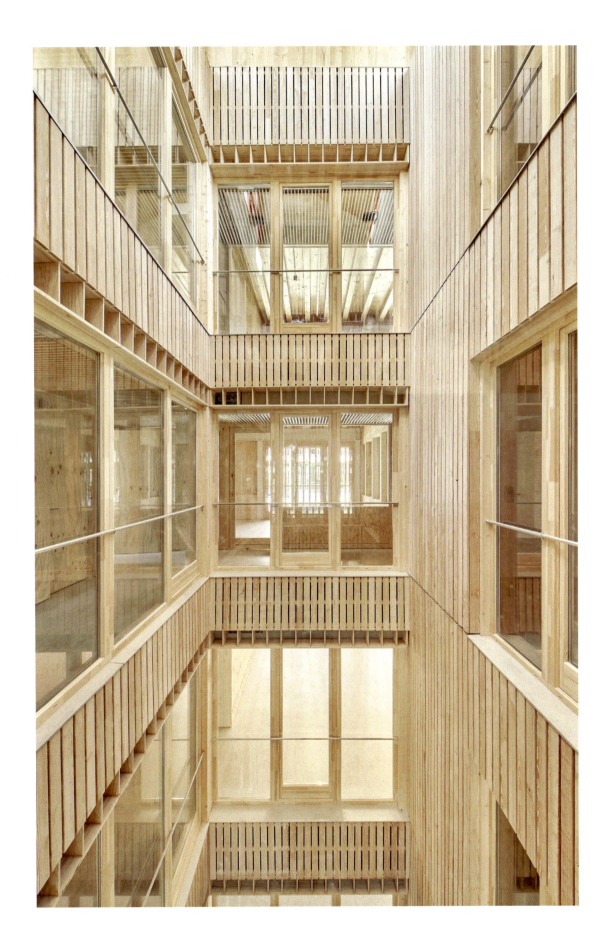

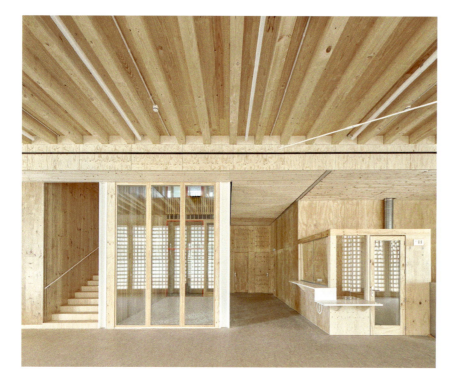

All elements of the building have been crafted with extreme precision, which is particularly visible in the staircase. The architects demonstrate that wood can be used structurally with great success in large scale projects.

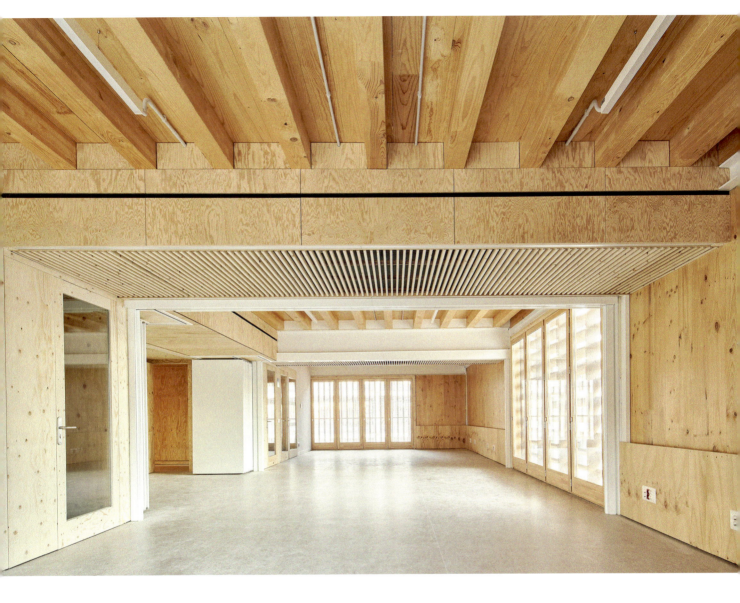

Apart from the electrical and data wires, the architects have left all elements of the wooden structure fully exposed. It is not only striking in its massiveness and solidity but also due to the natural charm of its textural nuances.

COMMUNITY LIFE CENTER TRINITAT

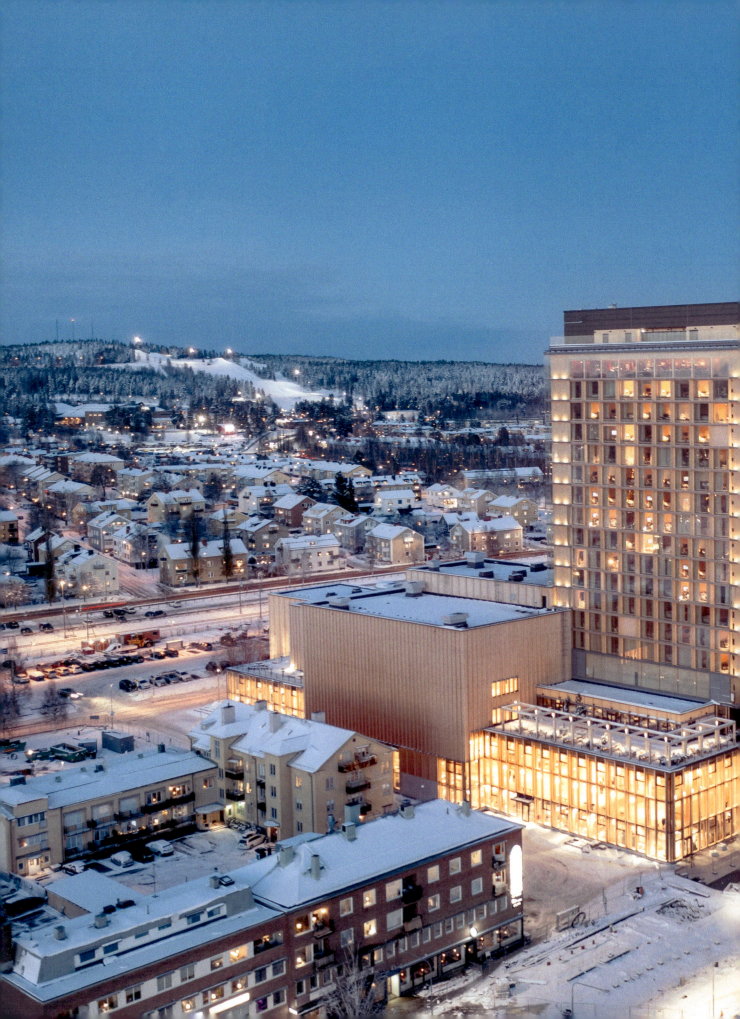

CULTURAL VENUES

TOHO GAKUEN MUNETSUGU HALL

TOKYO, JAPAN, 2021 // KENGO KUMA

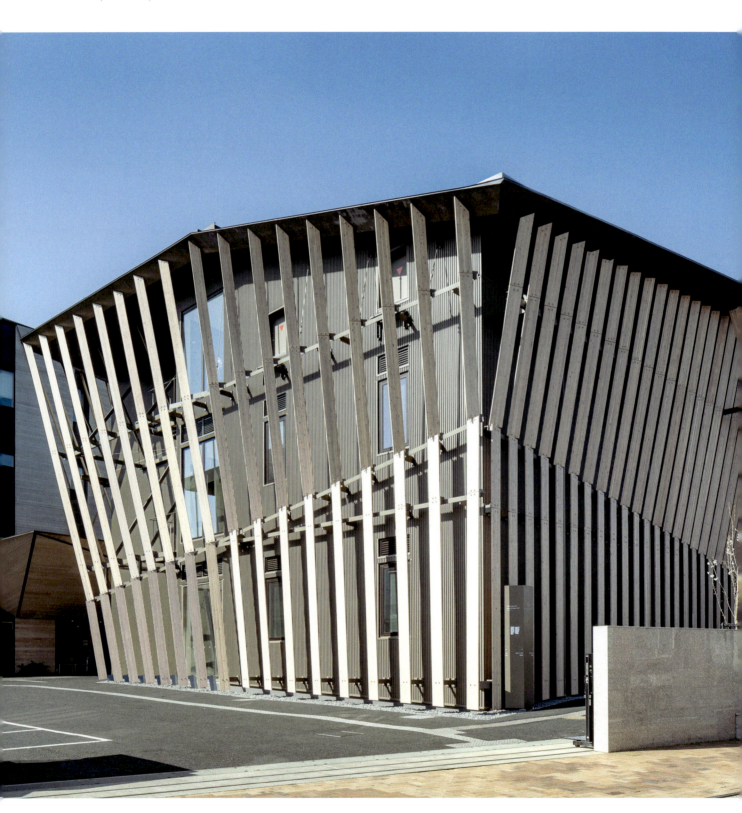

80

CULTURAL VENUES

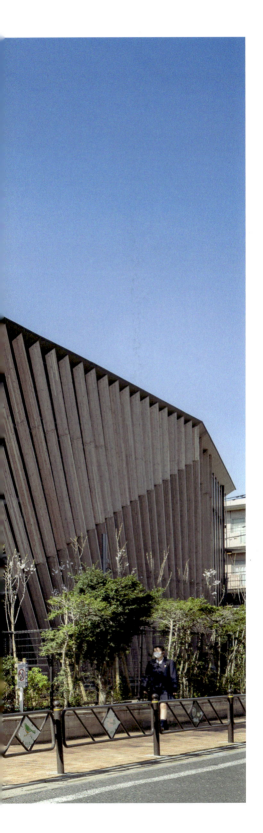

A concert hall made of wood and designed in the form of a gigantic musical instrument. This masterful project by Kengo Kuma demonstrates that the material can be successfully used in any scale or typology.

Envisioned for the Music Department of Toho Gakuen College of Music, Japan's pioneer music school may be hidden in a dense quarter of Tokyo but its distinctive volume is immediately visually striking with its originality. The exterior view is defined by large wooden louvers that evoke the strings of an instrument. Their regular yet dynamic arrangement is intended to suggest the creation of music, "as if they beat out a rhythm and add resonance to the entire hall," reflects the architect's studio. "We aimed to design the concert hall itself as a giant wooden instrument," they add. This unconventional outer envelope, which interacts with the sun and creates a play of light and shadow, also contrasts with the main façade not only in terms of the texture. The natural colour of the louvers dynamises the volume and creates a sense of movement, enhanced by the passage of sunlight throughout the day.

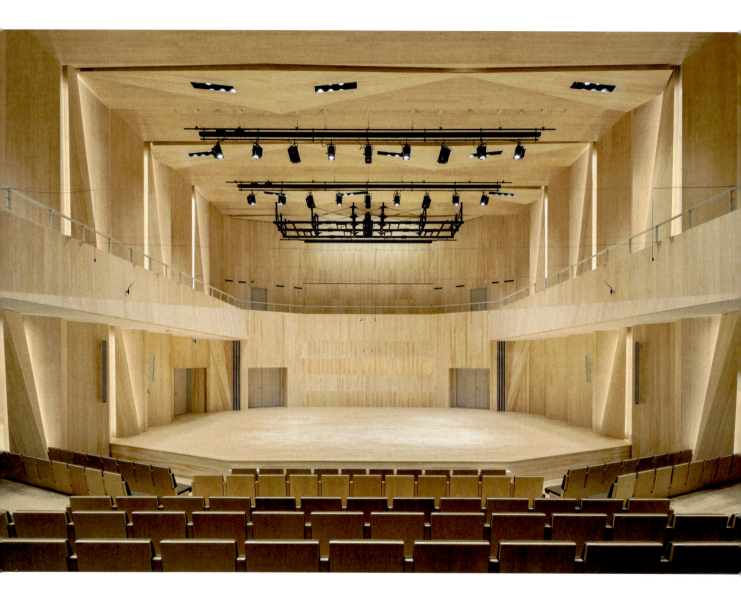

The interior of the building has been constructed of CLT hybrid panels made of cedar and cypress. The way the wood is applied varies depending on the space but it envelops each interior area in a warm and pleasant atmosphere. In the all-wooden concert hall, the architect has sculpted the surfaces rhythmically. The visual effect, accentuated by artificial lighting, is quite dynamic and above all provides perfect acoustics.

While envisioning a concert hall made entirely of wood, the architect's goal was to create the ideal acoustics. The building is made of CLT hybrid panels, a combination of cedar and cypress. They form a folded-panel structure, which the studio explains function as the interior and reflectors for the hall. Thanks to this all-wood structure as well as the exquisite qualities of the material, this concert hall has become the perfect space for performances, offering a truly unique music experience. The space is aesthetically appealing as well. Reflecting the solution animating the façade, the interior walls have been shaped in a rhythmic way. Accompanied by artificial lighting, this creates a very dynamic and vivid effect. Like in the case of the outer shell, this can be also seen as a visual reference to a melody's pattern. Compact and devoid of any superfluous decorations, the interior's focus shows the uniform power of wood when freely sculpted and, most essential here, provides excellent conditions for music performances. The audience sitting in this modest auditorium can fully enjoy the concerts thanks to the ideal acoustic environment that wood offers.

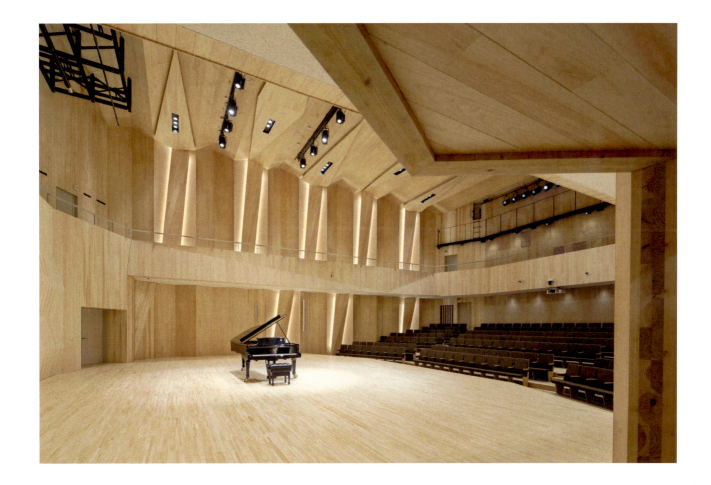

YABULI ENTREPRENEURS' CONGRESS CENTRE

YABULI, CHINA, 2020 // MAD ARCHITECTS

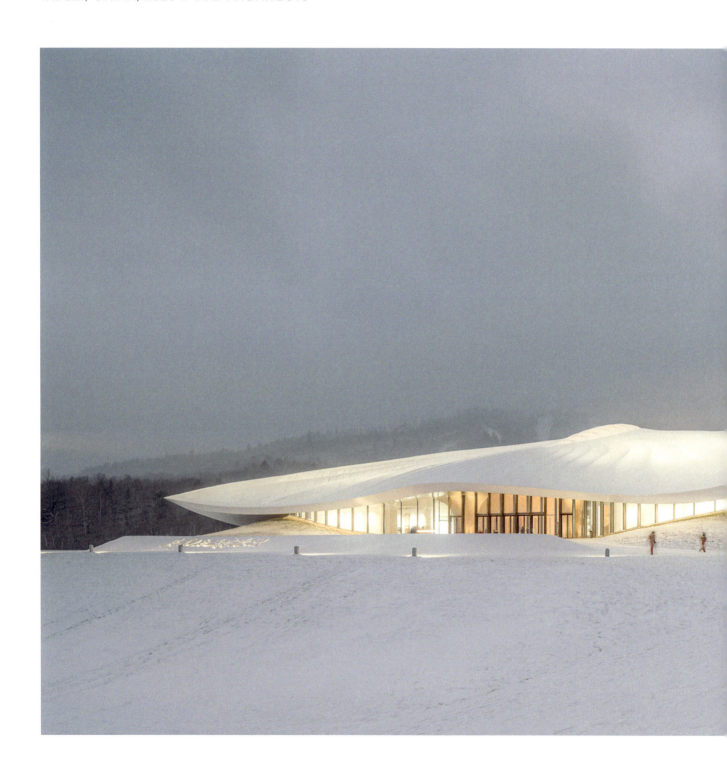

84 CULTURAL VENUES

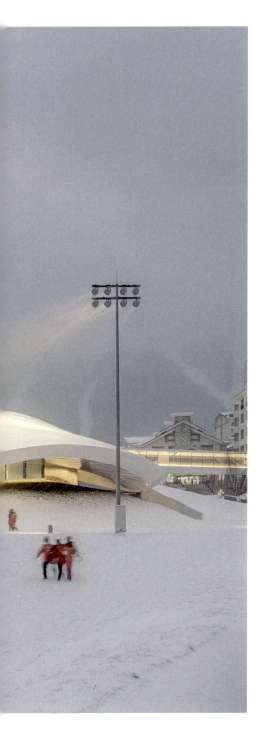

The MAD Architects studio call the Yabuli Entrepreneurs' Congress Centre "a tent beneath Snow Mountains" and, inspired by the local landscape, they have envisioned its sculptural volume to blend into the surroundings.

The local breathtaking scenery of the snowy mountains and sky full of stars was the starting point for the design process. "The bonfire and the tent served as design inspiration as these two elements reflect the human spirit of exploring the greater unknown, seeking truth and knowledge in the dark," the architects explain. Yabuli, a ski town with the largest snow training centre in China and the longest alpine ski slope in Asia, is famous for its omnipresent snow and mountainous topography. Planting a large venue into this natural wonder would never have been so successful if not for its imaginative and organic shape.

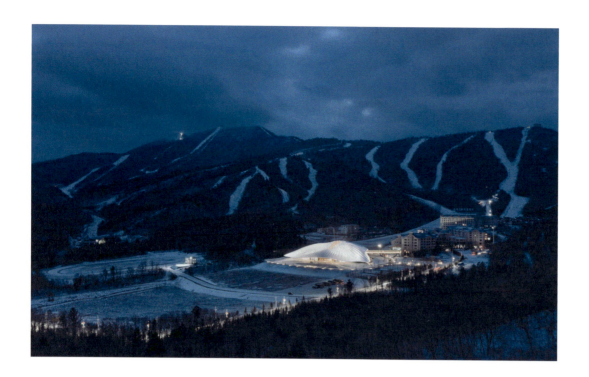

The undulating roof that is intended to echo the snow-capped mountains is covered with textured white aluminium panels to give the impression of a layer of fresh snow. This skilfully designed camouflage effect is enhanced by the fact that the building is perfectly adjusted to the site's curvatures. The dynamic silhouette offers various views when approached from different angles, all in a harmonious dialogue with the surroundings. Built as a permanent site to host the annual event of the China Entrepreneurs Forum as well as the Chinese Entrepreneurs Museum, the building has an impressive programme including the main conference space, which is entirely column-free and can accommodate up to one thousand people, as well as exhibition halls, over twenty well-equipped multi-functional rooms to host various conferences or trainings, and a library. At the heart is a spacious lobby with a gigantic central skylight flooding natural light into the interiors. Literally sculpted in wood, it can be used as a temporary performance space due to the great acoustics provided by the wooden walls with micro-perforations.

"During the day, the architecture is a form of land art on the snow-covered earth; at night, the warm lighting illuminates the structure like a burning bonfire by a tent," reflect the architects, inspired by the beauty of the local nature.

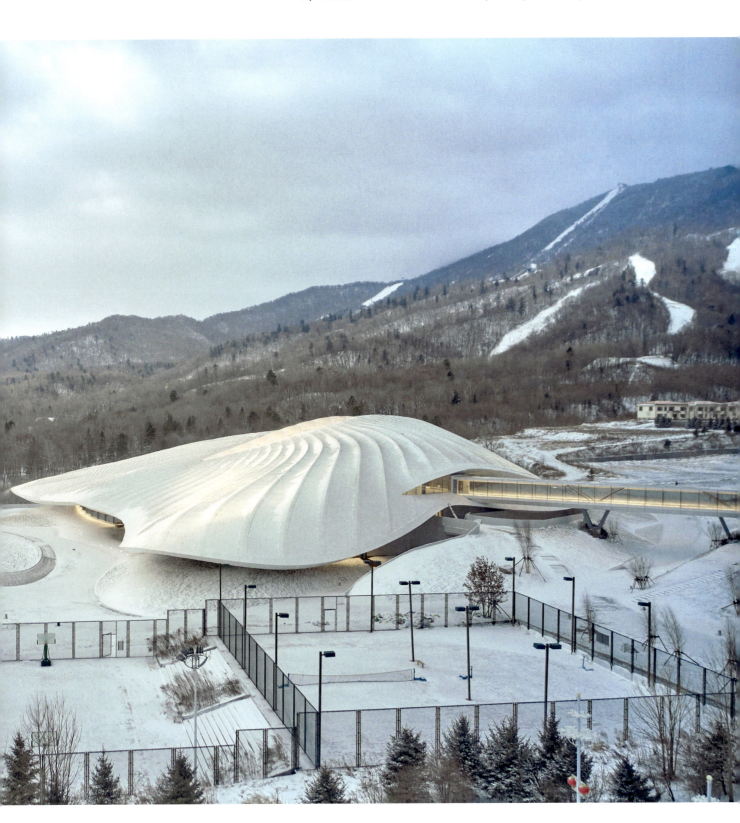

YABULI ENTREPRENEURS' CONGRESS CENTRE

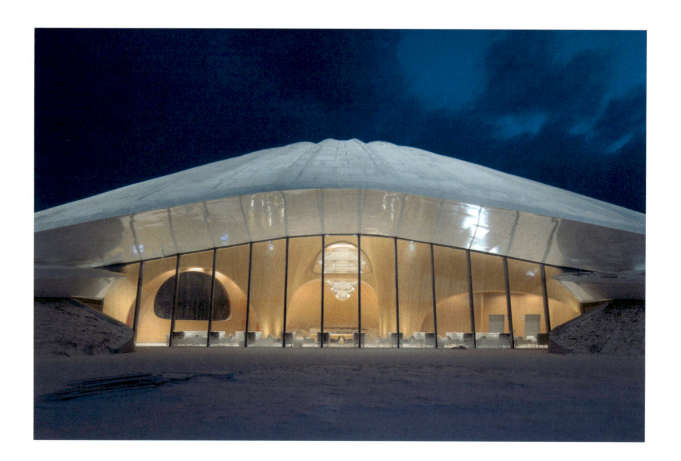

The undulating silhouette of the roof seems to be floating above the ground due to the floor-to-ceiling glass walls. This solution not only creates a striking visual effect but also erases the boundary between the inside and outside, inviting the snowy landscape into the dramatic interiors. The wood defining the spaces contributes to the smooth transition between the natural site and the architecture. Interestingly, additional ingenious solutions provide the continuity between the venue's spaces and the landscape, like the LED screen of the 350-seat auditorium that can be easily opened to let the surrounding mountains create a picturesque background for speakers. The plan of the extensive interior and the circulation was designed around the topography, as the building's height changes following the downward slope of the hilly plot, with part of it hidden entirely underground. Accessible from different sides, the structure has entrances on various levels depending on the terrain. The architects explain their vision: "While walking uphill in the snow, people see this structure as a humble gesture with open arms," and in the case of severe weather, passersby can conveniently hide underneath a cantilevered part of the roof at the farthest end.

The extensive lobby enveloped by wooden walls, which provide perfect acoustics, can be transformed into a performance space. The curvaceous staircase functions as a stage, while a spectacular skylight offers striking lighting effects.

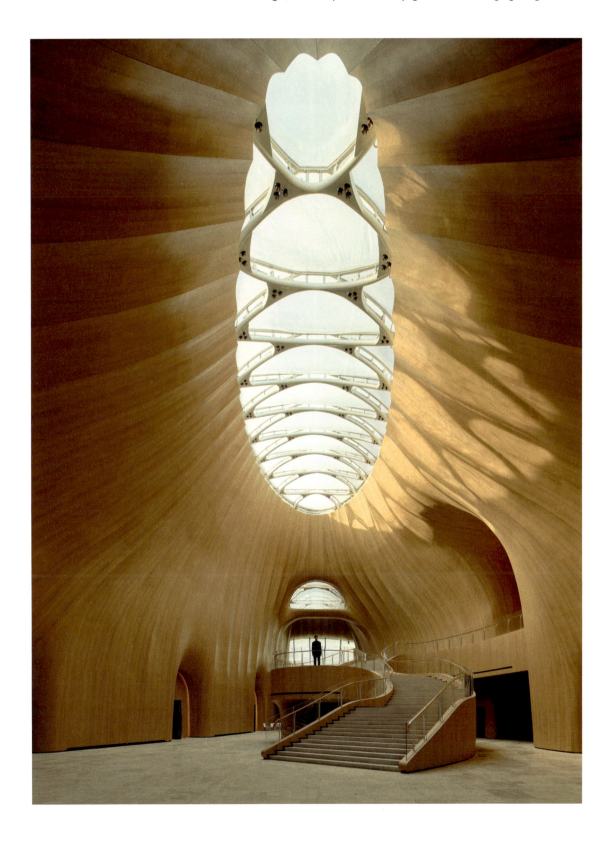

YABULI ENTREPRENEURS' CONGRESS CENTRE

SARA CULTURAL CENTRE
SKELLEFTEÅ, SWEDEN, 2021 // WHITE ARKITEKTER

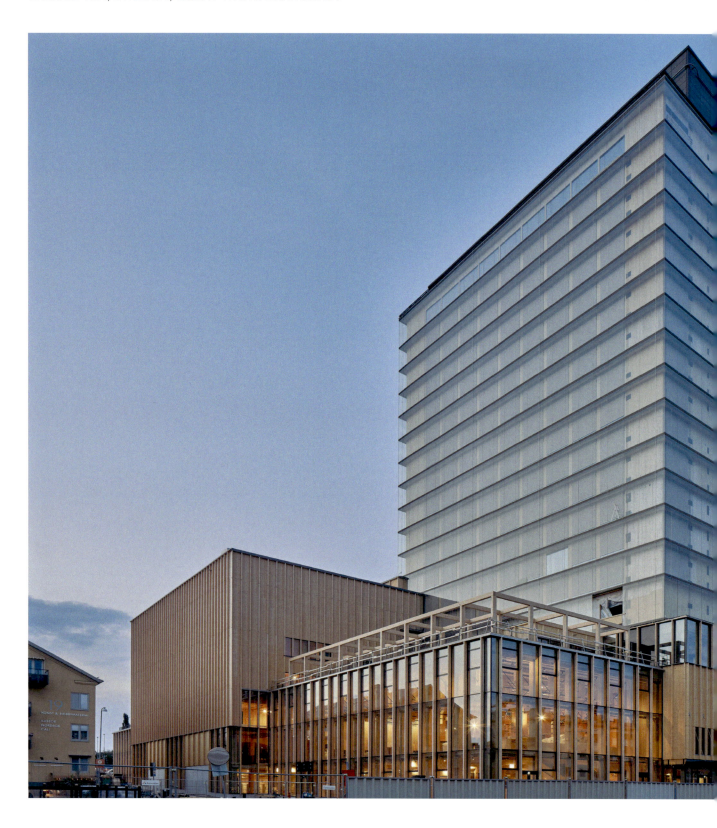

This geometric volume, with its dominating timber tower, houses spaces for art, performances, and literature, as well as a hotel. White Arkitekter, inspired by the long local tradition of wood architecture, has designed an exemplary and innovative high-rise building.

An architectural highlight of Skellefteå in northern Sweden, Sara Cultural Centre is a symbol of the city's timber architecture heritage. The architects worked in close collaboration with the local wood industry to implement the latest advancements in engineered timber technology. As a result, the project is also an ultra-innovative case study for the use of wood in high-rise buildings. "The timber structure of Sara Cultural Centre sequesters more than twice the carbon emissions caused by operational energy and embodied carbon from the production of materials, transportation, and construction on site," proudly states the White Arkitekter firm. Designed in great balance with the natural beauty of the site, as well as with the natural material, it is meant as a construction that will age well. The architects succeeded in entirely eliminating the use of concrete from the load-bearing structure, and thus managed to significantly reduce the construction time and the building's carbon footprint.

Made exclusively of locally sourced timber from regional sustainable forests, the construction's elements were processed in a sawmill near the building. The materials and technology have been adjusted to withstand challenging weather conditions. The complex consists of two parts — the lower, made of volumes in different sizes to achieve a human scale at street level, creates an original base for the central 20-storey high-rise. Each is based on a different construction system. The timber frame, pillars, and beams of the low-rise, which houses an arts centre, are made of glue-laminated timber (GLT), while the cores and shear walls are made of cross-laminated timber (CLT). This strategy effectively enhances the overall stability of the structure and redistributes the load of the taller volume. As a hotel, the tower is built of prefabricated stacked timber 3D-modules in cross-laminated timber (CLT) located between two elevator cores and enveloped in a double-skin glass façade. In a visually striking way, the architects have put the core of the building on view and exposed the wooden structure. At the same time, the reflective surface plays with light and mirrors the Nordic sky. Elements of the transparent outer shell, which literally pushes the boundaries of blending the interior and exterior, also play a crucial role in the lower volume.

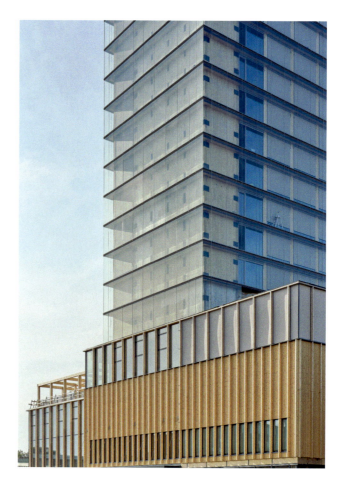

The wooden structure is distinctively exposed to showcase the purity and beauty of the material. "Realising a full timber structure of a complex building with mixed uses, mixed volumetry, and a high-rise of 20 storeys, Sara Cultural Centre broadens the application of timber as a structural material and proves that timber is a viable solution for virtually any building type," comment Robert Schmitz and Oskar Norelius.

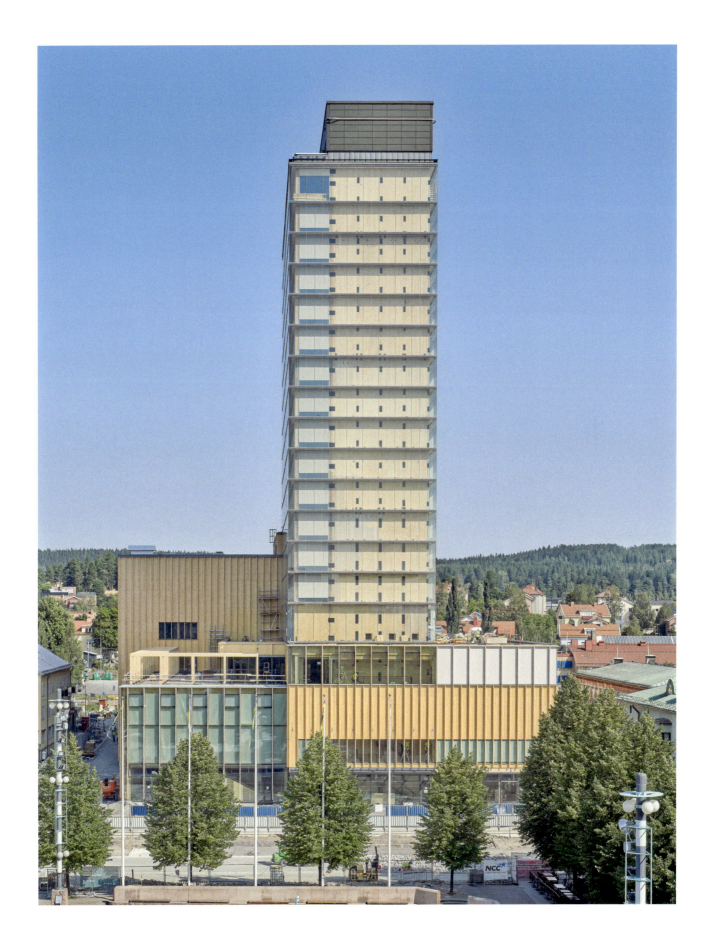

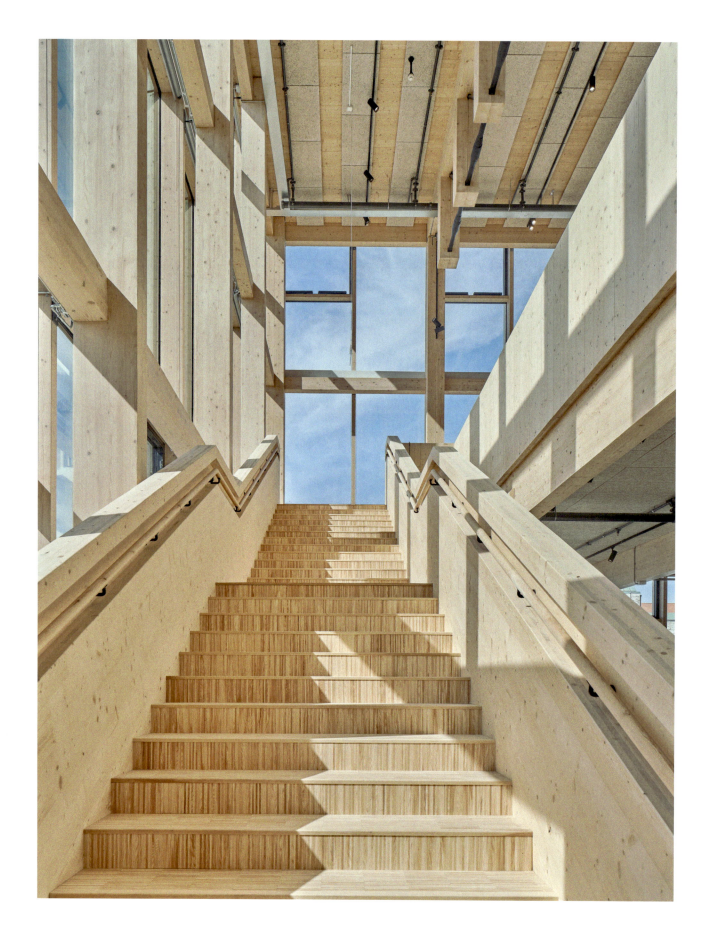

Sara Cultural Centre is home to the Skellefteå Art Gallery, Museum Anna Nordlander, Västerbotten Regional Theatre, the new City Library, and the Wood Hotel with a restaurant, spa, and conference centre with dramatic vistas of the striking natural surroundings.

By putting production behind the scenes and the exhibition spaces on view for passersby, as well as locating entrances on all sides of the building, the architects wished to highlight the role of the project as an inviting cultural hub for the local community. Sara Cultural Centre is also impressive inside. The solid frame is supported by glue-laminated timber (GLT) pillars and beams, which results in open layouts entirely in timber that create a stunning visual effect due to the large scale. The architects introduced another structural innovation by using trusses above the ground foyers. These are made of glue-laminated timber and steel and form a large, open-plan event space. All interiors leave the natural wood exposed and thus offer a very sensual experience through the varying textures and purity of the material. Additionally, the green roof, which not only provides thermal insulation but is also meant to absorb noise pollution and enhance biodiversity, turns the complex into an energy efficient building. The solar panels located at the top are said to compensate for the CO_2 emissions produced by the building.

SAMLING

NORD-ODAL, NORWAY, 2020 // HELEN & HARD

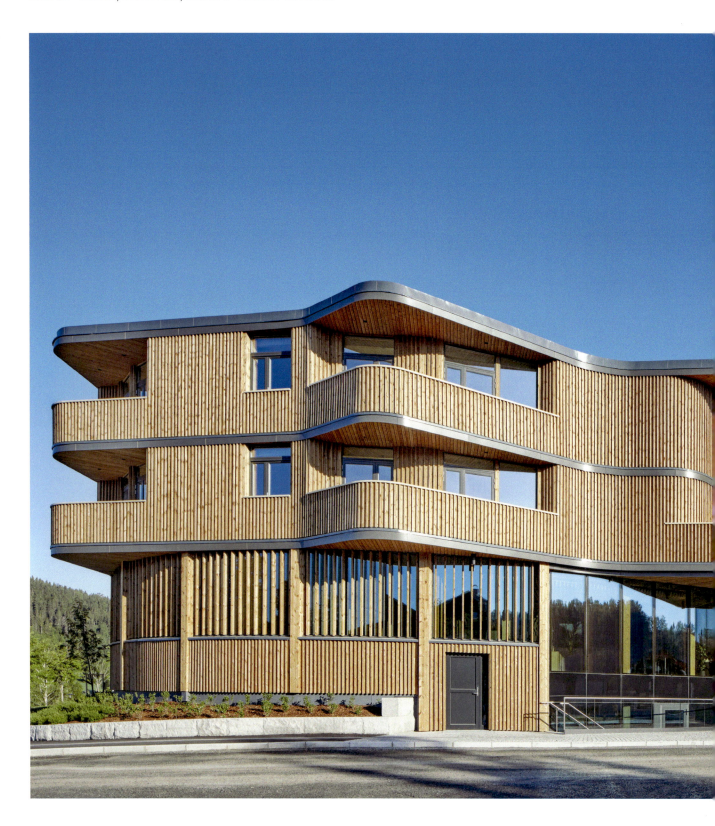

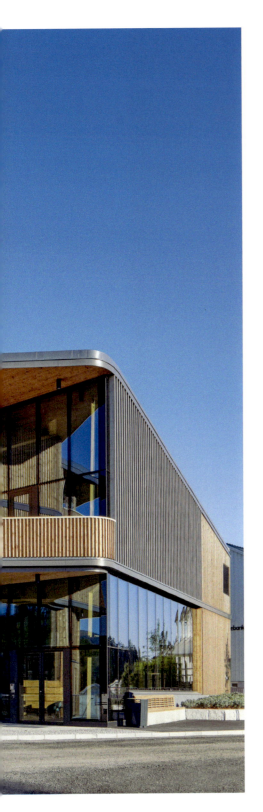

Samling has played a vital role in revitalising the community of the remote Norwegian village of Nord-Odal. Helen & Hard architects designed this multi-functional building in a holistic way with the main objective of ensuring that the layout organisation, construction, and materials coexist well together and offering an inspiring spatial experience.

Envisioned as a gathering spot for the village's inhabitants, it combines several functions and includes a library and new offices for the local bank, as well as ten apartments. This diverse programme packed into one volume required an inventive structure. Helen & Hard studio used wood in nearly all elements of the building. The architects not only find it environmentally friendly, but also cherish wood for its aesthetic and sensory qualities, including its pleasant scent, which were quite important in creating a welcoming and human-friendly atmosphere. "By having a substantial use of wood, the building inspires towards a more sustainable and responsible society, reflecting the cultural heritage of wooden buildings and the local wood tradition," they explain. The geometric shape devoid of sharp angles is additionally softened by the timber batten cladding, while vertical wooden slats enhance the dynamism of the delicately undulating walls. Placed around the whole volume, these wooden horizontal bands create an interesting rhythm and uniform skin.

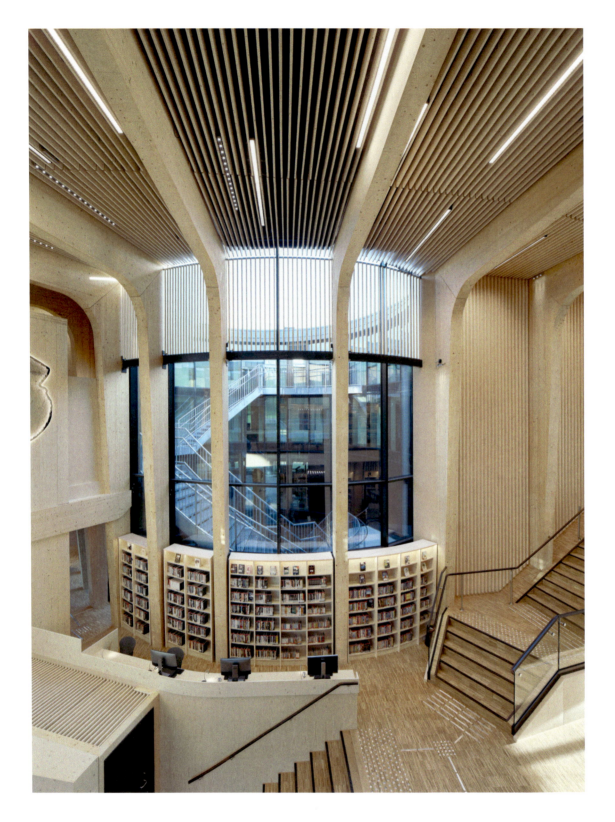

At the heart of the building is this impressive library. Its space has been rhythmically arranged with the help of organically shaped wooden lamellas, the soft curves of which enhance the warm and atmospheric beauty of the wood.

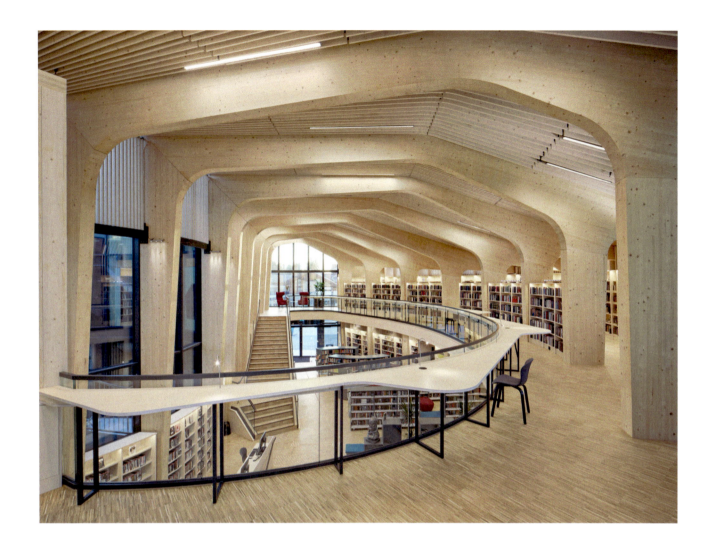

Only the entrance to the public spaces have been realised in floor-to-ceiling glass to invite in passersby as well as accentuate the connection between the interior and exterior, the architecture and the surrounding woodlands. This works particularly well due to the fact that Samling functions as a passage between the main street with public space.

From the outside, despite the wavy balconies marking the residential part, the building seems compact. Entering through the welcoming, transparent part offers a striking visual experience, as the interiors are spacious and open. This effect is achieved mainly through the stunning ceiling height and exposed wooden structure, which is a homage to the rich local timber history. The two-level-high space expands from the central oval atrium, while the organically shaped timber lamellas are arranged radially and designate spaces for various uses. A lightweight, curvaceous staircase leads to the gallery-like second floor of the library adding even more spaces to read, learn, or meet. The grandness of the library is counterbalanced by the cosy and warm finish made of different kinds of timber. This welcoming interior embraces visitors with its natural and modest charm. Oriented to the south and west, just above the bank headquarters, are ten apartments, the atmospheric interiors of which are defined by their wooden structure and finishing. The architects thought about large openings leading to the weaving balconies, distinct in the façade, which strike a perfect balance between letting in enough natural light and offering privacy to the inhabitants.

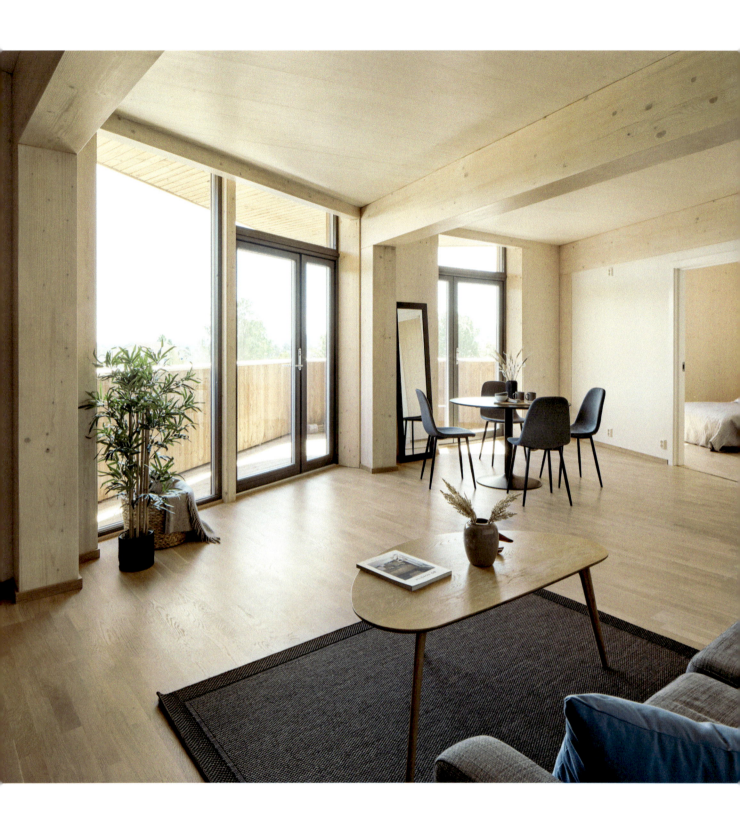

The residential part of the building consists of ten apartments with all-wooden interiors offering a warm, bright, and soft atmosphere. The living area is extended through large windows looking out onto curvaceous balconies, which connect the interiors with the surrounding landscape.

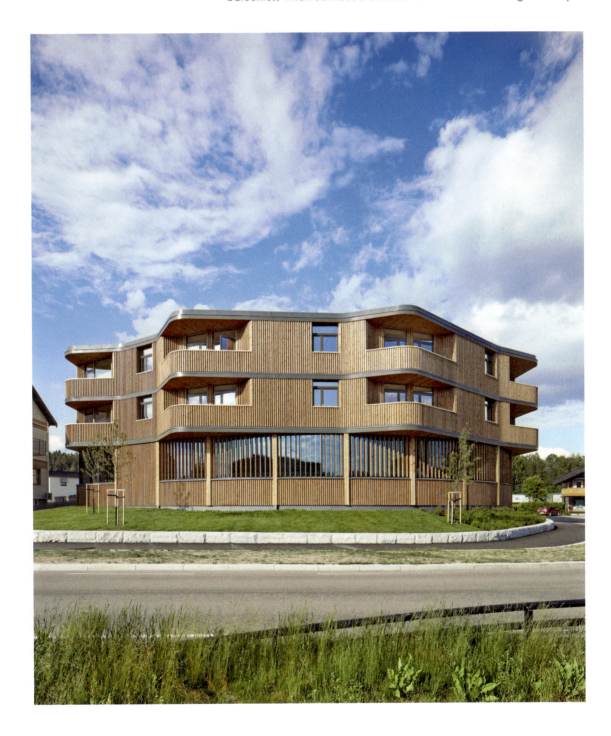

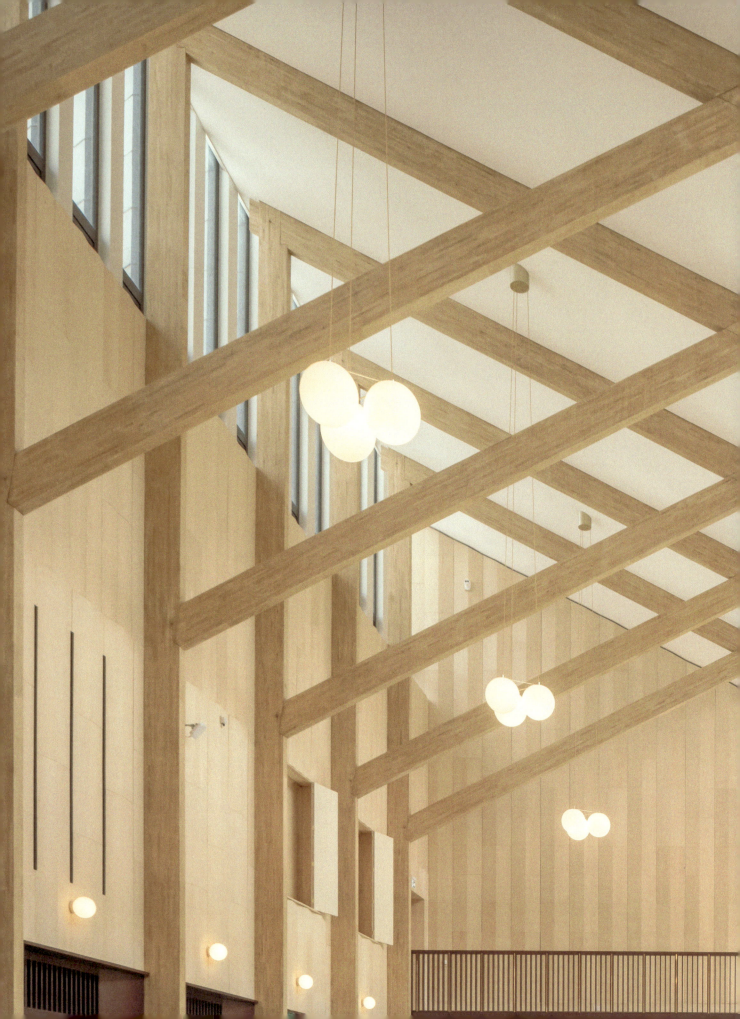

EDUCATION & SPORT FACILITIES

KITA IM PARK DAYCARE CENTRE

STUTTGART, GERMANY, 2020 // BIRK HEILMEYER UND FRENZEL ARCHITEKTEN

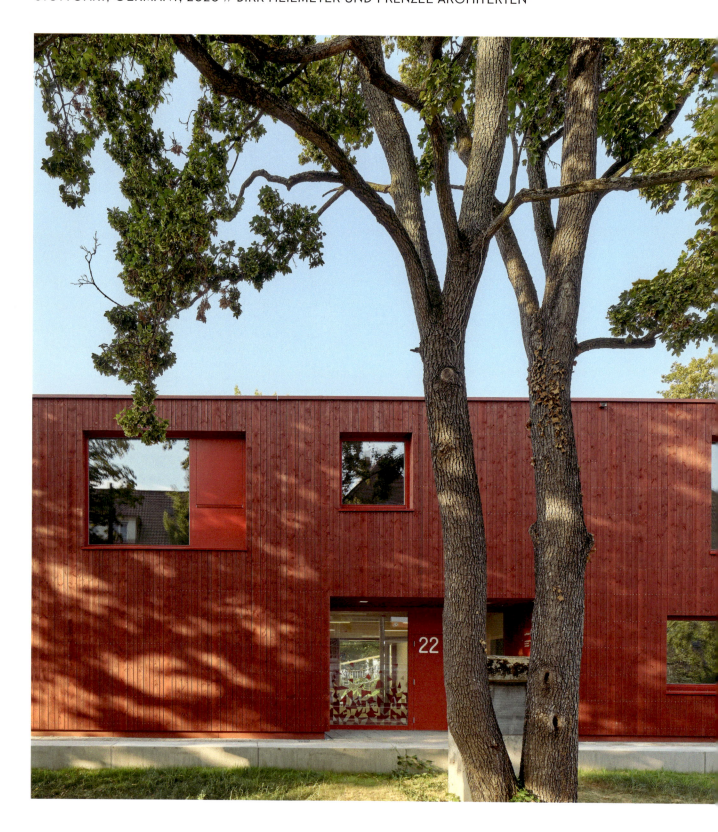

Designed according to the local regulations, the building fits perfectly into the plot. The architects achieved a striking visual tension between the minimalist volume and the vertical timber cladding in red that makes the building stand out against the historic greenery.

The new building of the nursery school in Stuttgart, designed by Birk Heilmeyer und Frenzel Architekten, is playful, has a natural charm and welcoming ambience. The architects' vision had to accord with the local building code specifying the exact depth of the building and the historical context of the plot, part of a green corridor with numerous trees, as well as the fact that the foundation would be made of a pre-existing underground bunker. A timber structure that was lightweight and simplistic, yet not lacking in originality, proved to be a perfect solution for all these restrictions. The two-storey volume, oriented from west to east due to the sloping terrain, is largely made of prefabricated elements. "The exterior walls benefit from all the advantages of a timber frame construction with ventilated façade cladding," remark the architects. The north façade with the entrance is pierced with large square openings, making the building look even lighter. The rhythm of the windows is significantly increased in the garden façade, which results in bright interiors and good communication between the inside and outside. Spaces on the ground level open directly to the adjacent playground, while the loggia along the whole length of the top floor creates small roofed spaces on both levels and is connected with the garden through external staircases on each side of the school. The red hue enhances the natural beauty of the wood and signifies a dynamism that goes well with the building's function. It also creates a stark contrast between the architecture and the surrounding park context.

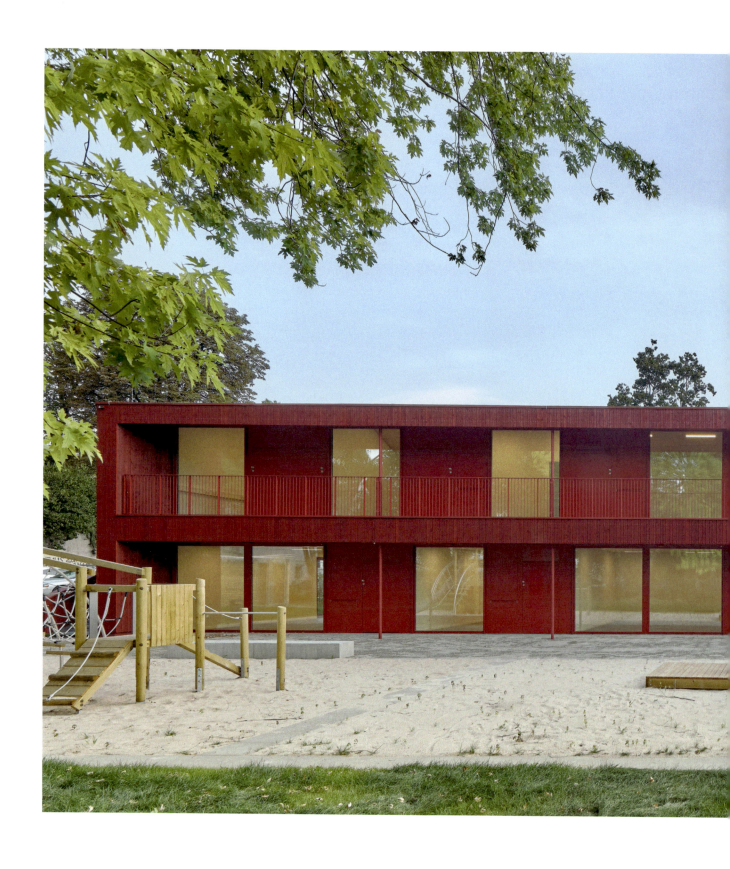

EDUCATION & SPORT FACILITIES

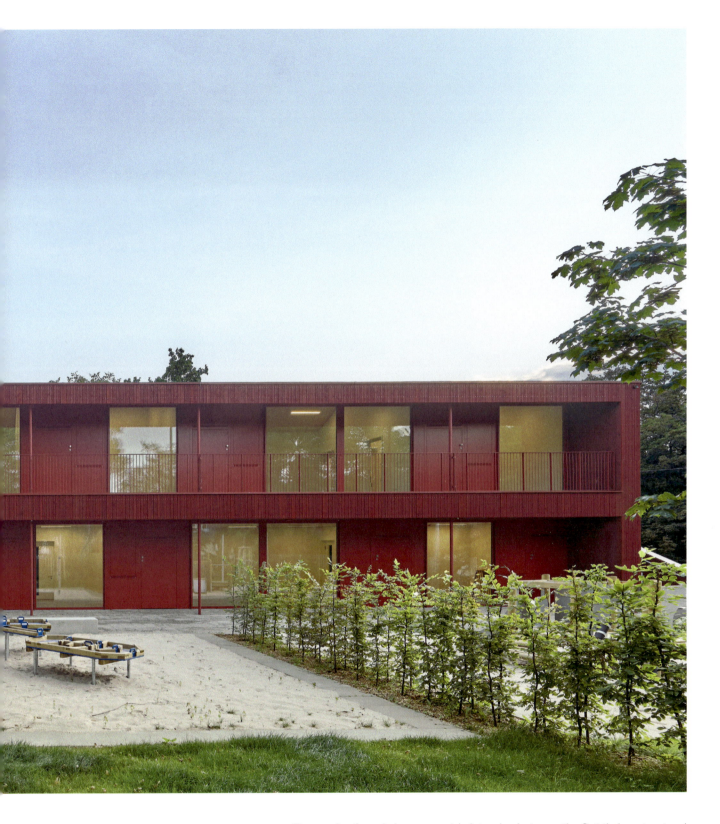

The garden façade is a geometric interplay between the flat timber structural elements and the floor-to-ceiling glazed wall parts, which adds to the building's lightness and smoothly communicates the interiors with the surrounding park.

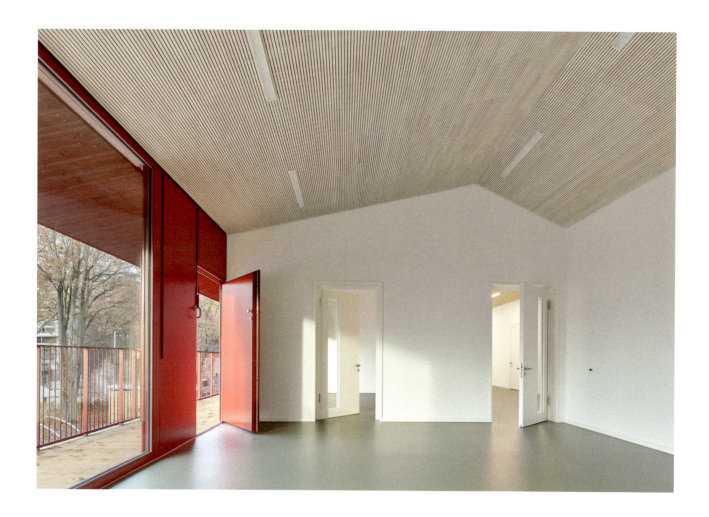

The interiors are envisioned with a good balance between practicality and safety, but also with a great sense of playfulness ideal for a nursery school building. While the outside silhouette follows a minimalist geometry, inside the architects have employed shapes and colours to create a fun-inspiring atmosphere. The façade wall remains red, while corridors and staircases get a contrasting green. The ceilings, featuring the exposed wooden structure with an efficient built-in lighting system, take on dynamic forms. The unusual shape of the roof reflects the segmentation of the building into a group space and an ancillary room area, as the architects emphasise. To enhance this impression, they also planned skylights in the roof covering the corridors, which is also a practical solution to facilitate both ventilation and light supply. The layout of the building is ruled by practicality and reflects the general simplistic approach. All pupils of the nursery school and their parents are led through the main entrance to a foyer, which opens to the garden. A multipurpose room, the group areas, and the adjoining rooms create a net of well-communicated and comfortable spaces on both floors. The exposed wooden structure, be it on the ceiling or walls, creates a warm and healthy environment for the children. Thanks to the large openings in the garden façade, the outer timber shell is also prominently visible inside, which extends this impression. The limited colour palette, although with vibrant hues, complements the natural aesthetic of the wooden building.

The interiors contrast with the minimalist outer shell of the building, offering children playful and inspiring spaces filled with natural light, vivid colours, and dynamic shapes.

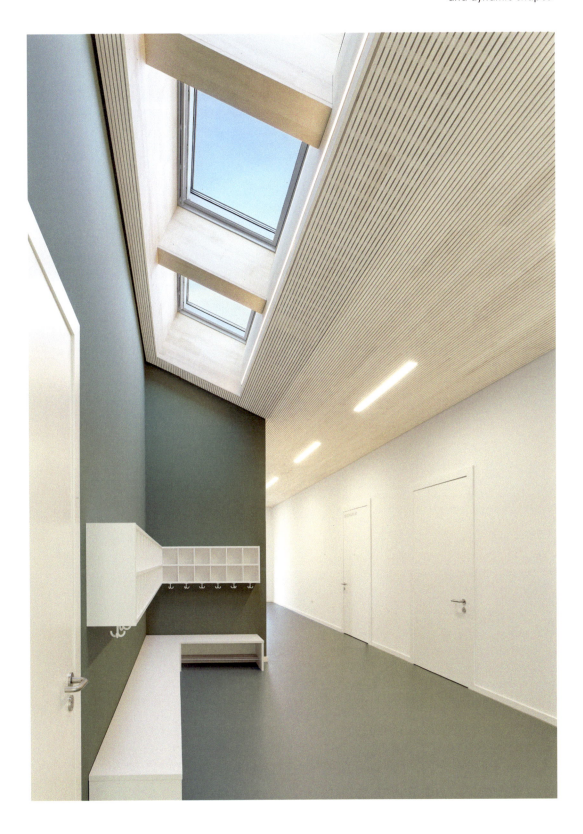

KITA IM PARK DAYCARE CENTRE

THE ARC AT GREEN SCHOOL

BALI, INDONESIA, 2021 // IBUKU

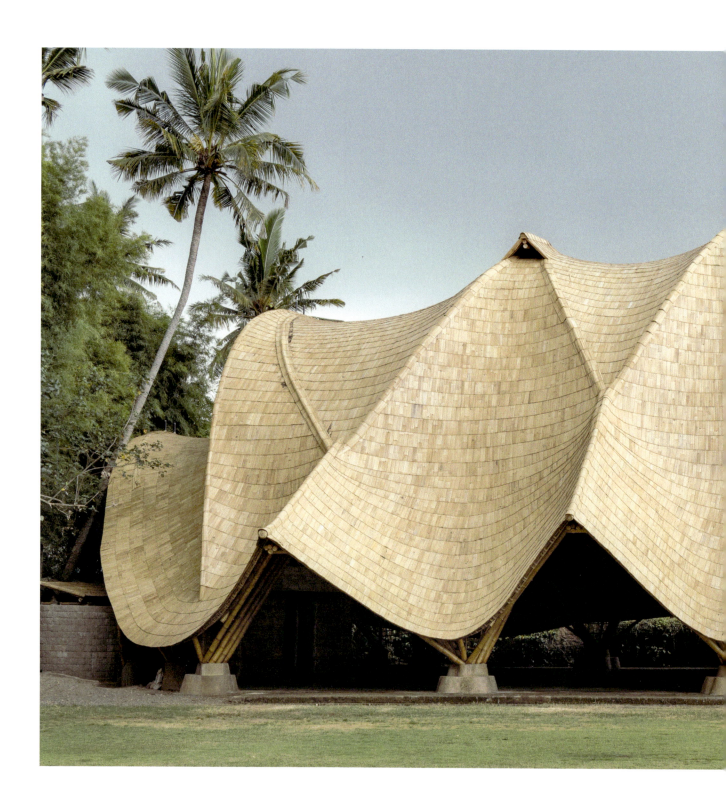

Inspired by nature, the Arc's spectacular volume is visually striking in its plasticity as well as its scale. Curvaceous and lightweight, the meticulous structure made of bamboo is the result of extensive research and ingenious engineering.

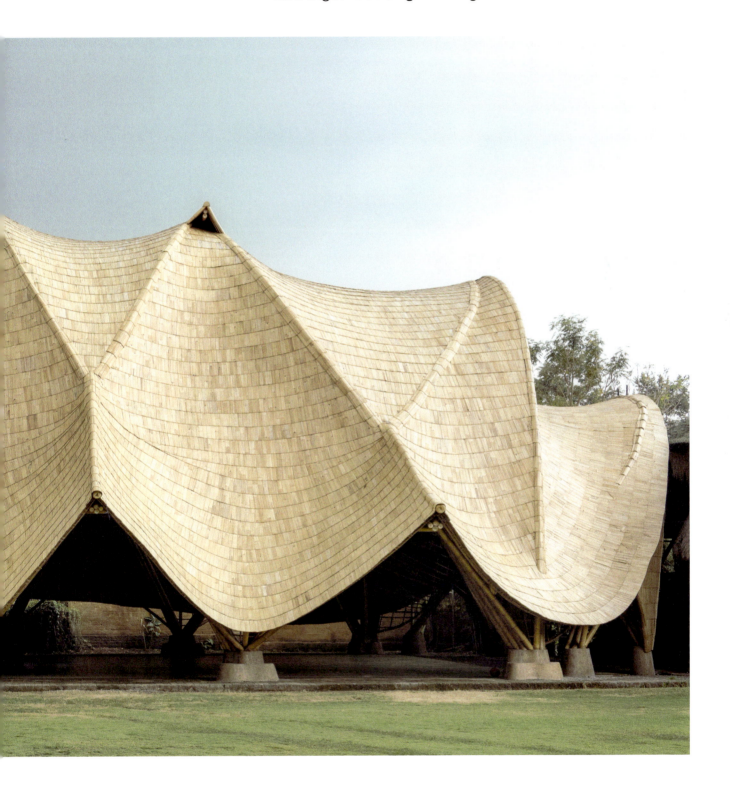

The Arc is the latest addition to the campus of Green School in Bali, which is widely known as an innovative and holistic educational project. Promoting itself as a school without walls and set in a scenic natural environment, it pays special attention to sustainability. This approach was essential when commissioning a new structure covering the school's airy pitch. The architects of IBUKU, in collaboration with Jorg Stamm, envisioned it as a series of intersecting fourteen-metre-tall bamboo arches spanning nineteen metres. They are interconnected by anticlastic gridshells that, as the architects explain, derive their strength from the fact that they are curved in opposite directions.

This masterly crafted and trendsetting example of truly sustainable architecture reflects not only the school's groundbreaking character but also the architects' philosophy to constantly push the boundaries and expand horizons in architecture and in design. The project required months of research and the development of a special technique that would create such a distinctive and expressive shape. Neil Thomas, the Director of Atelier One, the collaborator responsible for engineering, explains the final result in detail: "The gridshells use shape stiffness to form the roof enclosure and provide buckling resistance to the parabolic arches. The two systems together create a unique and highly efficient structure, able to flex under load allowing the structure to redistribute weight, easing localised forces on the arches."

Executed with extreme technical precision, the curvaceous structure was inspired by nature. To solve the problem of creating a large space with a minimal structure, the architects drew from the way a human ribcage is structured, with its thin yet strong construction protecting the lungs. "The Arc's counterintuitive orchestration of geometry brings the structure into a state of equilibrium, which means a dramatically decreased necessity for structural material," they state. While the arches are thin, the large spans of gridshells resemble a fluid cloth shaped by gusts of wind. Interestingly, it is the gridshells that hold the arches up and not the other way around. The curvaceous structure is strong enough not to be supported by trusses, which would undoubtedly obstruct the space. Instead, the covered area is spacious and airy. The visual impression is remarkable due to the impressive scale of the structure, as well as the fact that bamboo is typically associated with much smaller designs, like houses or furniture. Traditional bamboo forests on Bali are also part of the local tradition. The team of IBUKU in collaboration with Jörg Stamm and Atelier One demonstrate that bamboo can be employed in a grand style and with lots of fantasy, thanks to an unconventional approach and inventive use of geometry.

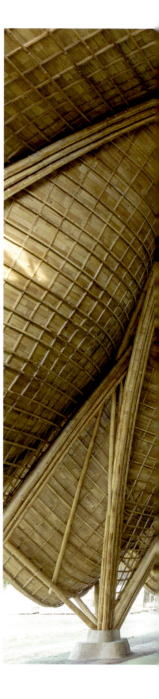

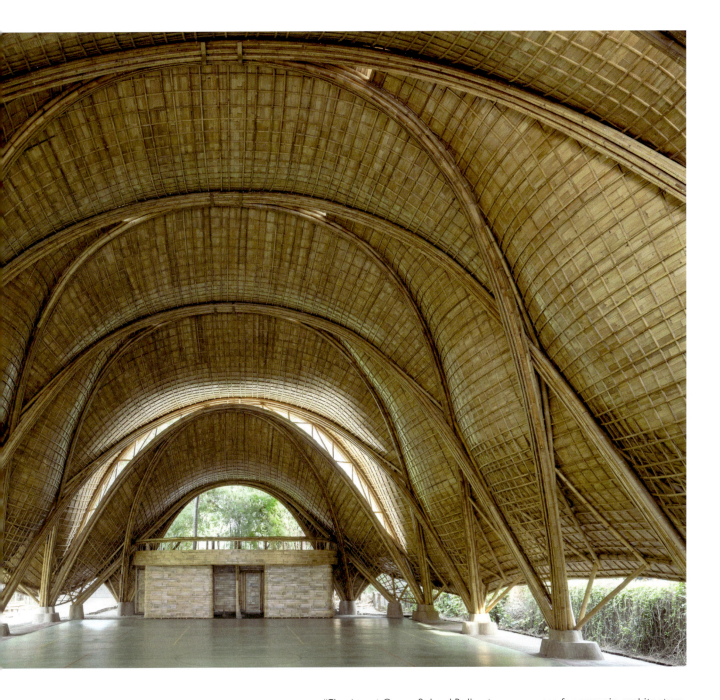

"The Arc at Green School Bali enters a new era for organic architecture, with its nineteen-metre-span arches, interconnected by anticlastic gridshells. It is a new community wellness space and gymnasium for the extraordinary campus, in collaboration with Jorg Stamm and Atelier One," explains Elora Hardy, the Founder and Creative Director of IBUKU.

CANTEEN AND MEDIA CENTRE

DARMSTADT, GERMANY, 2021 // WULF ARCHITEKTEN

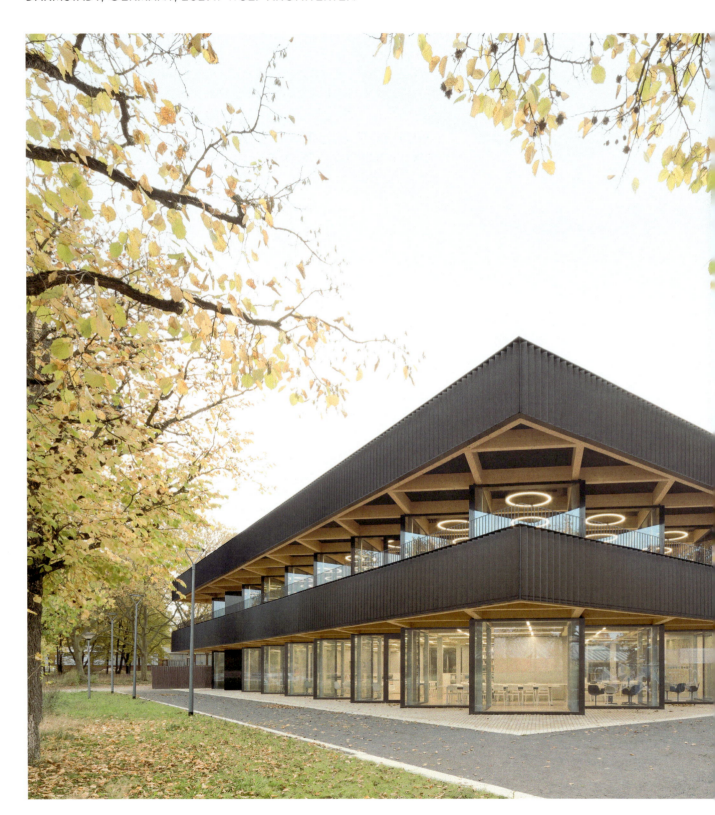

One's first impression of the new building for the Vocational School Centre North in Darmstadt is lightness combined with dynamism. The wooden structure is elegantly complemented by dynamically unfolding glass façades.

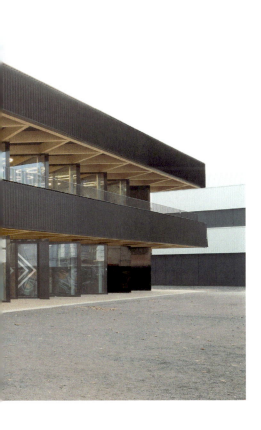

The Canteen and Media Centre designed by Wulf Architekten is a playful take on geometry. Rotated 45 degrees in relation to the building's edges, the layout of the centre is based on a square. The two-storey load-bearing wood structure remains fully exposed and is structured in the form of a very rhythmic grid, repeating the shape of a square. The figure is repeated in the entirely glazed façade, which envelops the volume and enhances the dynamic flair thanks to the serrated arrangement. This lightweight and transparent look is a visual introduction to the very spacious interiors. With a clearly divided programme, the two floors are similar yet have entirely different functions. The ground level, with easy access from the outside, is dedicated to the media centre but also includes seminar and office rooms for the adult education centre. For practical reasons, the canteen, with its serving areas as well as a dining hall meant for around three hundred guests, is located on the upper floor. Additional outdoor yet roofed seats are arranged on the balconies wrapping all façades. A distinctively curved white staircase joins both spheres and stands out against the otherwise rigorous geometry across the building. The regularity of the orthogonal grid of glulam beams based on a square of three by three metres is emphasised by a very elegant lighting system, again playing with forms.

The ground floor lighting is arranged in intersections, while large circular lamps mark the rhythm of the top level's ceiling. Additionally, in the canteen, the modules create frames for seating groups, each comprising a table and six chairs, to foster communication between students and follow the structural order of the space. The architects' goal was to shape the spatial impression through the load-bearing structure, which is achieved with great elegance thanks to the repeatable wooden module. The building proves that regularity, a repeatable rhythm, and simple wooden beam construction can steer clear of boredom or obviousness. Glass and concrete were chosen to offer a pleasant atmosphere in both the media centre and canteen. While the objective on the first floor was to create an inviting atmosphere, the top floor offers a relaxation area, much needed for eating time, that seems to sit in the middle of nature, as it is smoothly connected with the surrounding park through the transparent walls. The materials are combined in a way that creates an optical illusion of the structure partly floating in the air — although it is perfectly solid — and spanning spacious areas without many pillars that would block the continuous space of each floor.

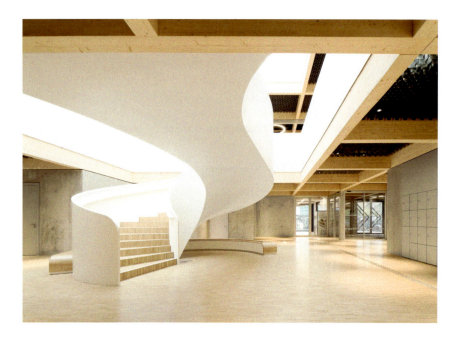

The two structurally identical levels have different functions and are marked by a geometric lighting system, with intersecting lights on the ground floor housing the media centre and large circles for the canteen on the upper one. An expressively curvaceous staircase creates a distinctive passage between them.

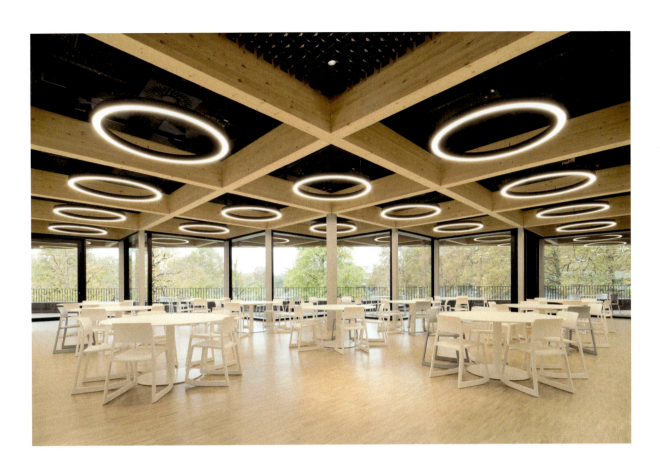

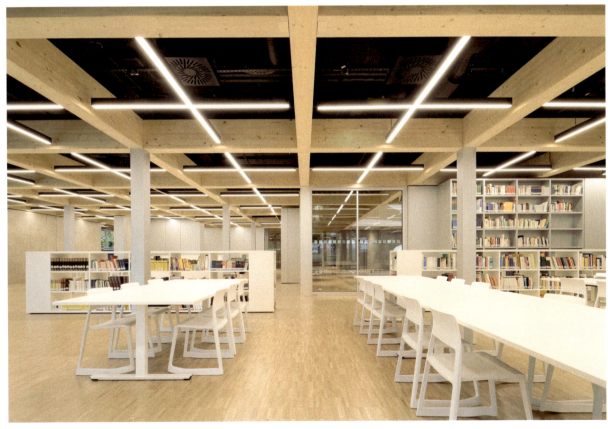

CANTEEN AND MEDIA CENTRE 117

HOMERTON COLLEGE DINING HALL

CAMBRIDGE, UNITED KINGDOM, 2022 // FEILDEN FOWLES

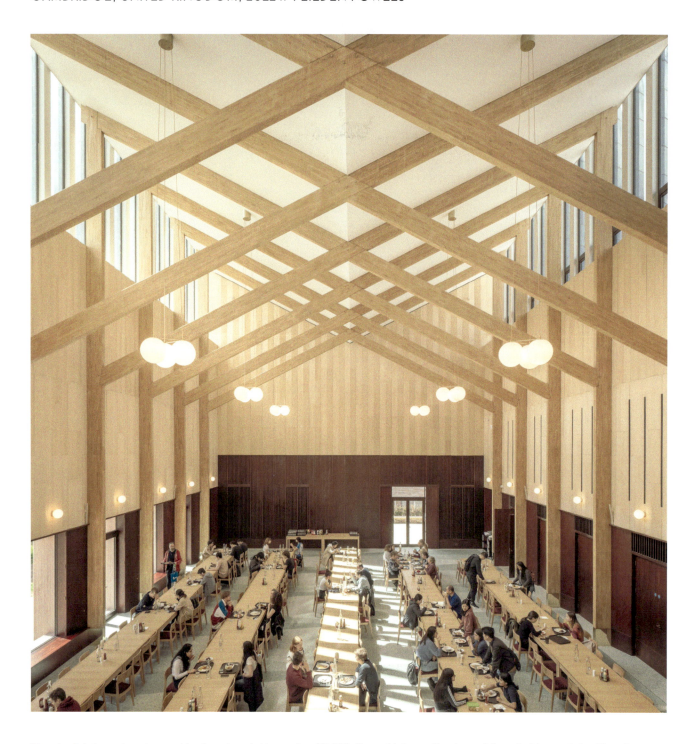

The playful shape is enhanced by the glazed skin made of 3,200 tiles, which are illuminated from inside at night. "Drawing on the Arts and Crafts tradition and the practice's keen interest in low-tech forms of design, the new dining hall is announced by a distinctive undulating mantle of green faience, a traditional form of handcrafted glazed ceramic tile originating in Italy, but popular in the UK from the 1860s, and found on many Victorian public buildings," comment the architects.

Everything in this exceptional project,
from the materials to the shape, from structure
to ornament, is an original take on tradition and
a skilful implementation of the latest technologies.
The faience-tiled outer shell contrasts starkly
with the massive timber interior.

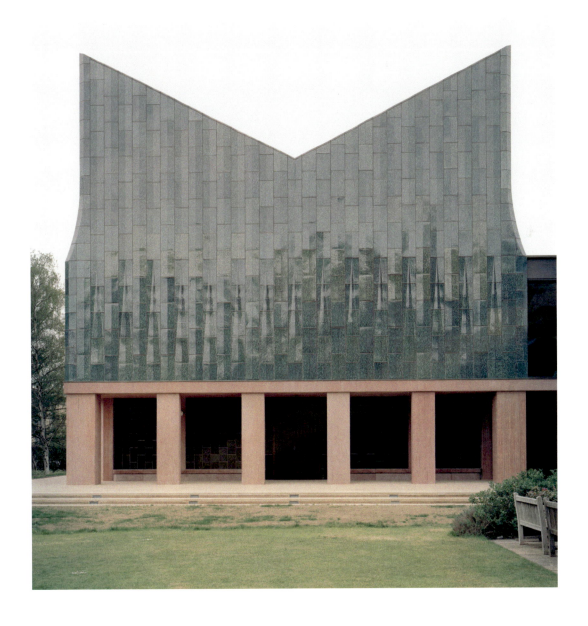

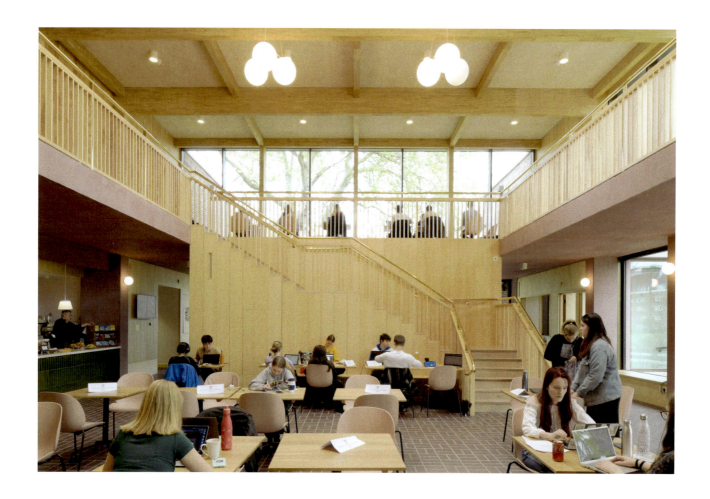

Formerly a teacher training college, Homerton was transformed into a full College of the University of Cambridge more than a decade ago. The need to accommodate a rapidly growing number of students led to the commissioning of this new dining hall. Constructed next to existing Victorian Gothic architecture and the Arts and Crafts style Ibberson Building from the early 20th century, the new creation is visually striking due to its original aesthetics, excellent craftmanship, and massive structure. Within this curious volume, Feilden Fowles planned an immense dining hall for up to 336 students as well as a buttery, kitchens, and associated staff amenities. The dining hall's vast space refers to historic examples of similar architecture, yet unlike in ancient traditions, the architects introduced a glazed base on the southern side, which lets in plenty of natural light and offers views of the adjoining greenery. The brightness, which was one of the objectives, highlights the massive structure and creates an airy atmosphere in the daytime. The abundant interior exposes a sweet chestnut glulam frame and butterfly truss, which is a visual reference to historical dining halls with an original twist. Here, the typically pitched roof has been transformed into a valley-shaped form, which produces a very dynamic effect. These striking structural features let the space change when dark into a dramatic setting that evokes the traditional ceremonial role of the hall.
"The frame was fabricated offsite and installed by a family team using traditional handcrafted carpentry joints fastened with oak dowels between the columns and beams," note the architects, who expertly combine craftsmanship and natural materials with contemporary construction and engineering technologies. This is also evident in the contrast between the green faience on the outer shell and the mass timber interior. The building is not merely designed to strike a great balance between the traditional and the modern in terms of structure

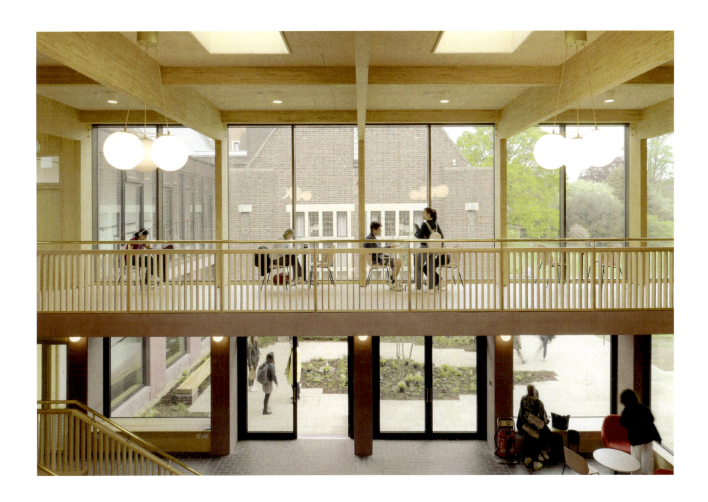

The new dining hall has additional space of a new buttery, which can seat up to sixty people and acts as an informal café. Additional seats and space for students to study or socialise can be found on the balcony above.

and aesthetics. Feilden Fowles architects also put a strong emphasis on environmental solutions.

The use of wood and low-carbon construction products and the optimization of the structure were not the only eco-responsible decisions made by architect, who embraced a holistic approach to sustainability when designing the dining hall. The building is entirely electric with with high-efficiency electric catering equipment as well as a ground source heat pump that reduces CO_2 emissions from heating and hot water. The high-level windows at the top of the south and north walls open to support ventilation with mechanical solutions in use only in peak conditions. Construction management processes to recycle construction waste and reduce the environmental impact, made possible in large part thanks to the use of natural materials, were another important part of the project.

THE ARIAKE GYMNASTICS CENTRE

TOKYO, JAPAN, 2019 // NIKKEN SEKKEI LTD + SHIMIZU CORPORATION

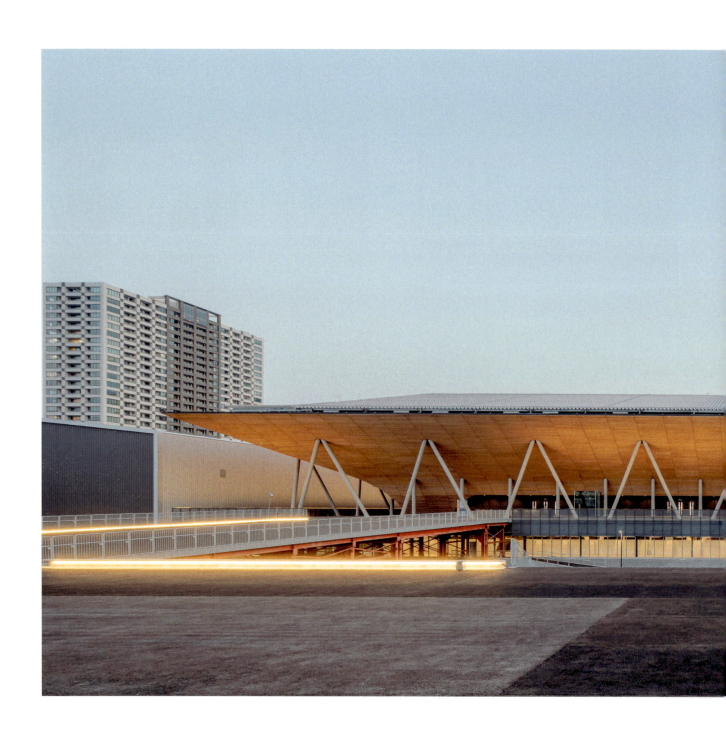

The generous use of timber was at the heart of their concept and the architects chose the material with special consideration based on the wood's characteristics. They describe the "function, structure, and space" of the building as being "tightly combined to achieve beauty and richness in simplicity, which is the essence of Japanese traditional wood architecture."

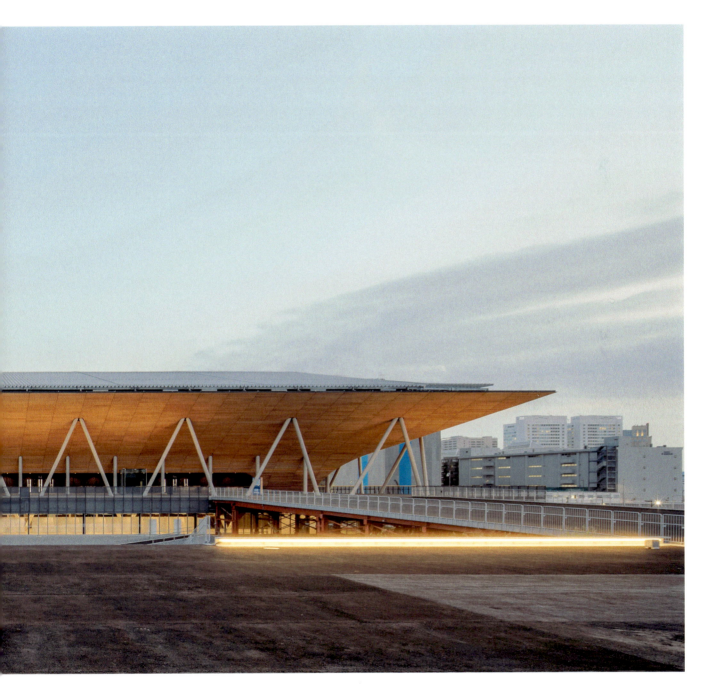

The architectural firm Nikken Sekkei and the Shimizu Corporation, responsible for the construction, have created in Tokyo one of the most breathtaking timber buildings in the world. "Reminiscent of a wooden vessel floating in the bay area," as the architects muse about their vision, the Ariake Gymnastics Centre is an extensive structure, sitting on the bank of a canal. The curvaceous shape was designed to provide both the best acoustic performance and thermal insulation properties. The material is in large part an homage to the district's heritage, as it used to be a timber storage pond. The roof frame structure, façade, audience seats, and even the exterior walls are all made of timber that is entirely exposed, while the structure is supported by steel elements in the construction. What is most visually striking is the scale of the building, which really pushes the limits of timber technology. Individual elements of large glued laminated timber have been used for the structure, not just for their structural stability, but also to achieve fire resistance. The organically shaped volume welcomes visitors with elevated façades based on supports to provide a roofed outdoor space for entering spectators. This original approach to incorporating circulation around the building by adding a concourse challenges the typical monolithic character of most sports centres. It also creates an interesting visual tension between the wooden Ariake Gymnastics Centre and the strictly geometric neighbouring architecture. By keeping the extensive volume low, the architects successfully planted the Ariake Gymnastics Centre into the context of the surrounding medium- and high-rise residential buildings. The arena stands out but does not create dissonance, instead softly inhabiting the horizontal plot.

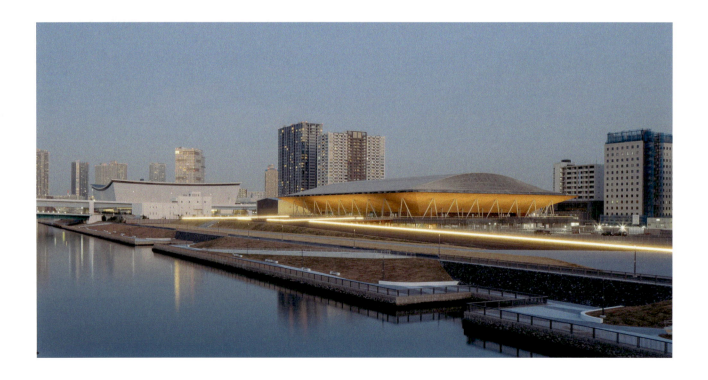

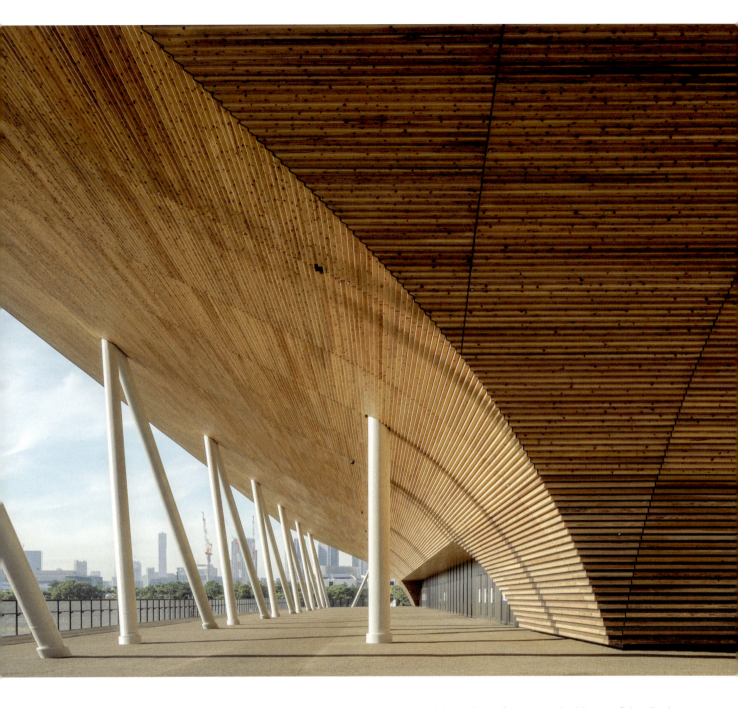

The shape envisioned by the architects is a reference to the history of the district, which functioned as a timber storage pond in the past. Playfully formed, the building is enhanced by the textured outer shell that demonstrates the natural beauty of the wood and its sculptural properties.

THE ARIAKE GYMNASTICS CENTRE

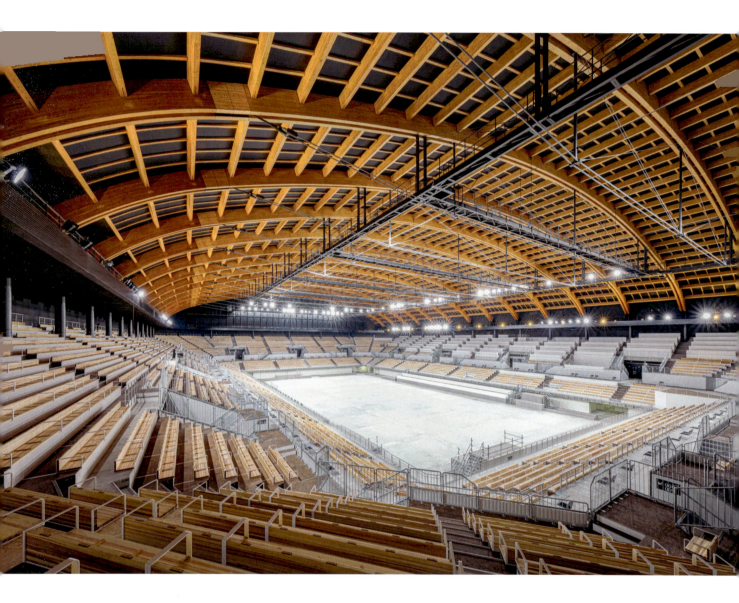

"The arena ceiling is a wood frame structure designed to reduce the weight of the overall structure," explain the architects, who effectively covered a gigantic space with an innovative system of Timber Beam Strings Structure and Cantilever Trusses. The result is quite dynamic.

The dynamic form is enhanced by textured surfaces that show the beauty and richness of the material, demonstrated on a large scale. The undulating wooden outer shell signalises an equally effective and powerful interior. The use of timber is particularly spectacular in the arena's extensive ceiling, the meticulous structure of which spans the building from one edge to the other in a rhythmic composition. It is also perfectly functional, as the shape of the frame effectively reduces the weight of the overall construction. Reducing it to the minimum scale was crucial due to the location along the canal and the soil quality. The architects note that this is Japan's first building that combines Timber Beam Strings Structure and Cantilever Trusses in a complex structural system, thanks to which they were able to achieve a significantly sized wooden frame to entirely cover the arena. Large glued laminated timber elements are used instead of trusses made of numerous small elements. This solution also provides a high heat capacity, and thus fire resistance, while also guaranteeing the stability of the structure. The Ariake Gymnastics Centre has been envisioned in a very flexible way, to be able to change its role. It initially became a temporary international facility for international sports competition, but with the removal of spectator stands it could be easily transformed into a permanent exhibition hall at a later stage.

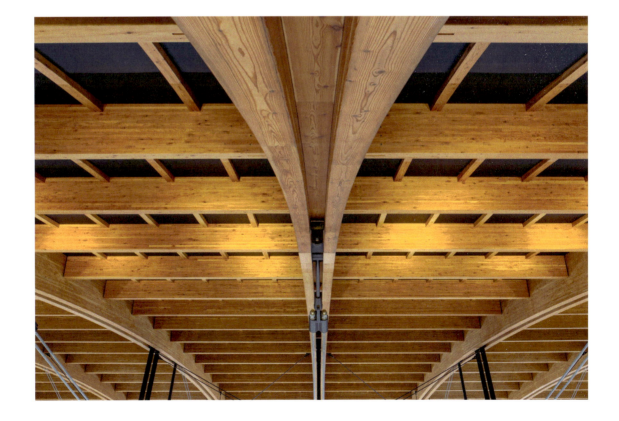

OREGON FOREST SCIENCE COMPLEX

CORVALLIS, OREGON, USA, 2020 // MGA | MICHAEL GREEN ARCHITECTURE

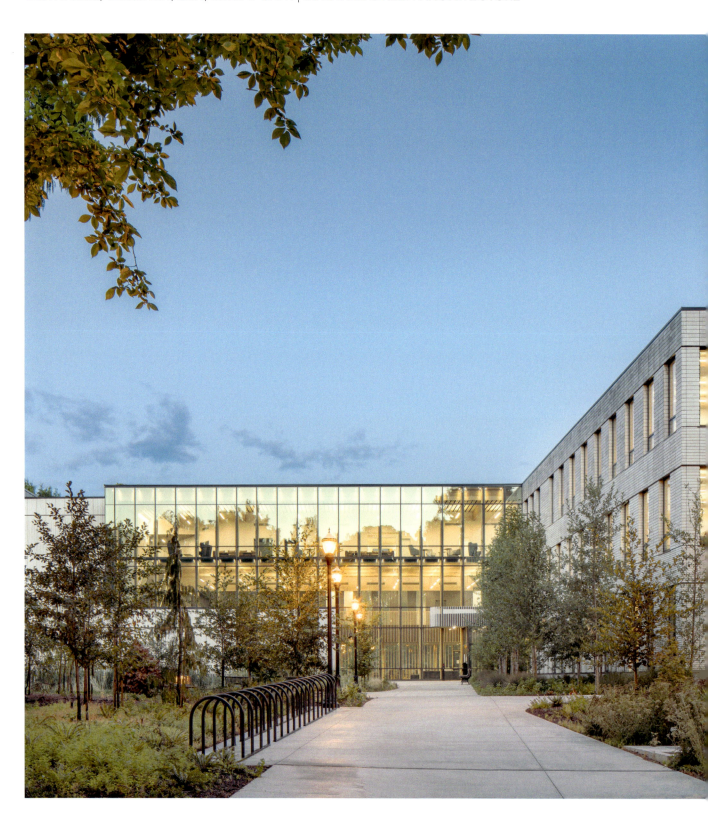

Michael Green Architecture's design for the College of Forestry at Oregon State University is an impressive complex of two mass timber buildings. These spaces — just as sustainable as they are inspiring — were envisioned in collaboration with the team of the college itself.

The new Peavy Hall and the AA "Red" Emmerson Advanced Wood Product Laboratory have become part of the Oregon Forest Science Complex. Multiple College of Forestry department teams, who also represent users across various functions, have played an active role in working out the concept for this dynamic learning hub defined by a collaborative spirit and meant to create, as the architects emphasise, a research environment for managing and sustaining working forest ecosystems in the 21st century. "Engagement with these unique and diverse groups meant that the buildings themselves were designed to be teachers and a living laboratory — something to interact with and to learn from," comments the architecture studio.

The AA "Red" Emmerson Advanced Wood Products Laboratory (AWP) is also a mass timber building and offers an innovative space to develop and test cutting-edge wood products and technologies

The two new mass timber buildings represent the structural power of the material with its highly aesthetic values, which are particularly expressively pronounced in the main building. Peavy Hall houses twenty classrooms and laboratories, which vary in size, as well as computer rooms. The idea was to design inspiring spaces that would facilitate various teaching styles for exploring all aspects of the forest landscape. "The building is designed as two intersecting bars, connecting to the existing Richardson Hall with an encapsulated CLT firewall," explains the studio, while the impressive centre of the building is the Rosenburg Forest Products Atrium. With its towering two-storey columns arranged rhythmically and made of solid Douglas fir, this space is connected with the Peavy Arboretum and creates a communication between the two levels. The wooden frame of the building is designed with respect to the high seismic requirements of the site. "A CLT rocking wall system was developed, the first of its kind in North America, with shear walls composed of separate sections connected vertically by a post-tension system," details the studio. Thanks to this solution, the walls are able to move and self-centre during an event.

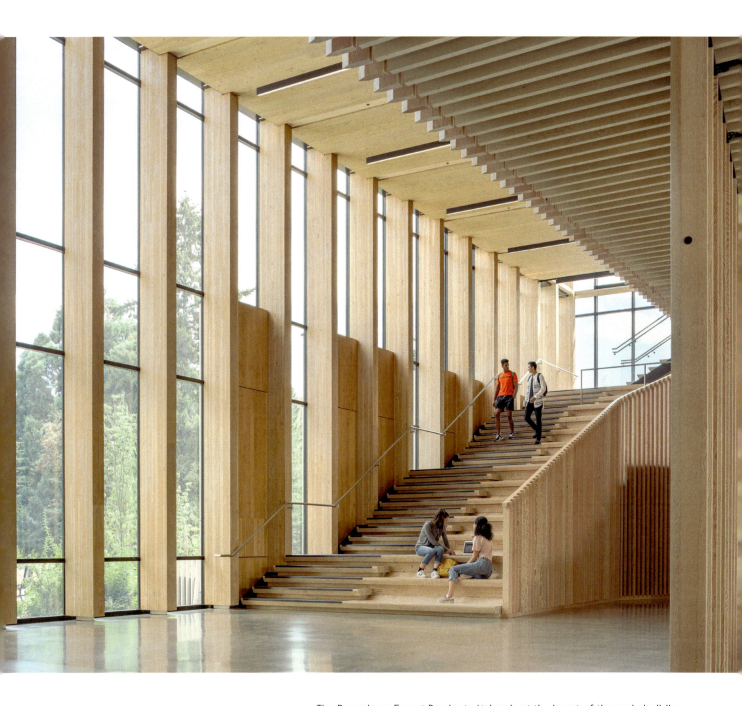

The Rosenburg Forest Products Atrium is at the heart of the main building. The glazed structure, based on three-storey Douglas fir columns, opens to the Peavy Arboretum, which features a collection of local plant species.

OREGON FOREST SCIENCE COMPLEX

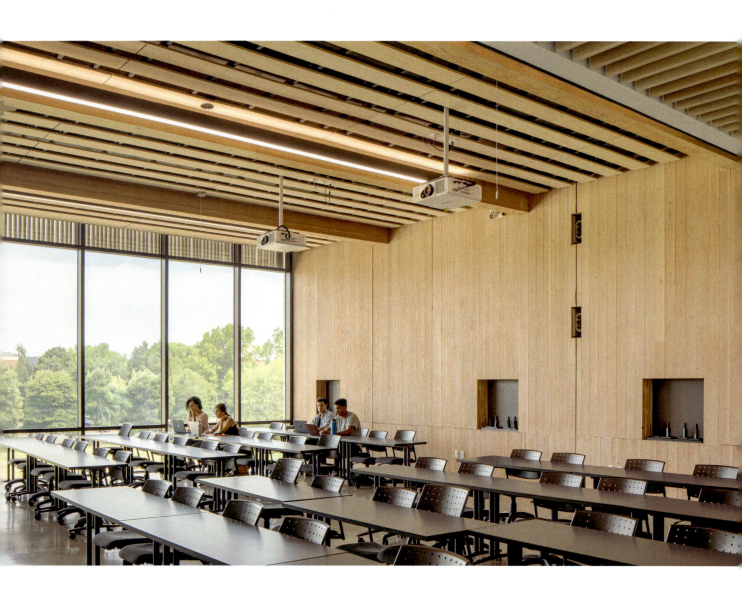

Interestingly, the structure has been equipped with more than 200 sensors that monitor moisture and gather data on both vertical and horizontal movements. The second, smaller building has been called the AA "Red" Emmerson Advanced Wood Product Laboratory and is a volume dedicated to innovative research. Its structure is made of a simple glulam and MPP system which together were able to create the long span for an expansive space for developing new wood products as well as new technologies for the material. "The lab space is broken into two bays: a structural testing bay, including a reaction wall and strong floor, and a manufacturing bay with advanced robotics and fabrication equipment," add the architects.

"The two new buildings extend beyond forestry to include the entire ecosystem, the industries that engage it, and more importantly, the wide variety of people who will be environmental stewards of our future: the students," reflect the architects.

OREGON FOREST SCIENCE COMPLEX

HOSPITALITY PROJECTS

GRAND WORLD PHU QUOC WELCOME CENTRE

PHU QUOC, VIETNAM, 2021 // VO TRONG NGHIA ARCHITECTS

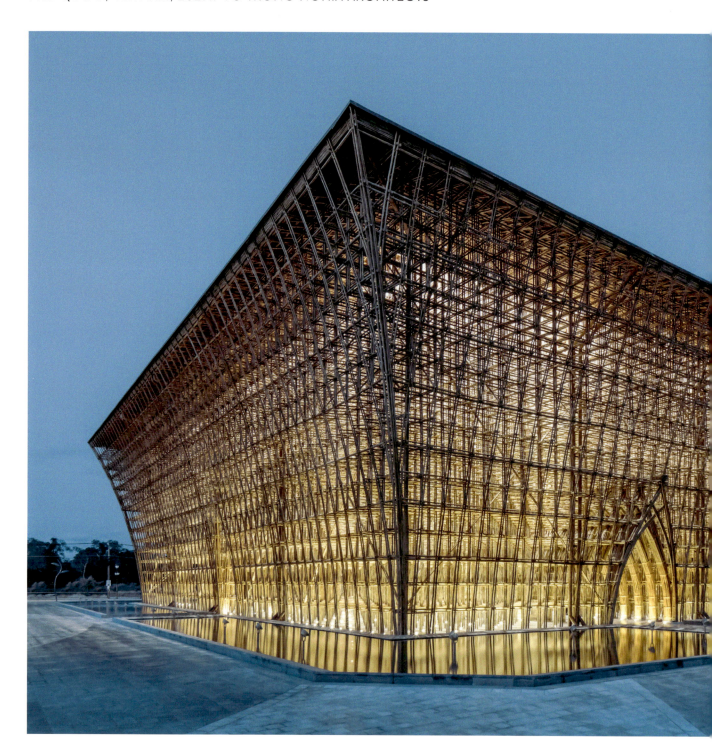

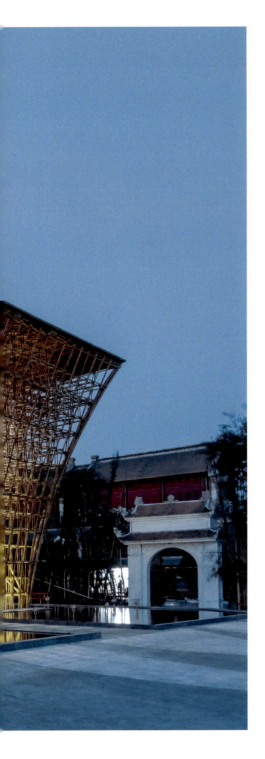

This meticulously interwoven structure is made of natural and low-cost sustainable material. Designing it to embody Vietnamese cultures, the architects used only natural-colour bamboo, ropes, and bamboo pins.

Envisioned by Vo Trong Nghia Architects, the Grand World Phu Quoc Welcome Centre as a complex shape combining arches, domes, and grid systems in a lightweight and spacious volume. "The light comes in beautifully and, along with the natural colour of bamboo, creates a warm and intimate atmosphere, even though the structure is very open in terms of airflow," comment the architects, who brought to this project their specialised knowledge on building with bamboo. The material was also used, according to the client's brief, as a reference to the cultures of Vietnam, with lotus and drum symbols that are sculpted into the dense grid. This curious hybrid of forms and shapes is fully visible from the inside of the building, which offers a unique aesthetic, especially striking due to its large scale. The bamboo is softly shaped into arches with meticulous precision. The grid is highlighted by the simplicity of joints made with ropes and low-cost joining elements. The architects' sculptural skills in bending bamboo are particularly visible in the shape of the roof. "A cantilever edge requires considerate use of cross bracing as secondary structural elements compared to main structural elements," they explain.

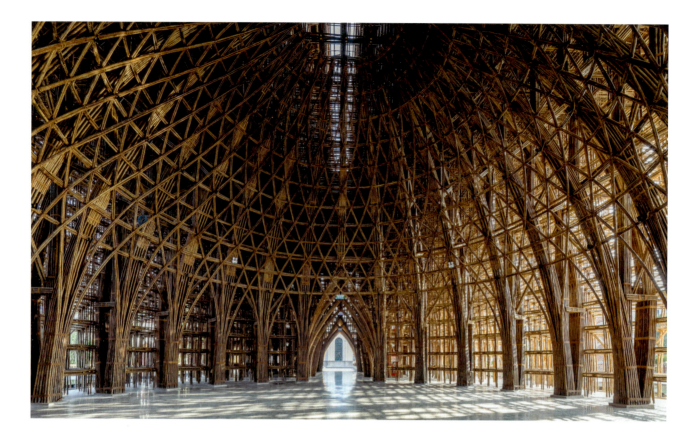

Systems of arches, domes, and a grid create a semi-transparent space, each part of which takes on a different, surprising form, realised in pure bamboo connected with only ropes and low-cost joining elements. The lightweight structure exposes bamboo in its natural form and colour, without any chemical treatment, and is made of 42,000 culms interwoven into a meticulous grid supporting natural ventilation and allowing access of light.

The entirely open and partly transparent space embraces visitors and offers a nest-like experience. The arch pathway leading through the whole building makes a corridor, enhanced by the light playfully filtered through the bamboo grid, and provides a smooth inside–outside connection. It is also an additional source of natural light for the extensive interior.

The energy efficient volume is a pure bamboo structure made of around 42,000 culms assembled together with only ropes and bamboo pins, which emphasises the seamless character of the grid. Its layers interlock systematically, creating a light skin which is shaped with great flair and imagination. This solution provides perfect ventilation without the need for artificial air conditioning. The access of light is also sufficient so that artificial lighting only needs to be used at night. Lit from the inside, the Grand World Phu Quoc Welcome Centre building displays its detailed and sophisticated texture for all passersby. Just as the play of light and shadow animate the interior during the day, the organic beauty of the volume is distinctive after sunset, with an effect that can be compared to that of traditional stained glass.

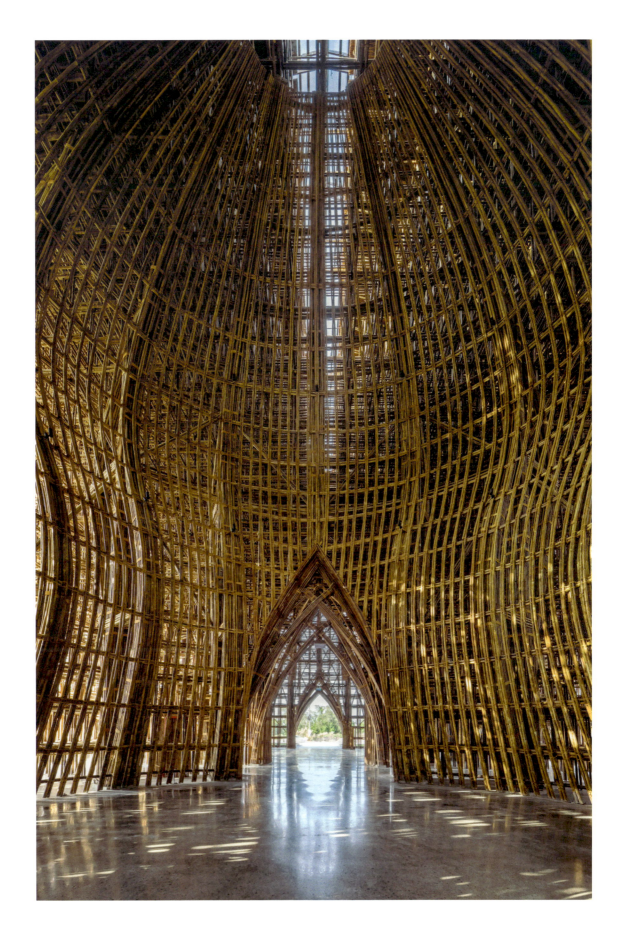

GRAND WORLD PHU QUOC WELCOME CENTRE

"We have all the responsibility to find new ways of thinking. And not only thinking, but actually doing," states the Voll Arkitekter studio, a pioneer in large and complex timber buildings with distinctive aesthetics.

Completed in 2019, Mjøstårnet is one of the very first high-rise buildings announcing the timber shift and is an exemplary project demonstrating how to build with local and sustainable resources. This building, over eighty-five metres high, was the world's highest timber building for three years. It has a mixed use programme that combines facilities designed for residents, locals, and visitors. The name of the tower in Norwegian means "The tower of Lake Mjøsa," Norway's largest lake. The building overlooks the lake and is located on a bank of the river Brumunda. The small city of Brumunddal with its surroundings is known for forestry and the wood processing industry, which allowed the architects to accomplish this project in a very green way. The architects searched for local materials and expertise; they add that from the tower's viewing platform on the top of the building, one can see where the timber for Mjøstårnet came from and where it was processed. This fortunate location demonstrates how sustainable solutions can optimise the efficiency of the construction process.

MJØSTÅRNET

BRUMUNDDAL, NORWAY, 2019 // VOLL ARKITEKTER

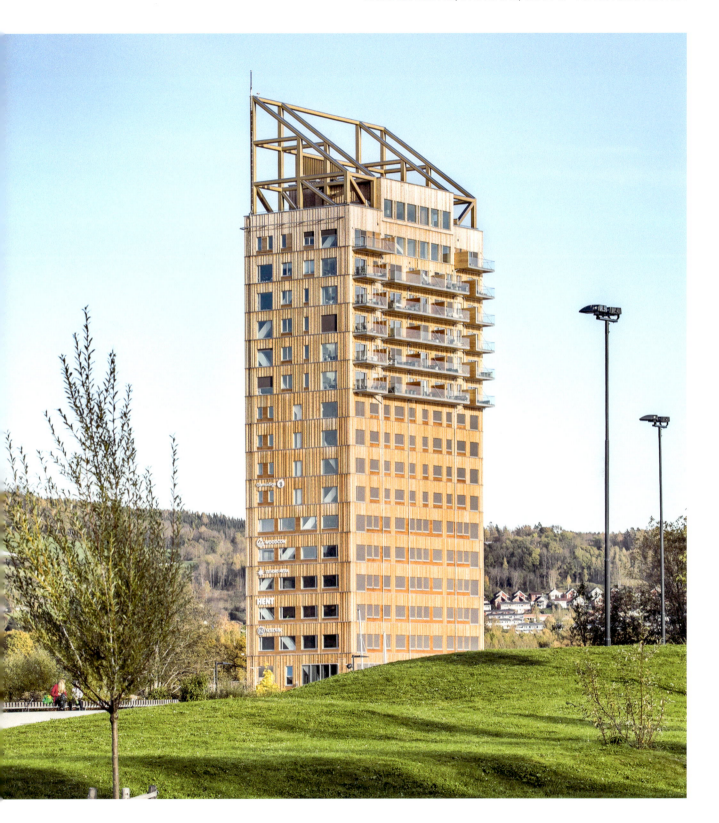

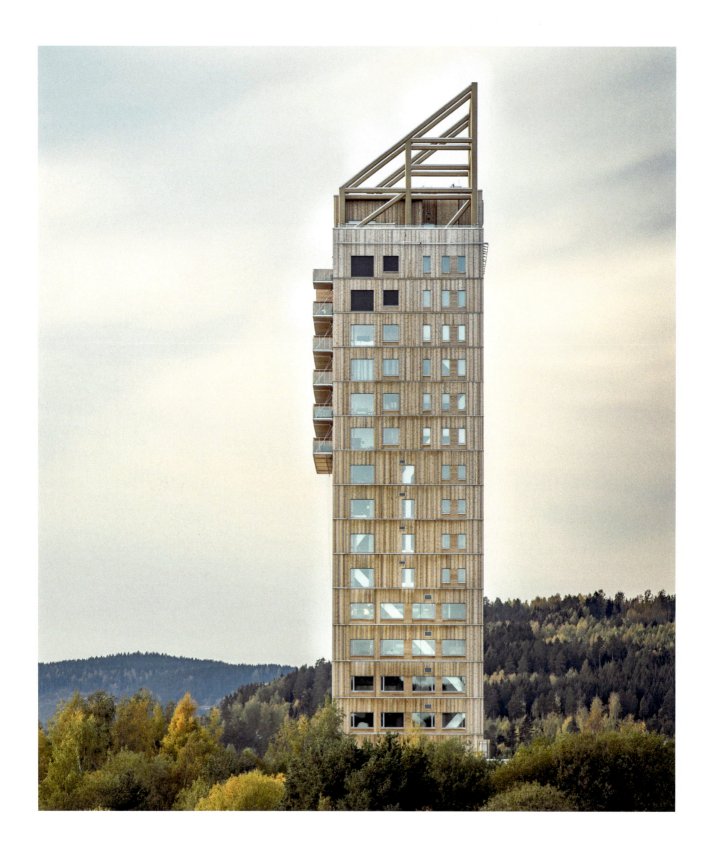

The elements of the structure made of timber are visible across the building and highlight the scale of this ambitious project. "We think it's exciting to see that wood construction has gained a new renaissance and we are proud to be able to help develop wood architecture to new heights," reflect the pioneering architects.

Made of fourteen thousand trees, the construction and cladding uses timber in a revolutionary way. The main load-bearing structure is made of large-scale glulam trusses, internal columns, and beams. "The trusses handle the global forces in the horizontal and vertical directions and give the building its necessary stiffness. CLT walls are used for the secondary load bearing of three elevators and two staircases," explain the architects. Prefabricated sections as well as floor slabs effectively accelerated the construction. The outer shell's elements are also prefabricated and attached to the timber core structure; this cladding is made of a fire-safe pine. While the constructional elements are left exposed, which can be seen from afar, there is also a focus on the haptic qualities of the wood. Various textures play an important role both inside and outside the building, as the aesthetic aspect of using timber was also crucial for the architects.

The tower successfully combines various functions that change like a chameleon across the eighteen storeys of the tower, starting with a public ground floor including a lobby, reception, a restaurant, and a pool located in the low adjacent building. Above, there are conference floors, five office levels and a four-storey hotel. The upper part of the tower is dedicated to residential spaces — floors between twelve and sixteen have units with balconies with a view of the lake, while level seventeen houses two large apartments and an event room. A penthouse and a public viewing terrace are located on the top floor. The capacious volume swiftly changes functions but remains consistent both structurally and aesthetically due to the highlight placed on timber.

Mjøstårnet is made of around 14000 trees that come from local sustainable forestry and were also processed nearby. Various hues and textures celebrate the natural and timeless beauty of wood, from the outer shell to the warmly designed interiors.

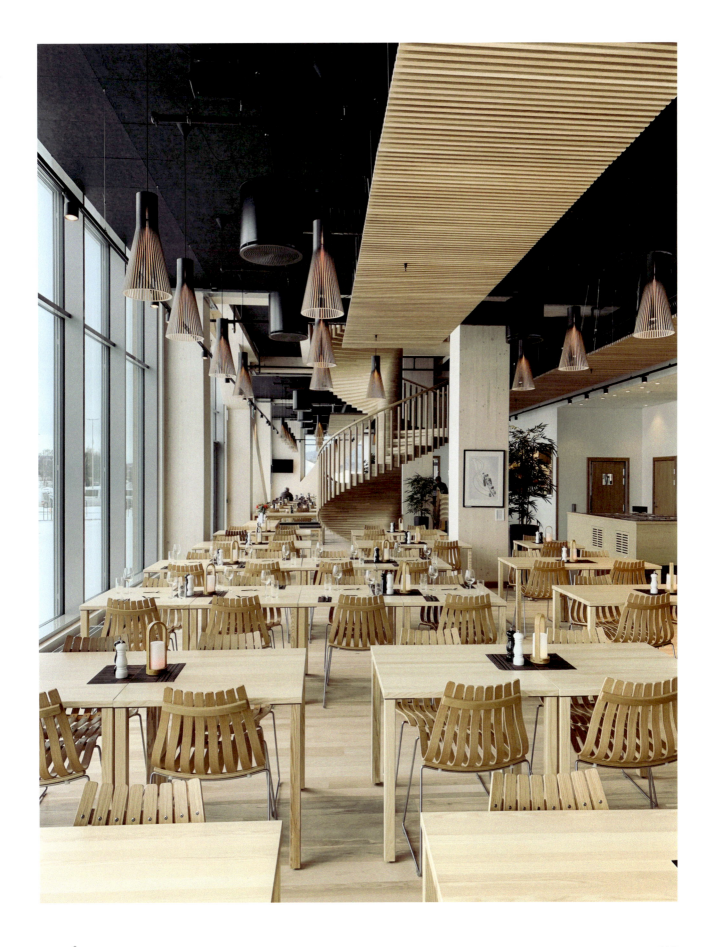

MJØSTÅRNET 145

HOTEL MILLA MONTIS

MARANZA, SOUTH TYROL, ITALY, 2020 // PETER PICHLER ARCHITECTURE

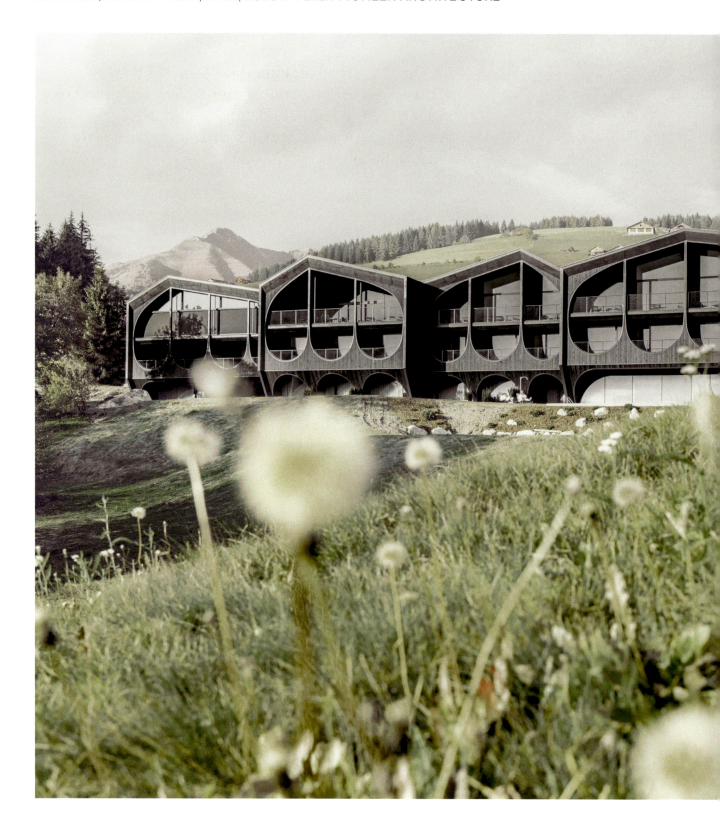

To find a perfect architectural form for this picturesque rural setting, Peter Pichler Architecture drew from the local architecture and through the particular use of wood gave a contemporary twist to historical forms.

It is common for the Peter Pichler Architecture studio to dive into the local specific context. The new is supposed to draw from tradition yet also be an innovate take on it. And such is Hotel Milla Montis, set in the midst of an idyllic Alpine landscape. Extensive meadows and fields form its backdrop, while a panorama of the Dolomites Mountains makes up its views. The positioning has been planned so that all rooms and common facilities, including the restaurant and the spa, entirely face out onto this scenery. The silhouetted façade repeats the same rhythm, yet the volume is visibly broken into four shifted and interconnected parts; the combination of their sloped roofs relates to the contours of surrounding mountains while also reducing the monolithic character of the building. The curved elements of the outer shell were inspired by the pitchfork used by local farmers, and create an inventive frame for the balconies and all glazed walls. The organic shapes of the large cut-outs resonate with the surrounding natural environment. The most essential decision, however, for blending the building into the landscape, was the treatment of the wood. A cladding made of larch was blackened so that the hue both matches the natural background and it maintains its natural look, completely blurring the dissonance between the unspoilt nature and the architecture.
"The composition is inspired by the vernacular architecture of the region and the classic wooden barn reinventing a contemporary reinterpretation of this typology," observe the architects.

As much as this exterior design creates a perfect dialogue with the mountainous scenery, the interior has been envisioned in a stark contrast to it. Wood is the main protagonist for the whole building, yet unlike the blackened larch outside, the inside has been realised exclusively with light wood and in a distinctively geometric manner. The natural palette of the ash wood is only complemented by green loden textiles used in the furnishings, which have nearly all been custom-made for the hotel, most of them also made of light wood. The architects' goal while planning the interior was very clear — to maintain the spirit of functional simplicity that is timeless and in line with the mountain architecture aesthetic. The all-wood surfaces create a box-like effect, which highlights the common spaces, like the restaurant and bar, and give them a warm and inviting atmosphere. Structurally, these public areas are reminiscent of the architects' inspirations and repeat their barn-like forms with impressive ceilings mimicking gabled roofs. The interiors are all very coherent and elegant in their wooden purity. Visually, the architects often play with the texture, leaving most of the walls smooth, while using a pattern of regularly arranged boards for the ceilings and some of the partitions.

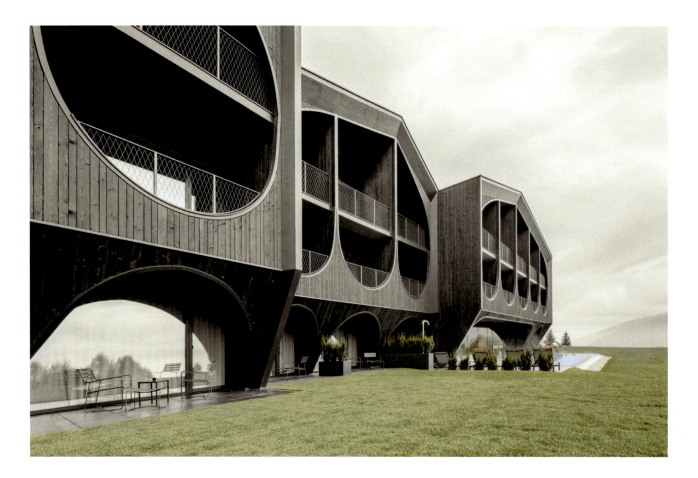

The idea of dividing the volume into four slightly shifted parts works really well with the cut-out silhouette of the façade and slanted roofs. Most of the rooms have roofed balconies and enjoy stunning views of the mountains, just like the common spaces.

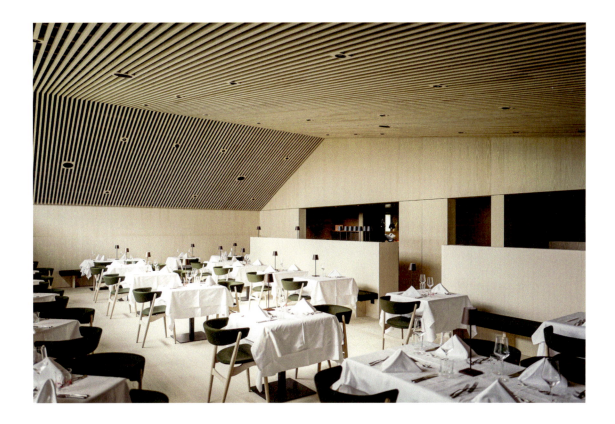

Contrasting with the dark façade, the interior offers the hotel guests a cosy atmosphere. The all-wood common spaces are the perfect expression of the elegant, functional simplicity characteristic of mountain architecture.

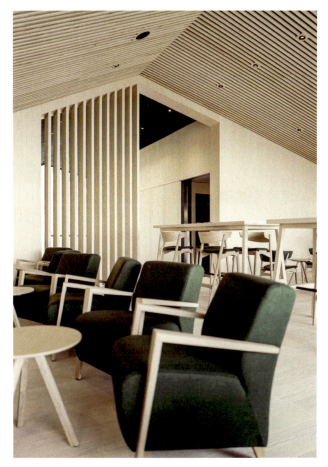

COEDA HOUSE

SHIZUOKA, JAPAN, 2019 // KENGO KUMA

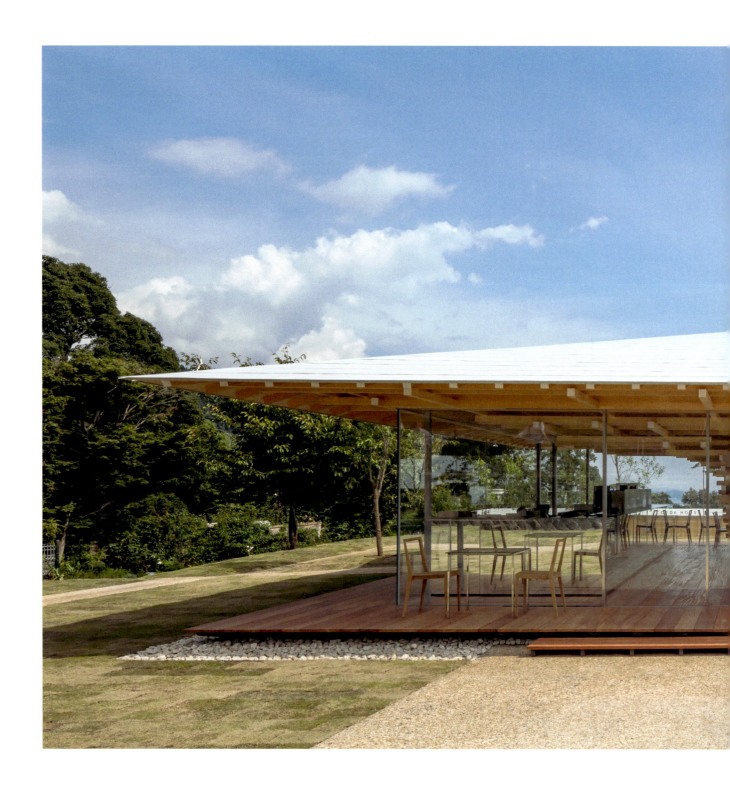

150　　HOSPITALITY PROJECTS

Sitting on a picturesque plot with a view of the Pacific Ocean, Coeda House is a unique café designed by Kengo Kuma. The extensive, tree-like structure provides lightweight shelter without dominating the natural surroundings.

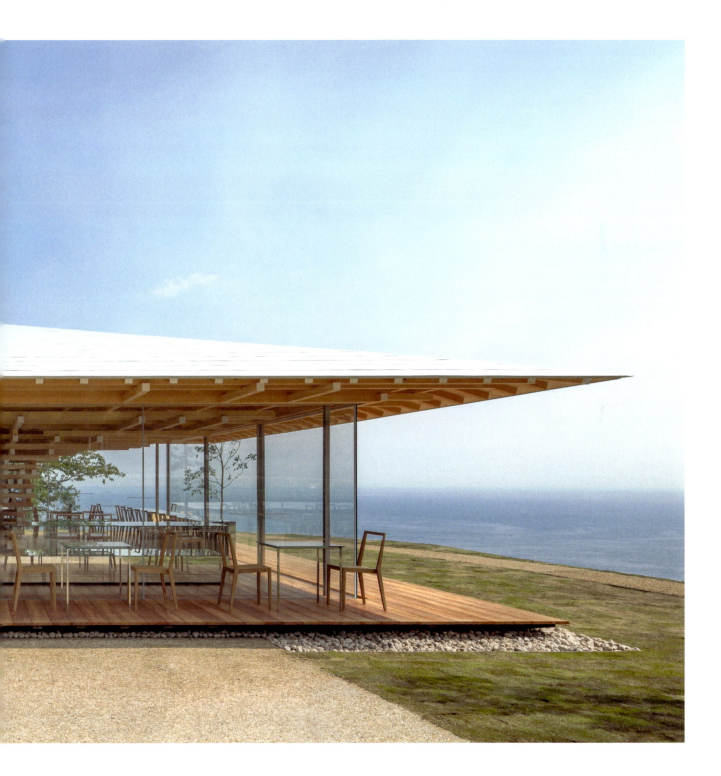

A pioneer in building with wood, Japanese architect Kengo Kuma used 8-centimetre-square cedar boards to create this curious structure for the space of a café located in the Akao Herb & Rose Garden in Shizuoka, a popular seaside resort. It offers visitors the chance to explore stunning rose gardens and striking views of the Pacific Ocean, as it is partly situated on a cliff. This was exactly the spot selected for the café envisioned by the celebrated Kengo Kuma. As with many other buildings in the architect's portfolio, this one is also a masterfully complex structural combination. Resembling Jenga blocks, the 8-centimetre-square boards made of cedar have been seemingly randomly stacked to create a tree-like form. This centrally located support allowed Kuma to eliminate any other columns, leaving the views of the surrounding landscape entirely unobstructed for visitors of the café to admire while enjoying a break.

The extensive roof is suspended over the floor, which repeats its shape. Sandwiched between them is the café space, enveloped by transparent glass walls with a small frame around all sides left for an outdoor terrace, both receiving much-needed shade, as the area on top of the cliff is exposed to the sun. The geometric arrangement of cedar elements rises from the central tree-like column and continues upwards into the ceiling, which adds even more lightness to the pavilion. The guests of the café can feel protected by this inventive parasol. It seems to be effortlessly defying gravity, but in reality, it is meticulously assembled and solidly reinforced in strategic spots with carbon fibre rod (which, as the architects state, has a tensile strength seven times stronger than iron). The visual effect is so powerful because the joints are not visible to visitors. This structural solution also decreases the risk of movement during possible earthquakes.

The aesthetic of the café is perfect not only from a practical point of view. Its ephemeral look clearly allows visitors to enjoy the beauty of the natural context of the plot, while being protected from excess sunlight and wind. But the light structure, though made of perfectly geometrical elements, is organised in a very organic way, ideally suiting the character of the space. The bright hue of the cedar wood enhances this impression. Kengo Kuma once again brings architecture as close to nature as possible, letting the first immerse itself into the second without compromising on any practical aspects. The space functions perfectly as a café, yet its discreet construction inspired by the organic world does not interrupt the landscape, but only completes it. Two normally contrasting elements are in perfect harmony.

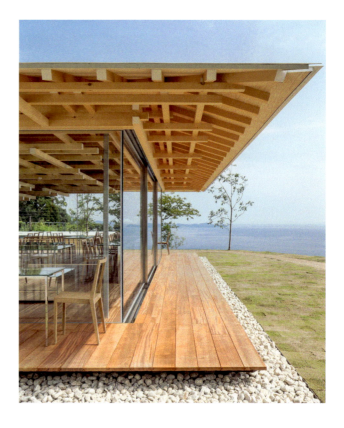

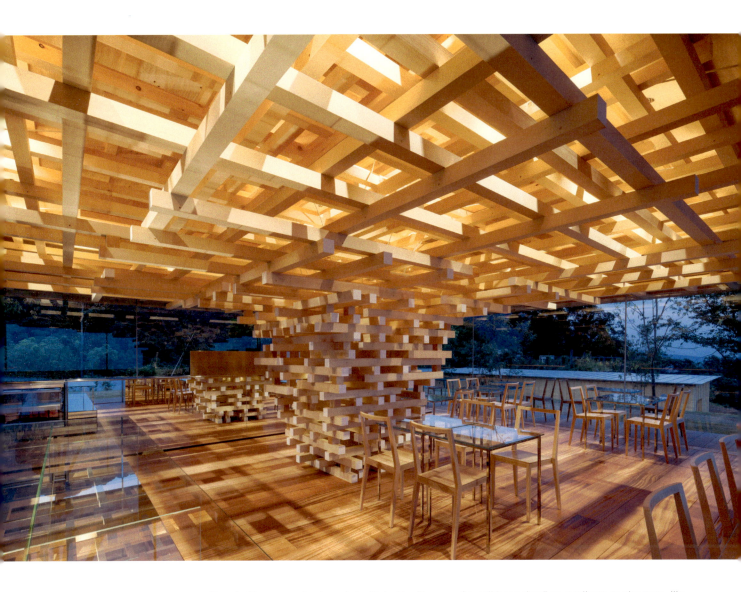

Coeda House can be translated into the "house of small branches" as a tribute to the tree-like structure it is inspired by. The thorough composition of cedar blocks seem to be floating lightly above the ground. The inventive structure of the roof protects the café's guests and allows them to enjoy 360-degree vistas from the spectacular cliff top, as do the transparent glass walls, which block the wind without obstructing the views.

FUCHSEGG LODGE HOTEL
AMAGMACH, AUSTRIA, 2020 // LUDESCHER + LUTZ ARCHITEKTEN

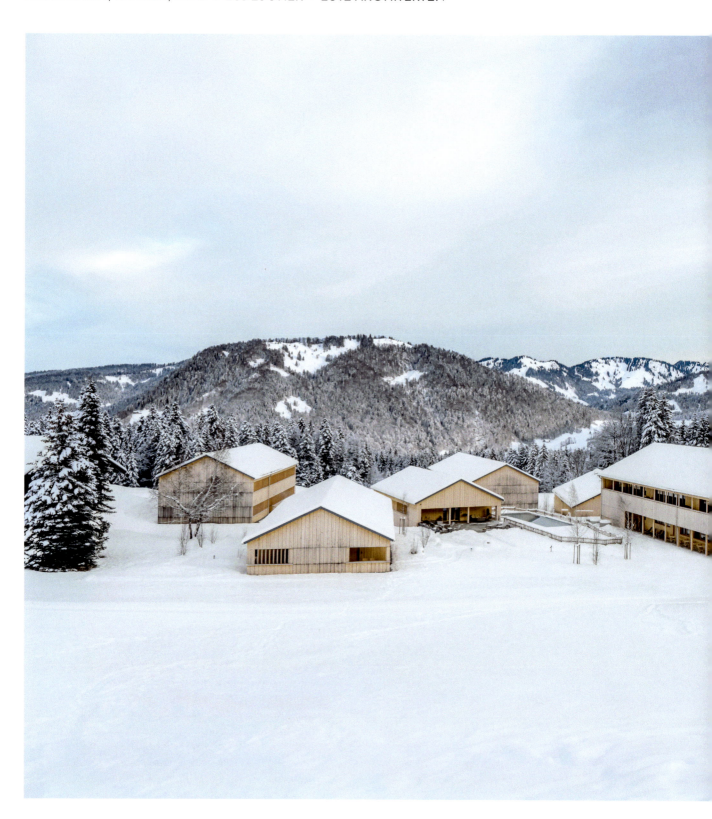

Its remote location with panoramic vistas of the mountains creates a scenic frame for the complex of Fuchsegg Lodge Hotel. The all-wood volumes and their specific spatial arrangement provide the natural, relaxed charm that the architects were aiming for.

Envisioning a rather extensive retreat in this unspoiled landscape created a challenge for the architects. With the goal of framing it harmonically with the natural context, Elmar Ludescher and Philip Lutz looked into the regional architectural traditions. They were specifically inspired by the idea of "vorsäss", a kind of loose settlement of simple farmhouses and stables, characteristic of the Alemannic Alpine, that is used exclusively in the summer time. The architects employed a similar typology but gave it a contemporary twist. Just like in the original, all the buildings are stylistically similar and their orientation depends on the topography. Traditionally, there are no defined street-like connections between the volumes, nor any fences dividing the spaces between them or separating them from the wider surrounding context. The spatial arrangement is naturally adjusted to the silhouette of the slope and creates a good balance — the buildings form a well-communicated cluster yet each volume has enough space surrounding it. There are no adjoining gardens. Instead, the architects allowed the surface of the hill to run naturally between the buildings and minimised the intervention into the landscape to only what was necessary.

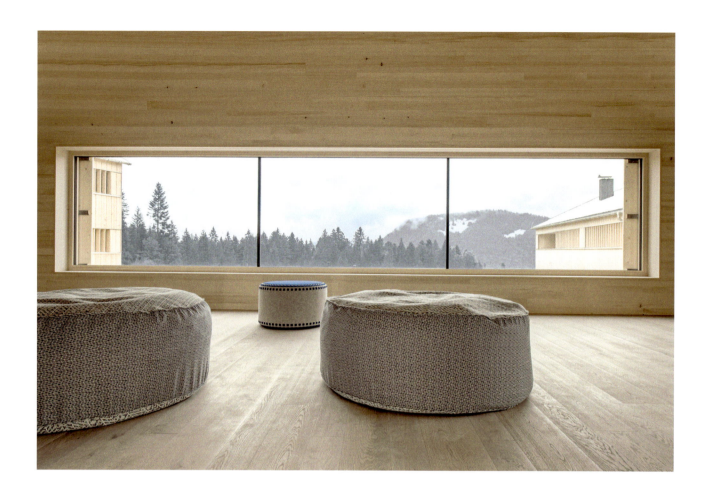

The ensemble of the Fuchsegg Lodge Hotel has been divided according to each building's specific role. Their volumes, however, are shaped and scaled in a similar way, which creates a uniform visual effect. Extensive but relatively low, the houses all have identical wooden structures, although the rhythm of their openings or balconies may differ slightly, and are covered with the same gabled roofs. Clearly, the strongest unifying element is the material. The naturally coloured wood fits perfectly into the surroundings and puts the visual focus on the structurally minimalist beauty of the collection of buildings. "The external appearance was a particular concern for us," explain the architects. "The houses were to become part of the landscape with a serene naturalness, so we designed a façade system in wood that allows the structures to 'age' uniformly into the site," the studio adds. The volumes are beautifully crafted inside as well, where all surfaces are made of a multi-textural and thus very sensory combination of various kinds of wood. For the floors, the architects used hardwood, ash, oak and maple, which are band-sawn and oiled for a natural effect. The walls and ceilings, which in the upper levels expose the structure of the sloping roofs, are made of silver fir with seamless fastenings. The light colour of all of the interiors' elements contributes to a soft and natural atmosphere, which also corresponds nicely to the landscape, seen through numerous windows.

The panoramic windows filter natural light, which fills the all-wood interiors in a very soft way. The architects used a combination of light-coloured ash, oak, maple, and silver fir with their various hues and textures to bring the hotel guests closer to nature and erase the limits between the inside and outside.

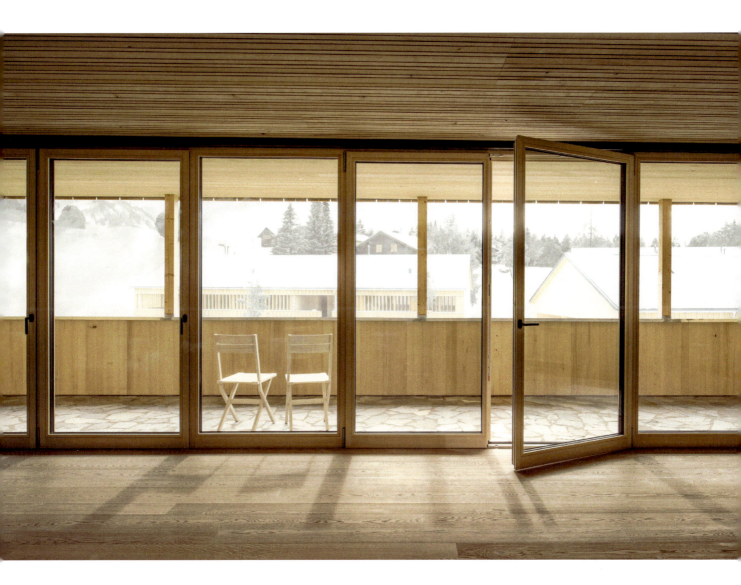

The craftsmanship of the simplistic façades is quite striking. As their highlight, the architects planned uniform window bands equipped with rotating wooden slats that filter the light and give a consistent look to all the buildings in the ensemble.

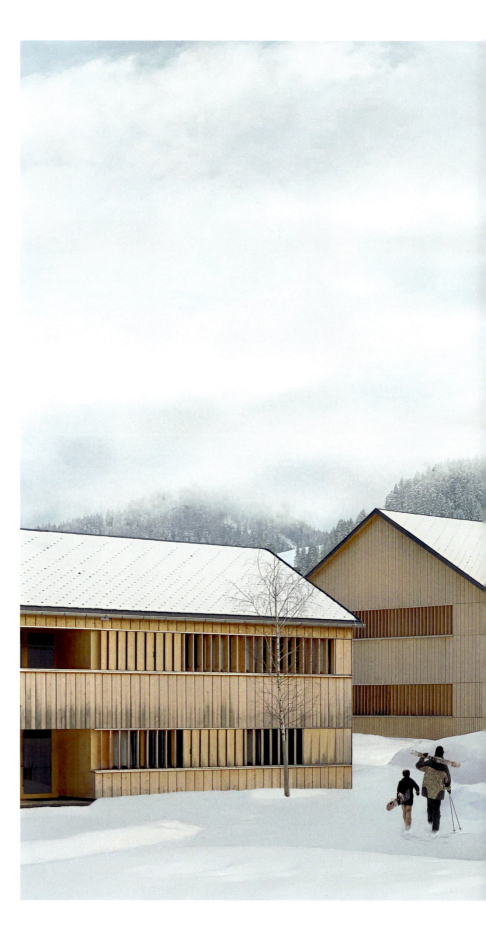

HOSPITALITY PROJECTS

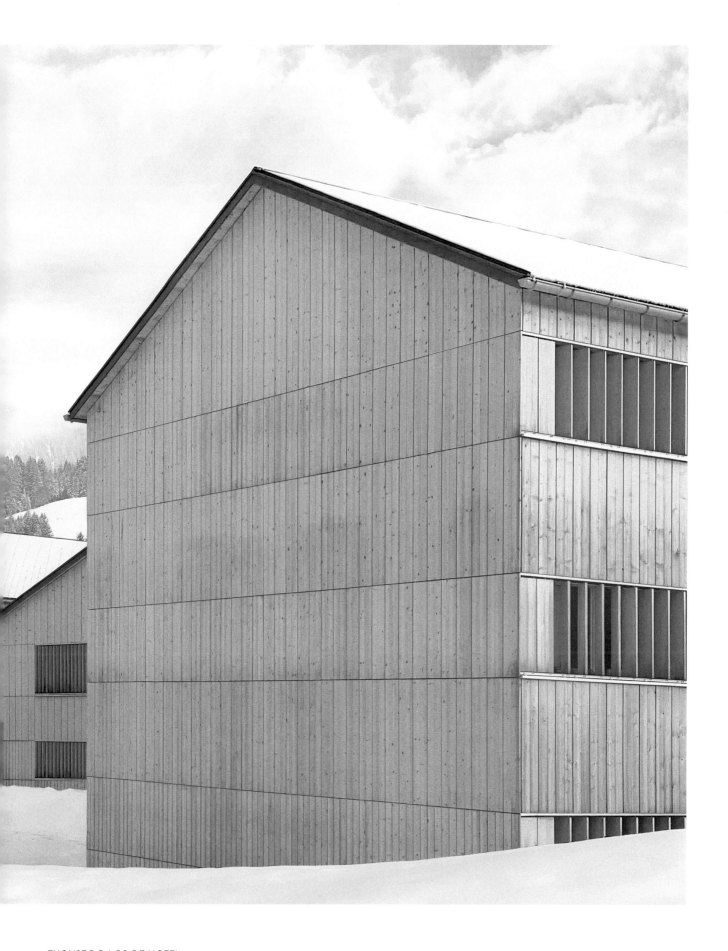

FUCHSEGG LODGE HOTEL

ZEN WELLNESS SEINEI

AWAJI, HYOGO, JAPAN, 2022 // SHIGERU BAN

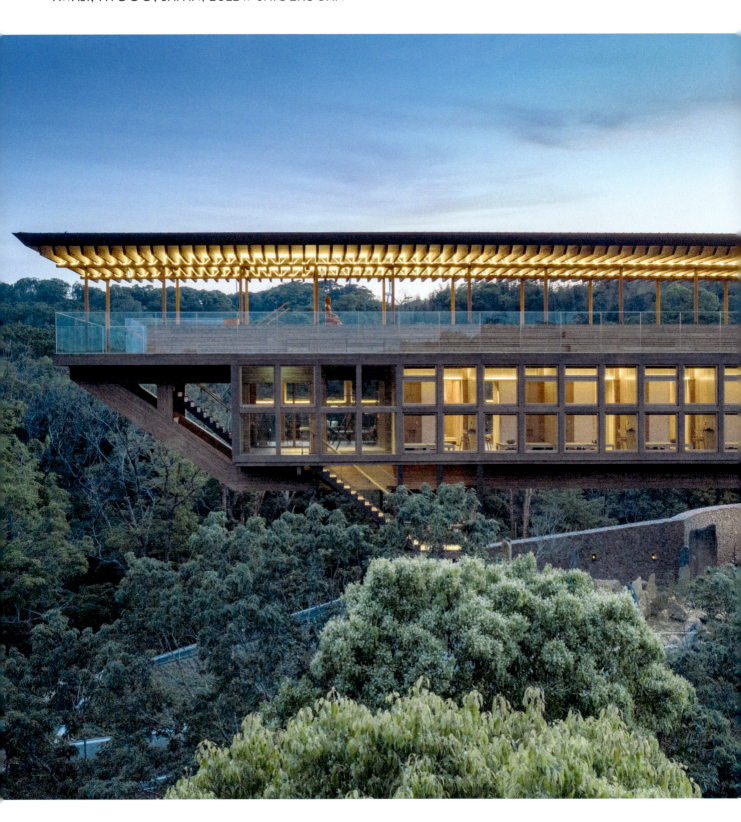

HOSPITALITY PROJECTS

To envision this poetic structure stretching out into a wooded slope, Shigeru Ban asked himself a question, "What kind of space should we create to 'perform meditation in the air'?" The result is a transparent timber structure partly suspended above the ground.

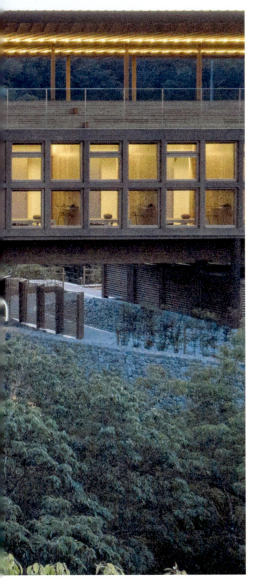

Located in the north of Awaji Island, the ZEN Wellness SEINEI sits on a steep slope over densely wooden surroundings. A spot like this, perfect for meditation, required an equally perfect architectural solution. "Although the site was a rough slope, it was a wonderful place to hear the singing of various birds, surrounded by thick trees," reflects the Pritzker-prize laureate, Japanese architect Shigeru Ban. His signature use of timber in architecture also marks this exceptional project. Ban's goal was to reverse the traditional relationship between people and trees, which are usually seen from below. By creating this lightweight structure reaching out to the greenery of the surroundings, the architect offers the visitors of ZEN Wellness unique experience of being immersed in the crowns of the trees and the sounds of birds. The first floor, based on a linear timber-framed 81-metre-long tube supported minimally on two steel grid-framed pillars, houses cosy private rooms and a canteen.

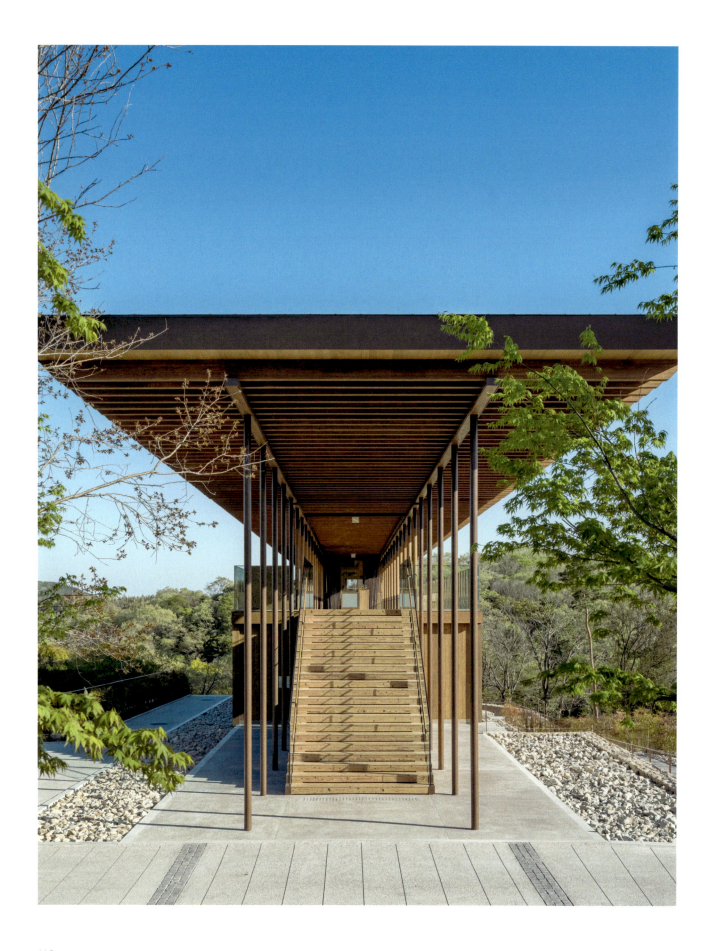

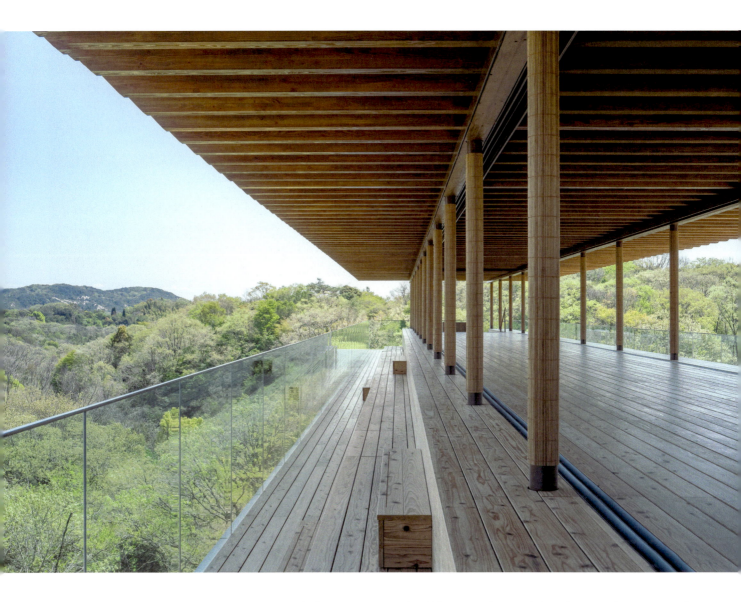

The challenging topography of the steep slope and densely wooded area created an exceptional environment for the lightweight timber structure. With its natural feel and semi-transparent character, it transfers the visitors of the ZEN Wellness SEINEI directly into nature.

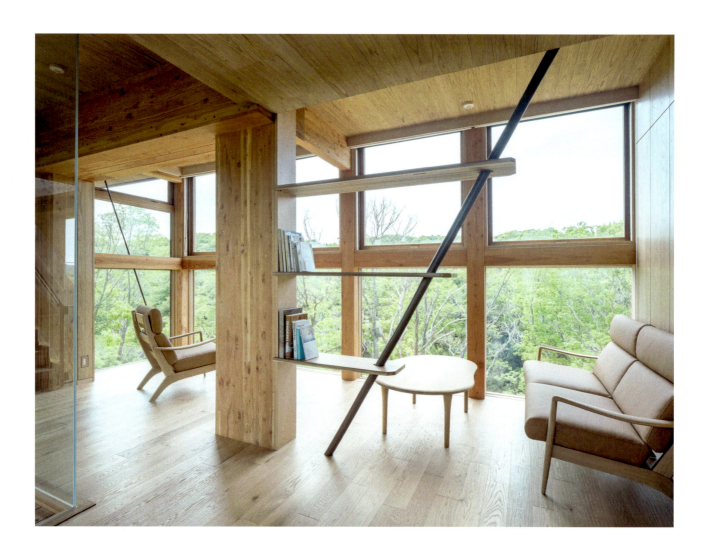

"The one-floor-high timber Vierendeel truss spans 21 m, and the end of the truss was cantilevered 12 m in order to reduce the stress of the long span," explains the studio. The top level is envisioned as an extensive and entirely open yet roofed outdoor deck for zazen (sitting meditation) and yoga. With a stepped down structure on the side and glass railing, this extensive space allows visitors to plunge into the calmness and greenness of the Awaji island landscape. The architect carefully scaled each detail, including the handrails along the perimeter, so that it would not obstruct the view for people seated on the floor. At the core of this vision was to make the building disappear. The extensive roof is supported by 12 cm diameter steel columns and thus cantilevered from the floor.

The structure is made of glulam beams of 105 x 300 mm at a pitch of 500 mm running orthogonally to the girder direction, which are arranged across the roof to function as rafters. "Normally, joists are set on top of larger beams running orthogonally, but inserting a large beam here would disrupt the spatial continuity of the interior and exterior," explains the architect. Here the small beams act as the struts to form an open truss, "together with top and bottom chords of minimal steel I-sections laid on

All interiors, both individual rooms and common spaces, are enveloped in wood. The material's warm and natural colour as well as soft texture create a cocooning atmosphere that relates well with the natural context created inside by the fully glazed walls.

their side, and diagonally inserted steel flat bars. The trusses, each spanning 3 m, avoided the need for large beams and made it possible to visually erase the structure," adds Ban. Due to the exposure created by the location at the top of a slope, the contrast between the architectural structure and unspoilt landscape is quite distinct yet softened by the masterful use of timber. Through perfect proportions between the open and glazed spaces, the structure creates a visual harmony with the site's natural beauty.

COMMERCIAL & OFFICE SPACES

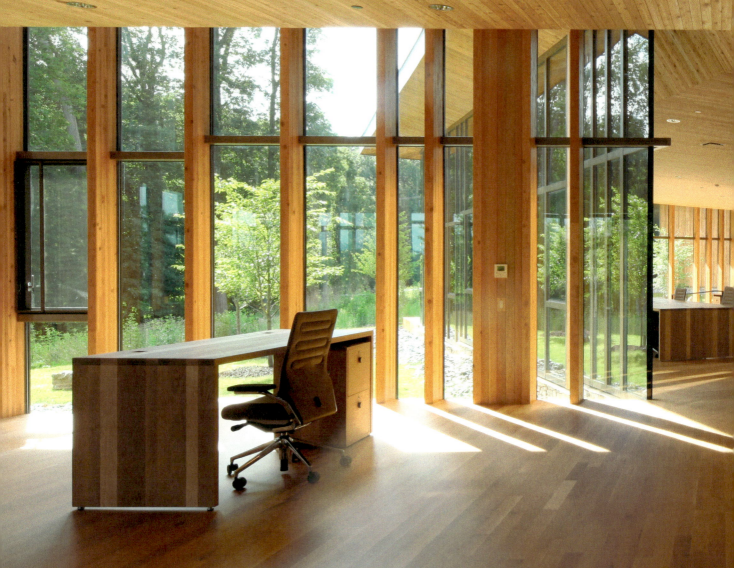

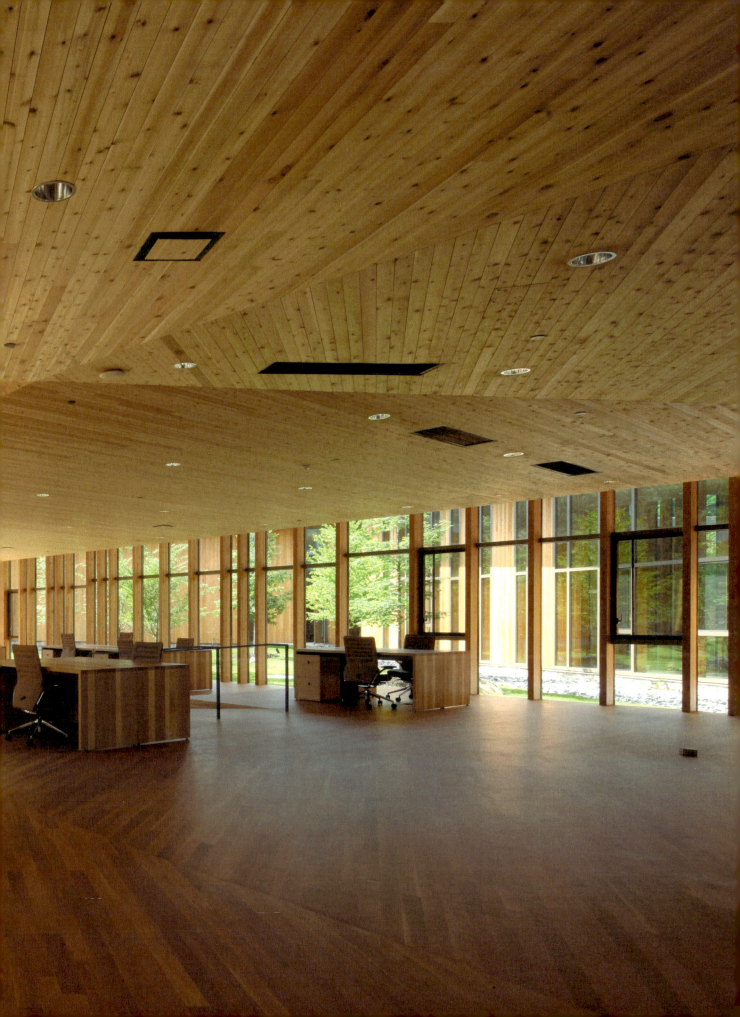

THE FINANCIAL PARK

BJERGSTED, STAVANGER, NORWAY, 2019 // HELEN & HARD

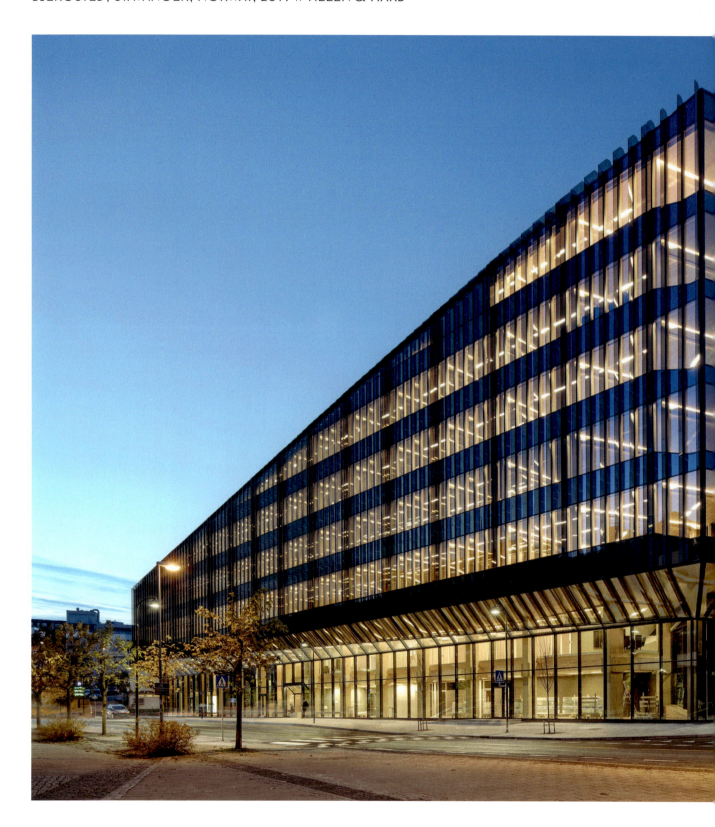

This innovative office was not only intended to be a healthy workspace, built so that the structure made of timber would also provoke a unique spatial and aesthetic experience. The architects also aimed to reduce the carbon emissions of the building process.

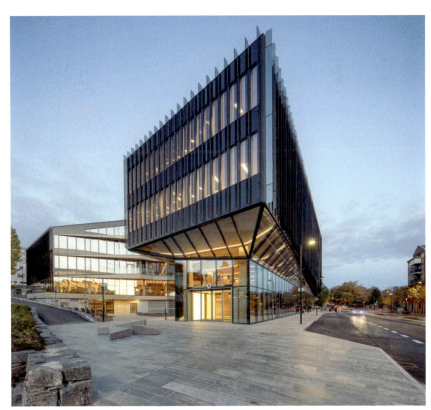

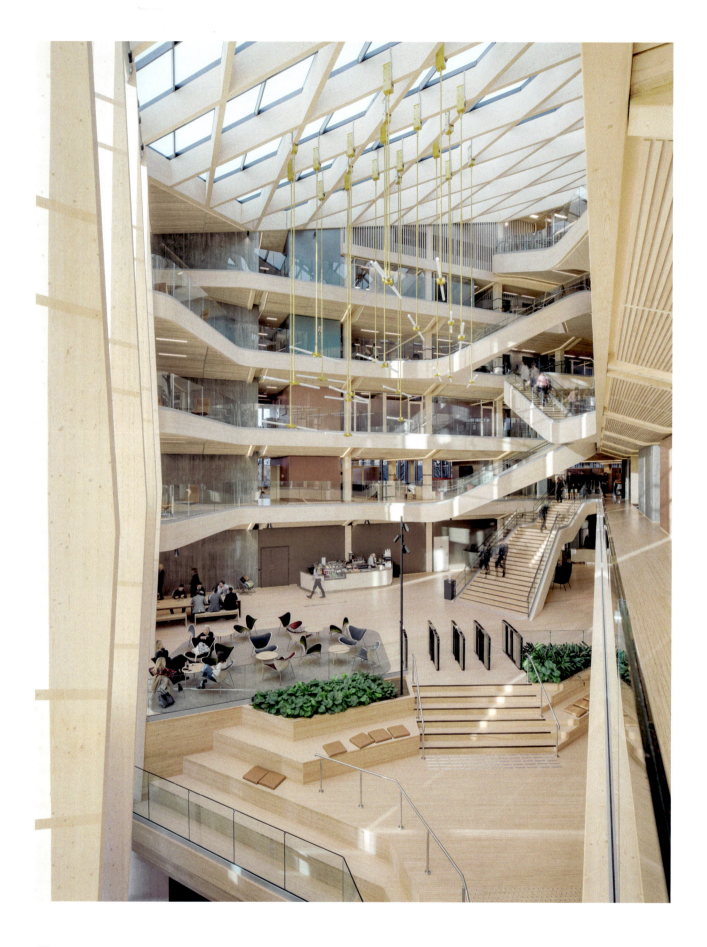

COMMERCIAL & OFFICE SPACES

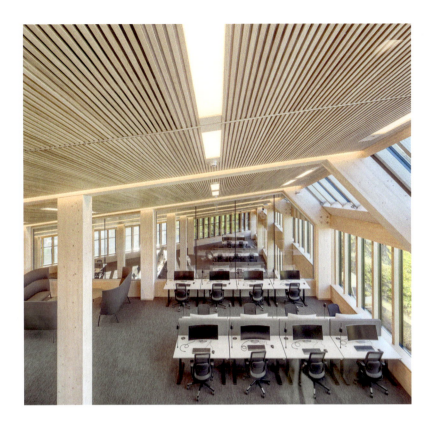

The focal point of the atrium is the staircase that meanders in two directions, with load-bearing stair stringers that support an open stair cantilevering five metres into the space. Quiet workplaces are located along the exterior façades of the building.

Realised by Helen & Hard architects in collaboration with the Oslo-based architectural studio SAAHA, the Financial Park building is far more than the new headquarters of a Norwegian bank. It may be the perfect case study for a modern way of thinking about creating workplaces. Made of natural material, with all-wooden construction, it creates a healthy and inspiring environment in a most striking way. The spatial arrangement of the triangular volume is proof that the architects do not know any limits in working with timber construction. As it sits on a corner plot next to some small wooden houses, it was important to scale the building to set it perfectly into this urban context without overshadowing the surrounding pre-existing architecture. The tectonic structure is visually striking from the first street view, as the architects decided to envelop it with a transparent glass outer shell. This creates an interesting contrast with the organic wooden interior, which is emphasised by the vertical glass fins for solar shading that are arranged along the whole lengths of the façades. At the same time, this solution entirely displays the skeleton as well as the interiors. While passersby can look inside the building, the office occupants have an unobstructed view of the neighbourhood. "The laminated beech girders and the timber joinery details are left exposed and expressed," note the architects. They conclude that "the narrative of how the building is made is clearly readable and celebrated." This combination of materials also adds lightness, both of which perfectly suit the warm and organic internal spaces, which look particularly striking after dark when the building is lit from inside.

THE FINANCIAL PARK

The undisputed centre of the Financial Park building is its spatially stunning atrium. It is encompassed between large glass walls and an effectively twisted staircase that is curved in two directions and cantilevers five metres into the space, thanks to a special system of load-bearing stair stringers. Additionally topped with a skylight, this large meeting space is airy and bright, which enhances its organic shape and reveals the structural, and very plastic, qualities of timber. The communication has been organised around this spectacular atrium as well with stems and flows through this central space. The staircase itself leads people from the entrance hall up to the seven floors above. While gathering places are located towards the atrium, smaller offices and workplaces have been planned along the façades, developing gradually in height along the two streets. All spaces received generous access to natural light, as there are practically no walls. Behind the rhythmic structure of the wooden beams, there are extensive openings that, especially on the higher levels, offer views of the greenery and nearby bay. From the interior perspective, the building is an ode to timber, placing the innovative and sustainable structure in the foreground. Its exposed elements, while functional, are also decorative, in the most natural way. Whether in the large meeting areas or more intimate workplaces, the interiors create a healthy and inspiring space that feels quite atmospheric.

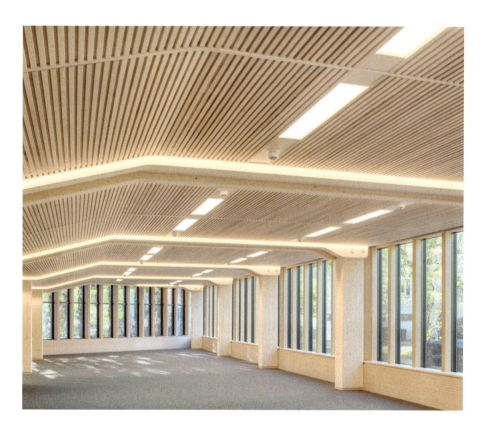

Laminated beech was selected for the ground floor columns and beams, while the rest of the structure is made of glue-laminated and cross-laminated timber (CLT) in spruce. "The timber structure is stiffened by the four stair-shafts, a continuous edge beam in laminated beech veneer along the façade on each floor and the CLT floor slabs," explains the studio.

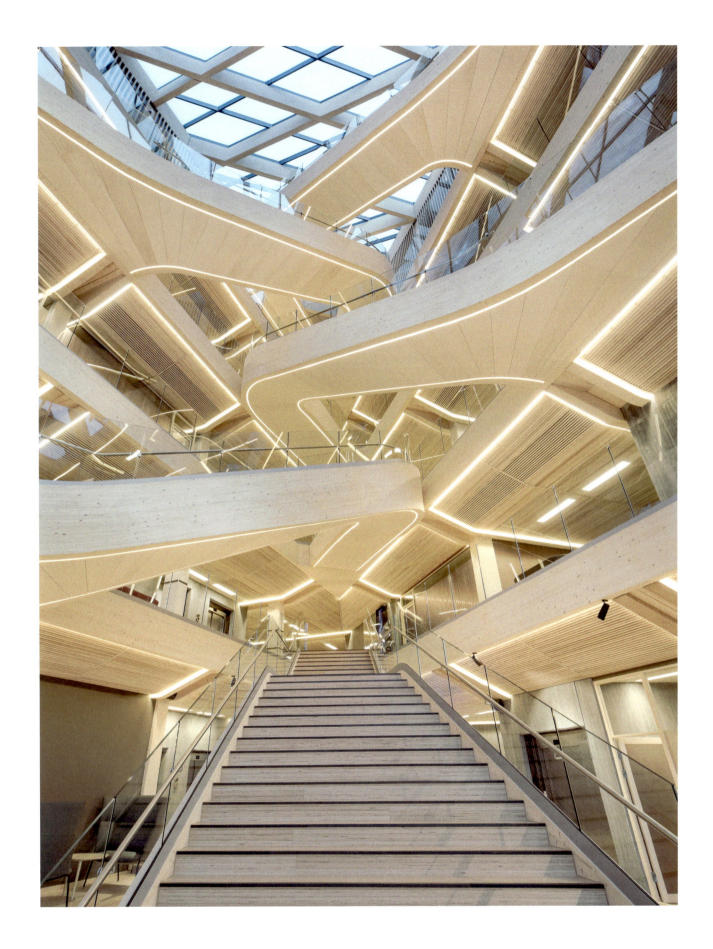

THE FINANCIAL PARK

6 ORSMAN ROAD

LONDON, UNITED KINGDOM, 2021 // WAUGH THISTLETON ARCHITECTS

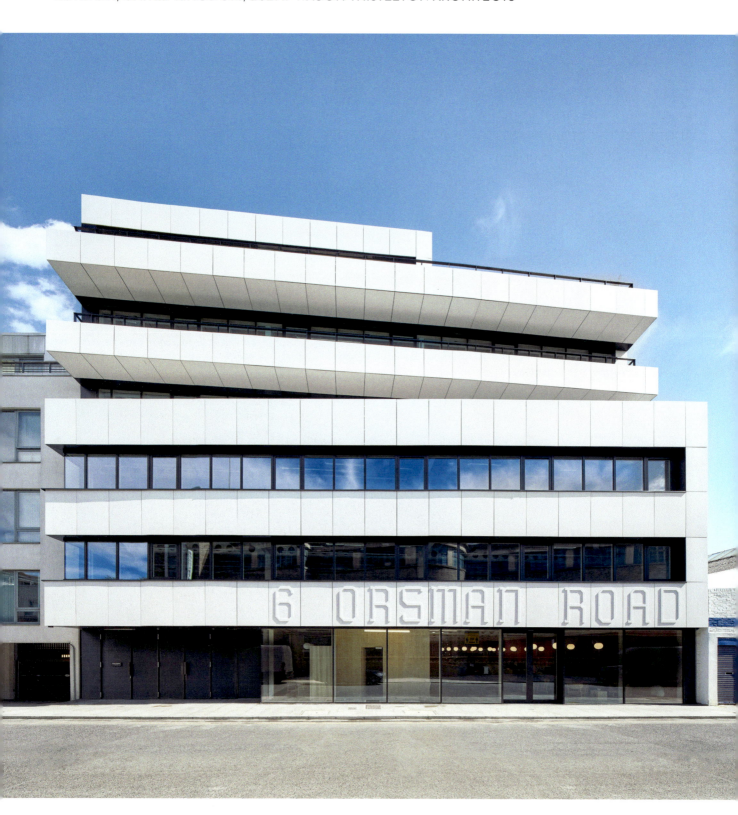

In designing one of the latest office buildings sitting on the Regent's Canal, Waugh Thistleton Architects followed three principles: reduce, reuse, and recycle. Thanks to the highly innovative and hybrid structure, the interiors are completely flexible.

For Waugh Thistleton, sustainability means longevity and architecture that can withstand change as well as demand. The interiors of Orsman Road are entirely flexible and can be re-configured, easily adapting to changing office model requirements.

The idea was to create an entirely flexible interior that can be arranged freely and is easily dividable into a common space for team meetings and more quiet workspaces. The architects decided to use a hybrid structure of cross-laminated timber (CLT) and steel to remove the need for columns. The lack of load-bearing walls as well as the system of demountable partitions allows for quick reconfigurations according to current tenant requirements. "The high performing ventilation system, opening windows, and balcony doors ensure individuals have a high level of control over their workspace, and the ability to curate it to meet their needs," note the architects. The top part of the six-storey volume creates large terraces with a view of the city towards the south. On this facade, the windows are deep-set and thus minimise solar gain. The structure, clad with white panels as a reference to the Bauhaus aesthetics, has been designed so that the whole building can be ultimately demounted and repurposed. A zero-waste policy was at the core of the design. "Every element of the construction has been considered to ensure as much as possible can be reused or recycled once the building reaches the end of its useful life," emphasises the studio.

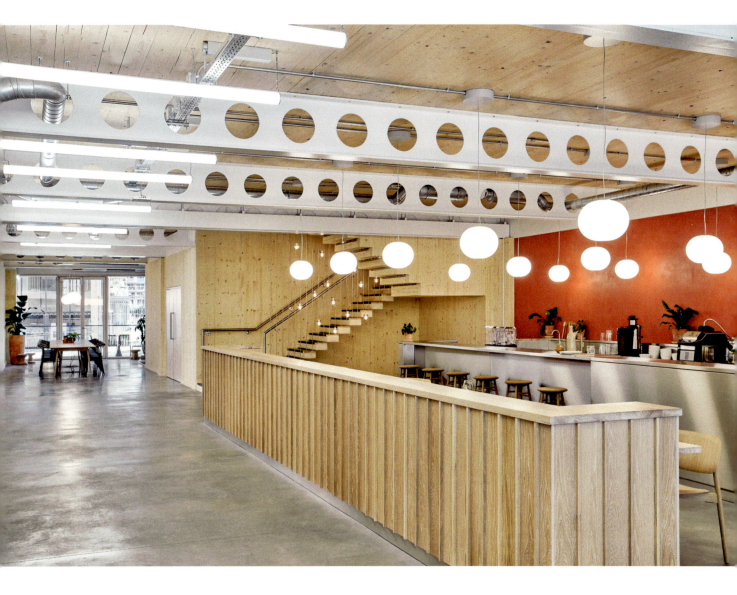

The sustainable construction process included the impressive fact that offcuts from the CLT (cross-laminated timber) structure were used to make furniture for the interiors.

6 ORSMAN ROAD

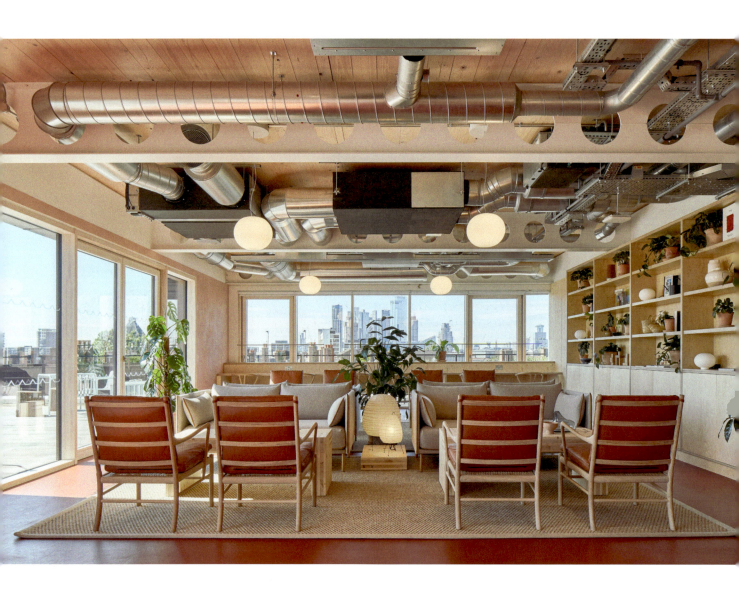

A warm and welcoming atmosphere is created with the combination of a soft and natural colour palette and carefully selected materials that complement the leading one — timber, which also symbolically reconnects the office users with nature.

The exposed CLT structure is not the only natural material used in the building. Clay plaster finishes and linoleum tiles are harmonious with the earthy tones of the wooden interior, which make it very pleasant to work in. The play of textures also participates in this comforting visual effect. All elements fit together so smoothly, which is highlighted by the natural light let in through the large windows (the canal façade is fully glazed). The open spaces on all levels are additionally filled with numerous green plants, which makes 6 Orsman Road a healthy and inspiring working environment.

The way the building affects those using it and their comfort was an important aspect of the project, as the idea was to create a productive atmosphere. The architects also achieved this through working with professional acousticians to prevent discomforting noise. While some areas are dedicated to collaborative work, including the lounge and the café, in many workspaces acoustic panels have been installed to absorb sound. Last but not least, the architects' mission of sustainability and facilitating well-being is continued on the roof. While photovoltaic cells provide a renewable energy source, office users can also relax on the large rooftop terrace, which has been turned into a sensational biodiverse space with a brown roof, insect boxes, and edible plants, as well as fruit trees.

The interiors are spacious and largely open yet offer numerous possibilities for any kind of work mode.

CATALYST BUILDING

SPOKANE, WA, USA, 2020 // MGA | MICHAEL GREEN ARCHITECTURE

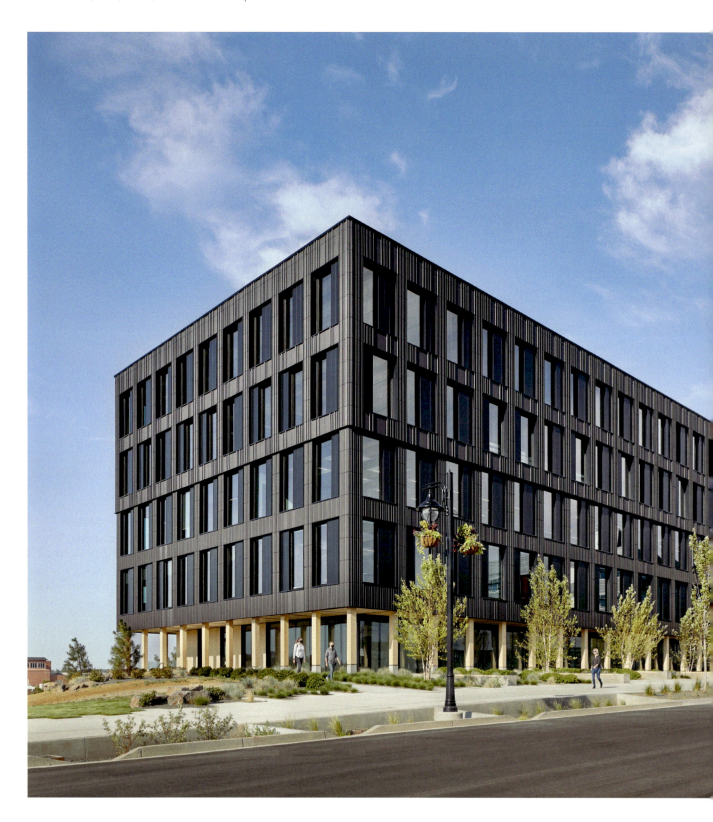

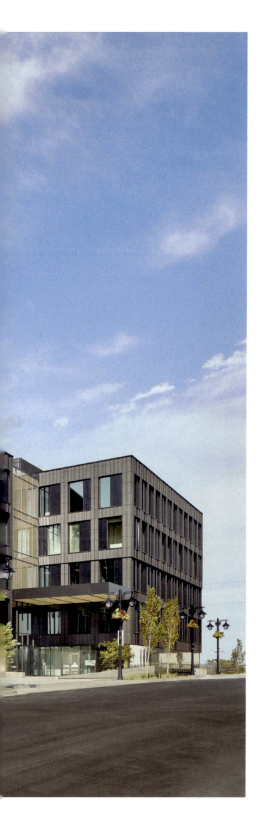

Constructed in the South Landing Eco-District, a new highly sustainable part of Spokane, Washington, the Catalyst Building is setting ecological trends and is a perfect expression of the ambitious programme.

Housing offices, classrooms, a common study area, and an Innovation Lab, as well as acting as a headquarters for Eastern Washington University's Science, Technology, Engineering and Mathematics programmes, the building was envisioned as a multi-functional laboratory for new sustainability technologies, materials, construction techniques, and design. As such, the architectural concept had to reflect all these ambitions. Michael Green Architecture aimed to design a mass timber building that could exceed the performance of a comparable steel or concrete construction. The final result demonstrates all possible benefits of the CLT structure including the aesthetics, the building's efficiency, and its environmental impact. Based on a Life Cycle Assessment (LCA) of the building created by the Carbon Leadership Forum at the University of Washington, the architects stress the importance of using lower-carbon materials not only for energy usage benefits but also due to the total carbon emissions over a building's lifecycle. "This project proves that sustainable development outcomes and new construction methods can coexist with more traditional metrics for affordability, operational efficiency, and tenant comfort," they conclude. For the Catalyst Building they used over 4,000 cubic metres of CLT and glulam product, which as the studio states have stored 3,713 metric tonnes of carbon dioxide, effectively meaning that the carbon storage of the timber is close to offsetting the embodied carbon impact of the construction. To maintain the high sustainability standards of the project, the CLT panels for the structure were sourced from local forests, using ecological harvesting practices, and also manufactured in close proximity to the site.

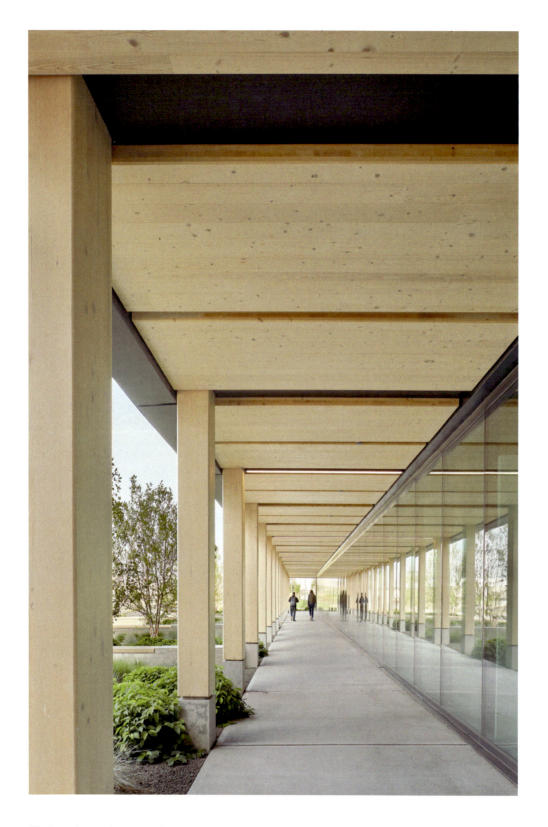

"By focusing on lower-carbon materials, the conversation around sustainability in the built environment can broaden from only energy usage to total carbon emissions over a building's lifecycle," state the architects.

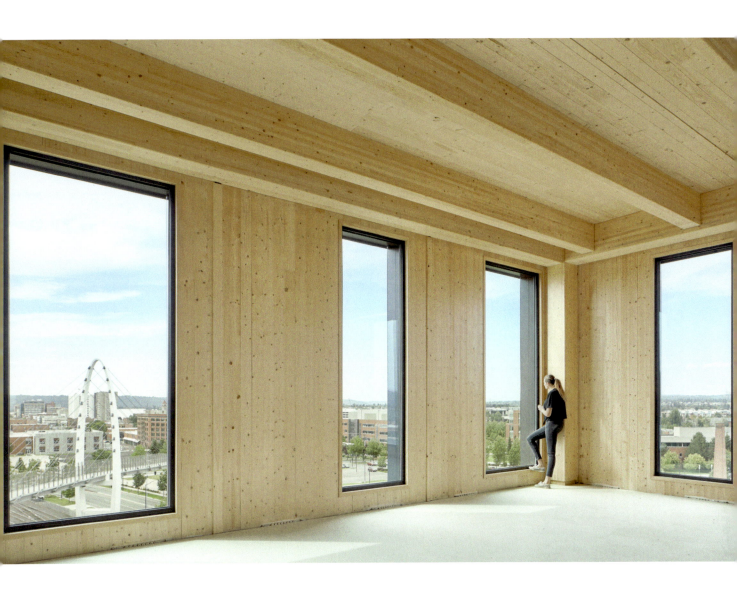

Located on an irregular site, the building has been connected to the University District with the Gateway Bridge, a pedestrian passage. The layout of the floor plates is simple to meet the complex programme requirements and to offer flexibility both for academic multi-functional use and as an office space. The Catalyst Building smoothly combines industry and academia as a platform for innovative collaboration, yet also demonstrates how a combination of new construction methods and a sustainable approach can be affordable, operate efficiently, and, last but not least, be comfortable for tenants.

As an exemplary realization for Spokane's new South Landing Eco-District, the hub is a trendsetter for sustainable strategies, which in addition to the effective use of timber also concern rainwater capture, reducing water use, and drawing energy from a centralised energy plant for the whole eco-district. It is also worth noting that thanks to the structure design, the performance of the building's airtightness far exceeds the requirements of the Passive House Standard.

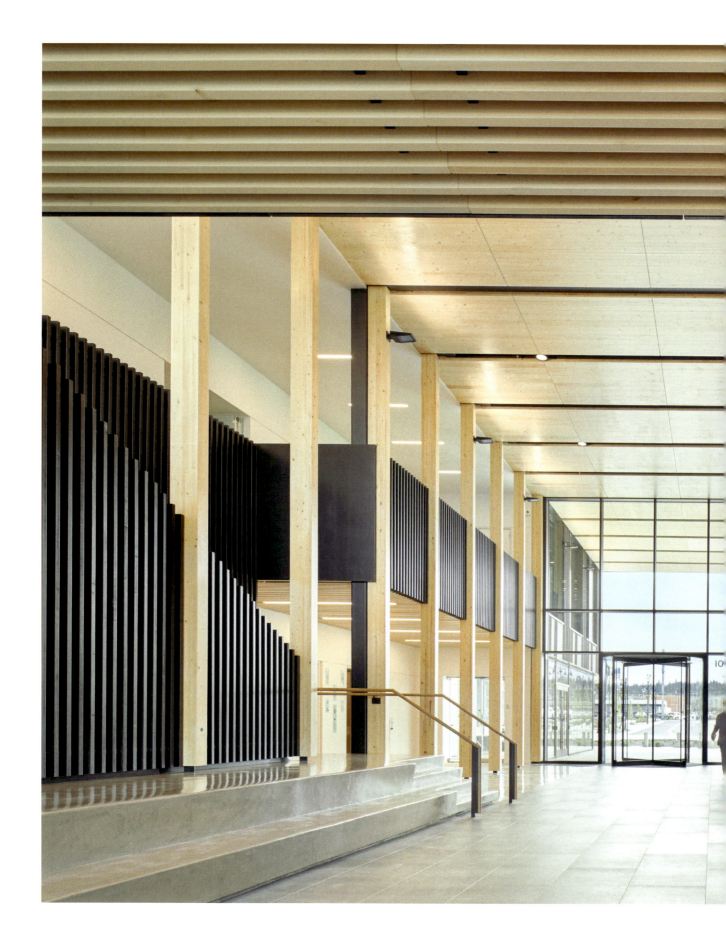

COMMERCIAL & OFFICE SPACES

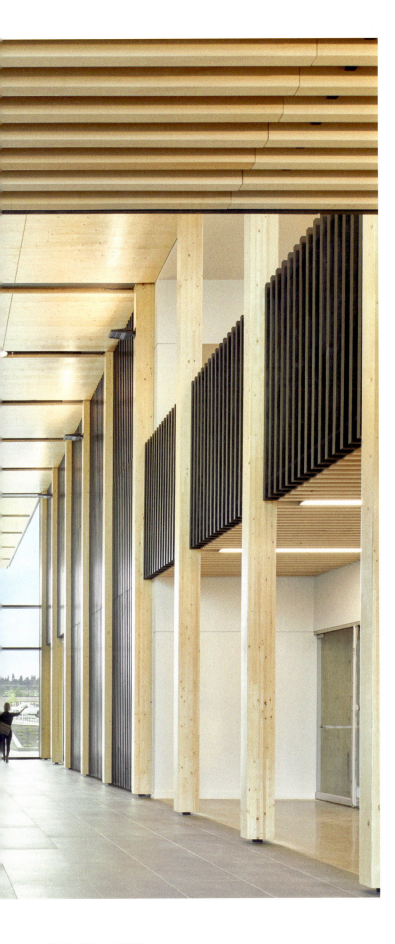

While the façade has been elegantly blackened, the interiors are defined by the exposed wooden structure in its natural colour, with the two hues intertwined in the spacious entrance hall.

CATALYST BUILDING

TE WHARE NUI O TUTEATA, THE SCION INNOVATION HUB

ROTORUA, NEW ZEALAND, 2021 // RTA STUDIO + IRVING SMITH ARCHITECTS

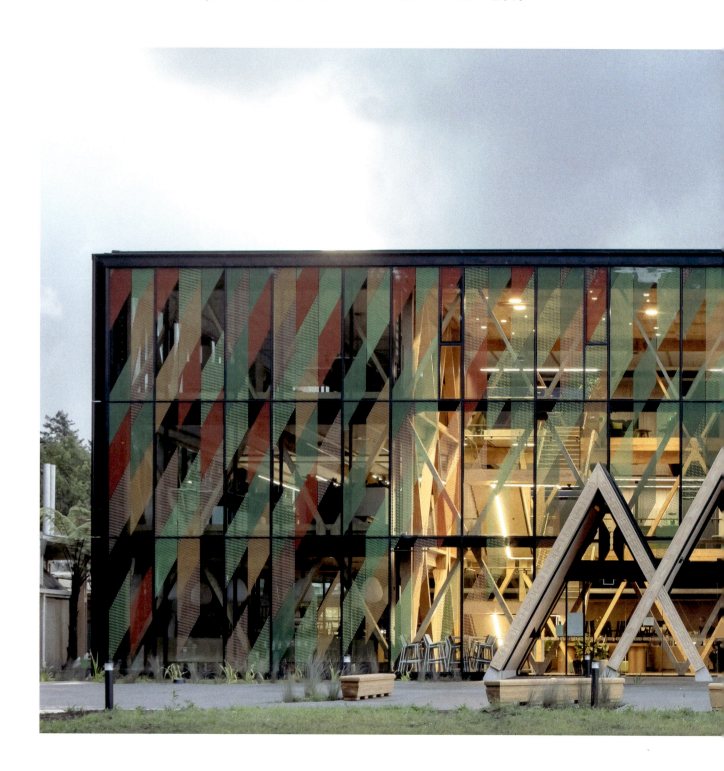

The SCION Innovation Hub achieved embodied carbon zero at the time of its completion. The expert use of timber in combination with its innovative ventilation and low energy solutions make it a truly sustainable building.

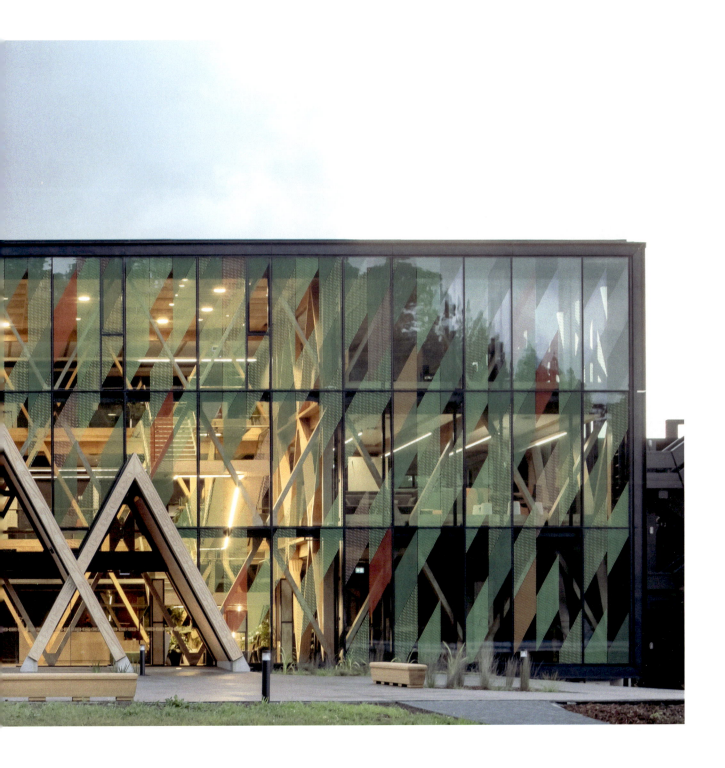

A building designed as the new headquarters of SCION, a New Zealand research institute specialising in technology development for the forestry industry, required a particularly complex approach. It was intended not only to be innovative and sustainable but also to showcase timber technology, exhibit Scion's work, and engage with the forest. These ambitious goals have been accomplished by two architectural practices — RTA Studio and Irving Smith Architects — in this ultra-innovative hub. Part of the transformation of an existing campus with numerous smaller buildings, the new building, centrally located, forms a signature new entrance to the complex sitting on the edge of a Redwoods forest. As the architects stress, "the Hub reveals itself to emerge in prime view as visitors pass through the entry gates," so its volume had to distinctively display all its qualities. Through a glass envelope, the three-storey volume reviews the structural skeleton of the building made of a diagrid of high-performing Laminated Veneer Lumber. The striped pattern filtering natural light helps regulate the internal temperatures and refers to a leafy forest. Three triangles made of gluelam timber form an inviting entrance and lead to a triple-height atrium where wood plays the main role. With a café and an exhibition of wood-fibre technology, this is the common public space. Above the atrium, the higher levels offer the more private open-plan office and collaborations spaces that are created with special care for the acoustics. At the top is a striking wooden ceiling that was custom-designed and based on the structure of a Radiata Pine genome. The timber battens and plywood panels it is made of depict the barcoding effect from the tree's DNA. The architects exposed the timber structure to allow the wood's natural qualities to create a warm atmosphere.

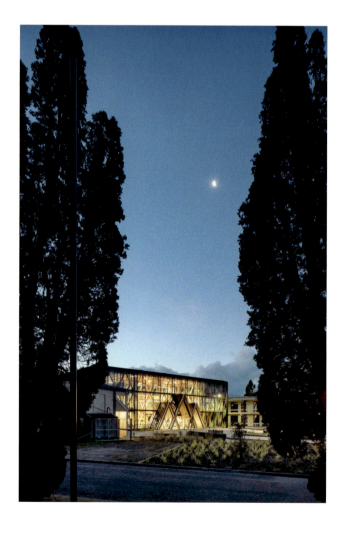

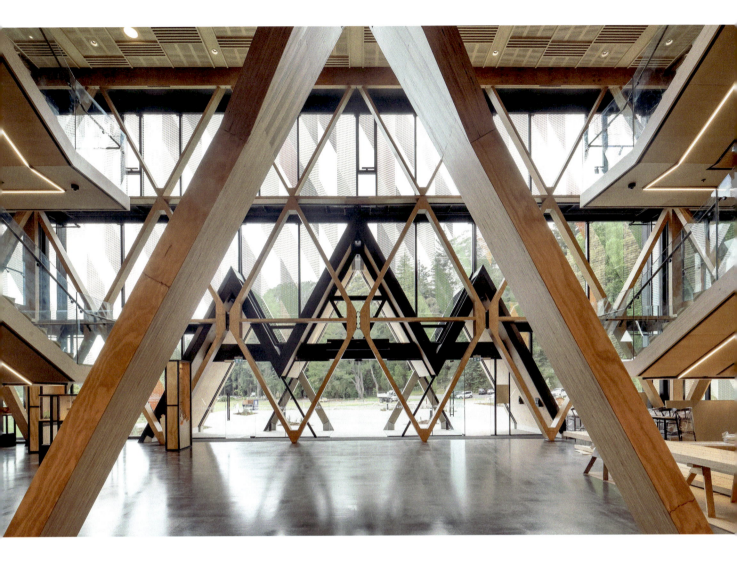

The geometric diagrid executed in wood creates a rhythmic envelope for the building, and as a series of regular components in the form of diamonds and triangles, it also simplified prefabrication and assembly.

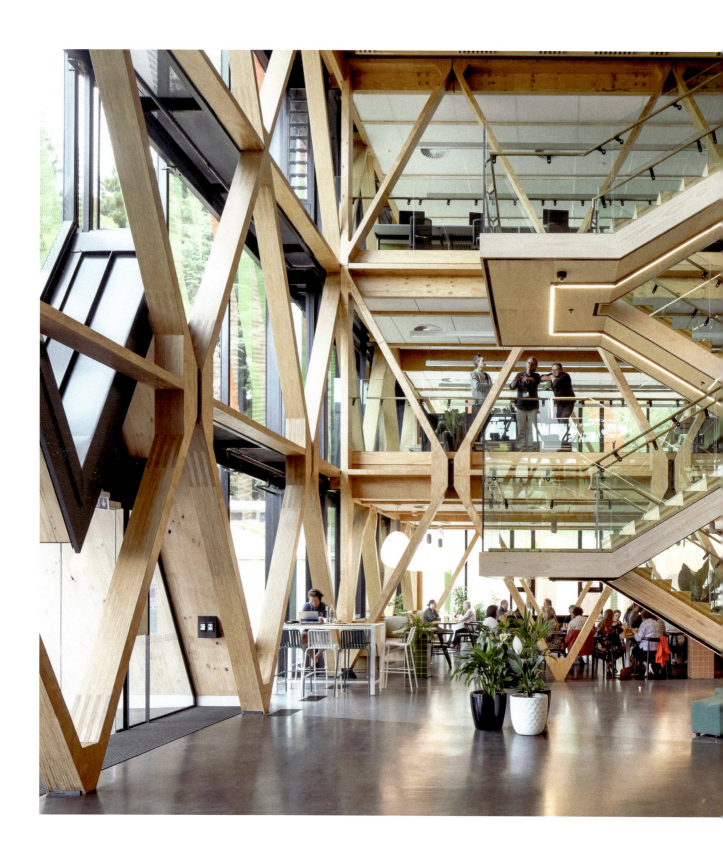

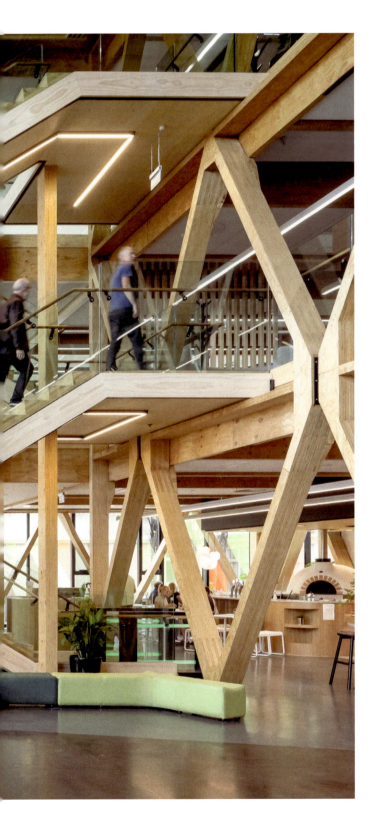

"Extensive prototyping and testing have allowed laminated LVL structural nodes to be used at key junctions," the architects explain. They add that "the structural node transfers loads and holds a seismic fuse to yield and be replaced after an earthquake."

The architects carefully selected timber not merely for its performance qualities but also to create tactile interiors. Locally grown exotic hardwoods like Tasmanian Blackwood, used for the handrails, and Victorian Ash, used for screening elements, were combined with the structural Radiata Pine. Timber components were prefabricated and the structural diagrid assembled from repeated elements, which made fabrication as well as the building process much simpler. The use of lightweight composite cross-laminated timber (CLT) is exposed throughout the structure. One of the most spectacular elements is the cantilevered three-level staircase in the atrium. Wood is also used to create acoustically considered spaces in certain parts of the buildings. It is not only the use of wood that contributes to the building's sustainability. The new SCION headquarters are based on a mixed-mode ventilation system that operates between active and passive modes. "The double skin office wings are used for solar preheating and as a de-stratification path from the triple-height public atrium back to the air handling plant in the winter, with the atrium allowing the ductless supply of outdoor air," the architects explain. Additionally, low-energy lighting and low-water-usage sanitary fittings make the whole building as sustainable as it can be.

SWALES, JST HARRISBURG PRODUCTION ENGINEERING CENTER

HARRISBURG, USA, 2021 // RYUICHI ASHIZAWA ARCHITECT & ASSOCIATES / ARCARI + IOVINO ARCHITECTS

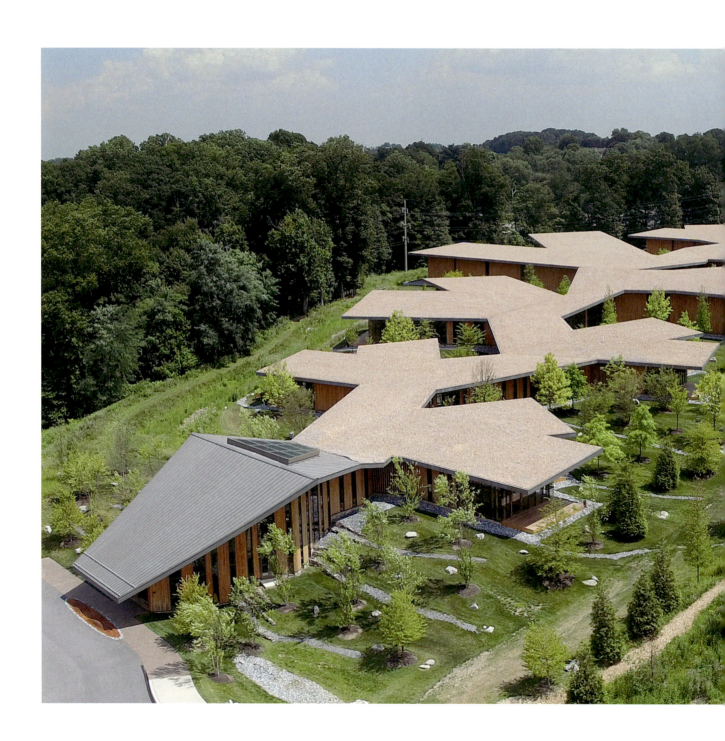

COMMERCIAL & OFFICE SPACES

This branch-shaped volume in an industrial area of Harrisburg, Pennsylvania, is not only a distinctive and original timber building but also a sustainable solution for the local environment with its 14 "swales" located across the site to allow rainwater to penetrate the ground.

The "swales" are deep grooves dug along the contour lines that the architects integrated into the branch-like building, which occupies a site overlooking the Appalachian Mountains. In this project, they demonstrate how architecture can become a component of water circulation by allowing rainwater from the roof to be distributed to the ground on site through the swales. They catch the water that flows over the sloped surface and retain it in the surrounding soil, where it is collected by the plant roots and seeps into the earth. The result of this unorthodox solution was immediately visible — "by moistening the land with 'swales', the trees have begun to grow [creating a] spontaneous transition to the forest where various creates started living," comment the architects. They refer to it as a "design that heals the environment through the soil."
This philosophy also demonstrates a Japanese sense of harmony with which the client wished to inform the project.

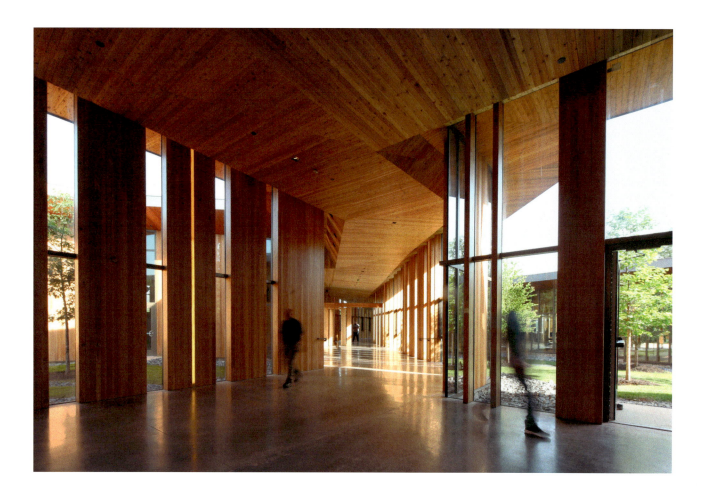

The zigzagging shape of the roof not only defines the outer character of the building but also determines the dynamic space in the interior, be it in the open-plan workspaces or the corridors joining various parts of the volume.

Another essential aspect was the interaction between the architecture and the surrounding nature. The complex shape evoking the structure of a branch is adjusted to the topography of the slightly sloping terrain on the one hand, and enables an equal distribution of the swales on the other. "By maximizing the exposed outer wall area with a branched plan, we increased the points of contact between the interior and exterior, enabling people to feel the natural breeze, light and movement of water, and relate to the dynamic scenery of the garden which is subjected to seasonal change," explain the architects. Various types of plants and trees were planted on the irregular greenery spots between the "branches" of the irregular volume. To create a visual harmony between the building and the context, the architects used local timber species for both the interior and exterior.

The shape is also configured to use mainly natural energy and to limit the need for electricity to the absolute minimum according to the passive design rules; the architects carried out numerous simulations to plan the most optimal way of incorporating light, heat gain, air, and rainwater into the layout. The structure of the building is entirely wooden and based on a relatively simple frame made of columns and beams as a reference to the forest. The volume is divided into a workshop space, with a structural arrangement of tree-like columns and strategically placed openings, and an office area envisioned as a continuous and open space. The denser use of pillars in the workshop wings keeps the structural balance and enables the connection between the users of the building and the natural surroundings. A generously glazed outer shell envelops the office wings on all sides, filling the workspaces with abundant natural light. As a result, this unusual office building creates a healthy environment, offering physical wellbeing for its users.

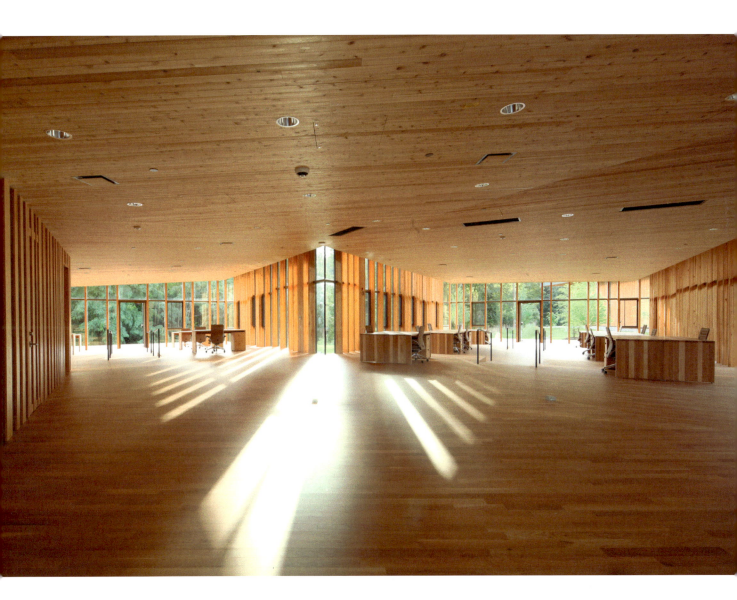

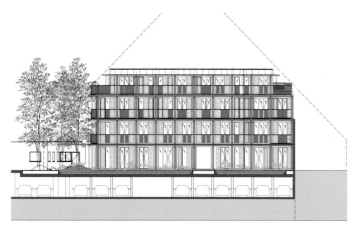
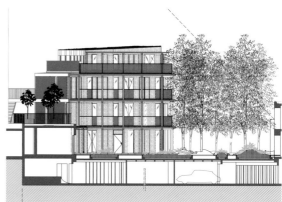

Façades

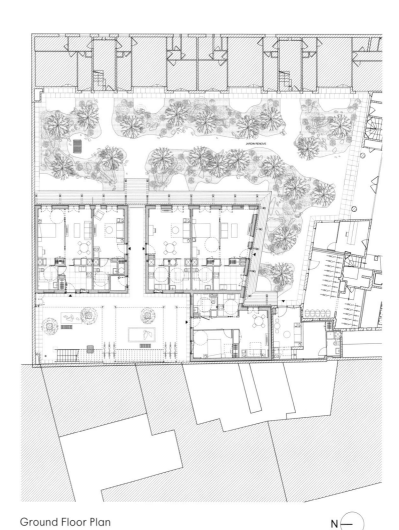

Ground Floor Plan N

14 LOGEMENTS HOUSING COMPLEX (pp.16-21)

ARCHITECT(S): **Mars Architectes**
LOCATION: **Paris, France**
COMPLETION: **2020**
FLOOR AREA: **716 m^2**
WOOD: **European douglas fir**

VILLA VUGHT (pp.22–27)

ARCHITECT(S): **Mecanoo**
LOCATION: **Vught, The Netherlands**
COMPLETION: **2019**
FLOOR AREA: **638 m²**
WOOD: **Cross Laminated Timber, European silver fir**

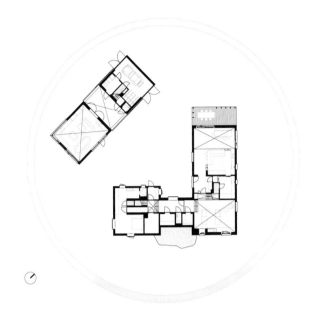

Ground Floor Plan

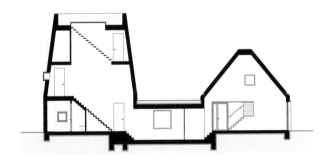

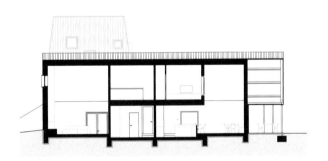

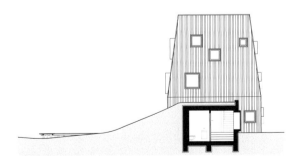

Sections Villa

Plans

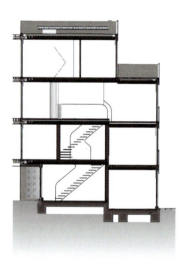
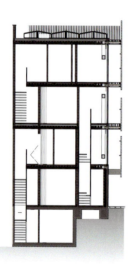

Sections

FREEBOOTER (pp.28-33)

ARCHITECT(S): **GG-Loop**
LOCATION: **Amsterdam, The Netherlands**
COMPLETION: **2019**
FLOOR AREA: **240 m^2**
WOOD: **Cross Laminated Timber**

Sketch

200 ANNEX

MTR (pp.34-39)

ARCHITECT(S): **Alain Carle Architecte**
LOCATION: **Mont-Tremblant, Québec, Canada**
COMPLETION: **2020**
FLOOR AREA: **605 m²**
WOOD: **Pine, Cedar**

First Floor Plan

Ground Floor Plan

Roof Deck Plan

First Floor Plan

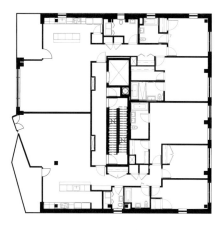

Fifth Floor Plan

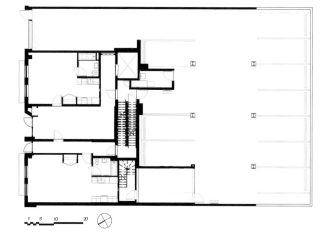

Ground Floor Plan

TIMBER HOUSE 670 UNION STREET (pp.40-43)

ARCHITECT(S): **Mesh Architectures**
LOCATION: **Brooklyn, NY, USA**
COMPLETION: **2022**
FLOOR AREA: **2,230 m^2**
WOOD: **Mass timber**

LATHHOUSE (pp.44-49)

ARCHITECT(S): **Birdseye**
LOCATION: **Sagaponack, New York, USA**
COMPLETION: **2020**
FLOOR AREA: **810 m²**
WOOD: **Repurposed fence wood**

Structure

First Floor Plan

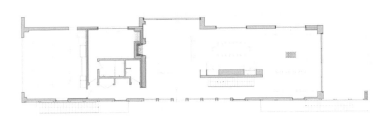

Ground Floor Plan

203

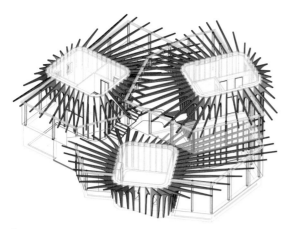

Structure

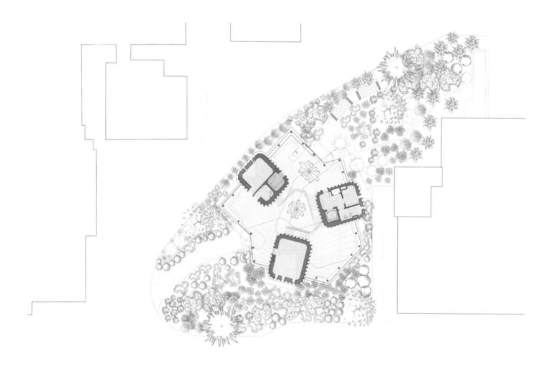

Ground Floor Plan

MAGGIE'S LEEDS CENTRE (pp.52-57)

ARCHITECT(S): **Heatherwick Studio**
LOCATION: **Leeds, United Kingdom**
COMPLETION: **2020**
FLOOR AREA: **462 m²**
WOOD: **Spruce**

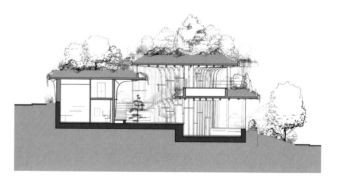

Cross Section

ALTO TÂMEGA TOURIST INFORMATION POINT (pp.58-61)

ARCHITECT(S): **And-Ré Arquitectura**
LOCATION: **Chaves, Portugal**
COMPLETION: **2020**
FLOOR AREA: **100 m²**
WOOD: **Local timber**

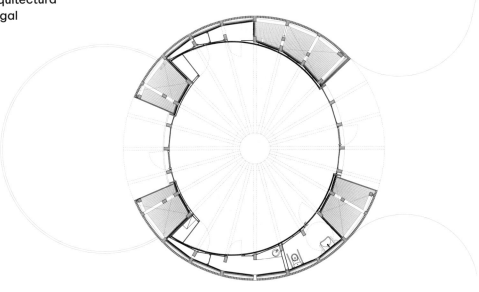

Floor Plan

Sections

Sections

Ground Floor Plan

TAVERNY MEDICAL CENTRE (pp.62-65)

ARCHITECT(S): **Maaj Architectes**
LOCATION: **Taverny, France**
COMPLETION: **2020**
FLOOR AREA: **1,095 m²**
WOOD: **Timber**

MICROLIBRARY WARAK KAYU (pp.66-71)

ARCHITECT(S): **SHAU Indonesia**
LOCATION: **Semarang, Indonesia**
COMPLETION: **2020**
FLOOR AREA: **182 m²**
WOOD: **Bangkirai-based FJL (Finger Joint Laminate), Meranti-based Plywood**

Section

Ground Floor Plan

First Floor Plan

Second Floor Plan

Third Floor Plan

Ground Floor Plan

First Floor Plan

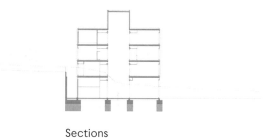

Sections

COMMUNITY LIFE CENTER TRINITAT (pp.72–77)

ARCHITECT(S): **Haz Arquitectura**
LOCATION: **Barcelona, Spain**
COMPLETION: **2021**
FLOOR AREA: **2,300 m²**
WOOD: **Radiata Pine, plywood, Cross Laminated Timber, Larch**

TOHO GAKUEN MUNETSUGU HALL (pp.80-83)

ARCHITECT(S): **Kengo Kuma**
LOCATION: **Tokyo, Japan**
COMPLETION: **2021**
FLOOR AREA: **2,392 m²**
WOOD: **Cross Laminated Cedar and Cypress**

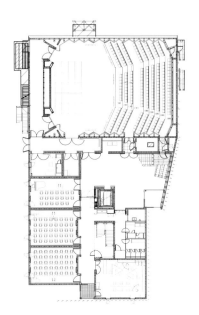

Ground Floor Plan

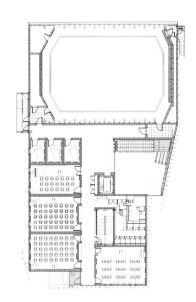

First Floor Plan

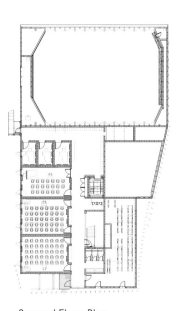

Second Floor Plan

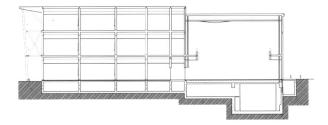
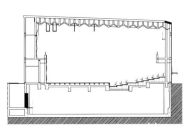

Sections

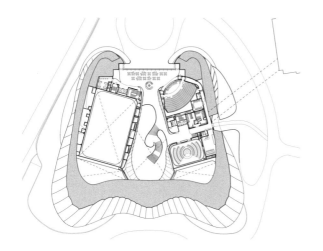
First Floor Plan

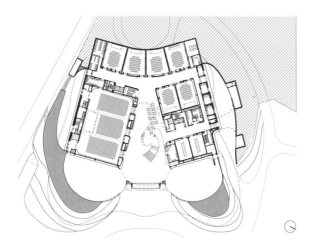
Ground Floor Plan

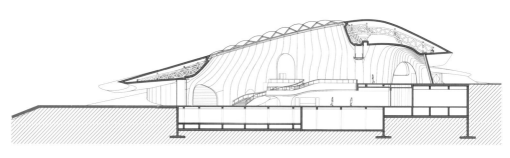
Section

YABULI ENTREPRENEURS' CONGRESS CENTRE (pp.84-89)

ARCHITECT(S): **Mad Architects**
LOCATION: **Yabuli, China**
COMPLETION: **2020**
FLOOR AREA: **16,198 m²**
WOOD: **Timber**

210　　　　　　　　　　　　　　　　　　　　　　　　　　　　　　　　　　　　　ANNEX

SARA CULTURAL CENTRE (pp.90-95)

ARCHITECT(S): **White Arkitekter**
LOCATION: **Skellefteå, Sweden**
COMPLETION: **2021**
FLOOR AREA: **30,000 m^2**
WOOD: **Cross Laminated Timber, Glued Laminated Timber**

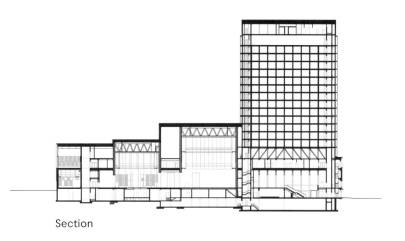
Section

Nineth Floor Plan

Twentieth Floor Plan

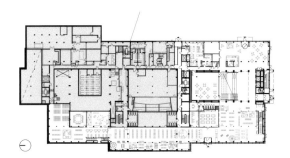
Ground Floor Plan

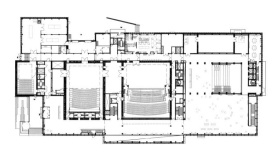
Second Floor Plan

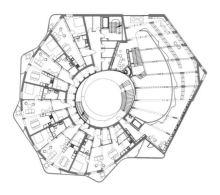

Second Floor Plan

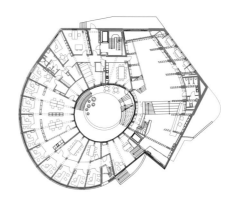

First Floor Plan

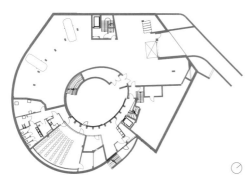

Ground Floor Plan

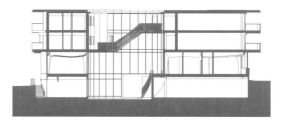

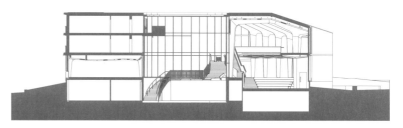

Sections

SAMLING (pp.96–101)

ARCHITECT(S): **Helen & Hard**
LOCATION: **Nord-Odal, Norway**
COMPLETION: **2020**
FLOOR AREA: **3,000 m²**
WOOD: **Selection of local timber**

KITA IM PARK DAYCARE CENTRE (pp.104–109)

ARCHITECT(S): **Birk Heilmeyer und Frenzel Architekten**
LOCATION: **Stuttgart, Germany**
COMPLETION: **2020**
FLOOR AREA: **965 m²**
WOOD: **Structural timber**

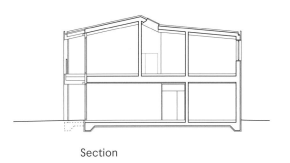

Section

First Floor Plan

Ground Floor Plan

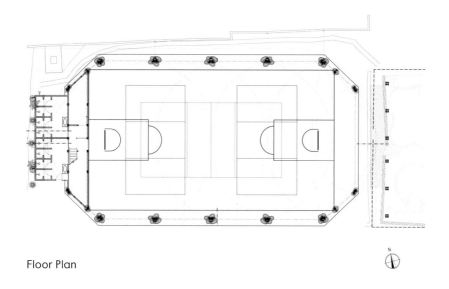

Floor Plan

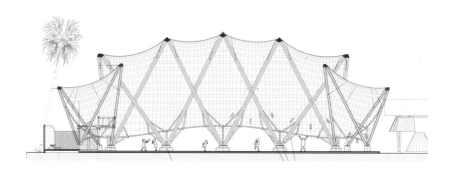

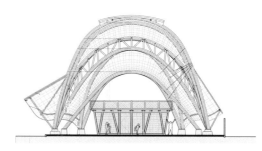

Sections

THE ARC AT GREEN SCHOOL (pp.110–113)

ARCHITECT(S): **IBUKU**
LOCATION: **Bali, Indonesia**
COMPLETION: **2021**
FLOOR AREA: **760 m^2**
WOOD: **Bamboo**

CANTEEN AND MEDIA CENTRE (pp.114–117)

ARCHITECT(S): **wulf architekten**
LOCATION: **Darmstadt, Germany**
COMPLETION: **2021**
FLOOR AREA: **3,530 m²**
WOOD: **Glulam beams**

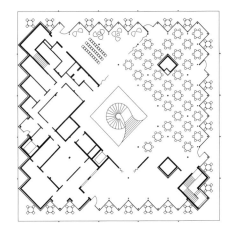

First Floor Plan

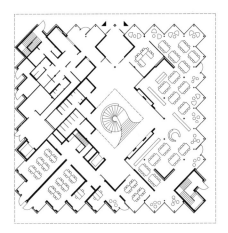

Ground Floor Plan

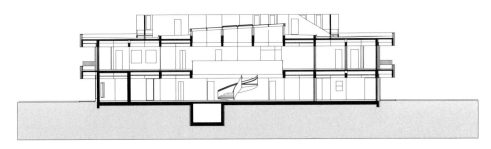

Section

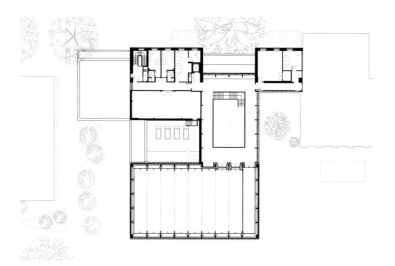

First Floor Plan

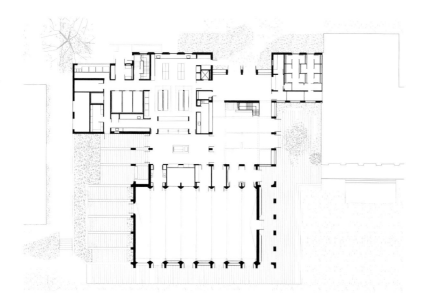

Ground Floor Plan

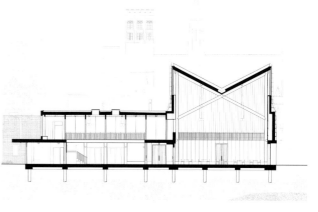

Section

HOMERTON COLLEGE DINING HALL (pp.118–121)

ARCHITECT(S): **Feilden Fowles**
LOCATION: **Cambridge, United Kingdom**
COMPLETION: **2022**
FLOOR AREA: **1,665 m^2**
WOOD: **Sweet Chestnut glulam timber frame**

THE ARIAKE GYMNASTICS CENTRE (pp.122–127)

ARCHITECT(S): **Nikken Sekkei LTD + Shimizu Corporation**
LOCATION: **Tokyo, Japan**
COMPLETION: **2019**
FLOOR AREA: **39,194 m²**
WOOD: **Timber beam strings structure, cantilever trusses**

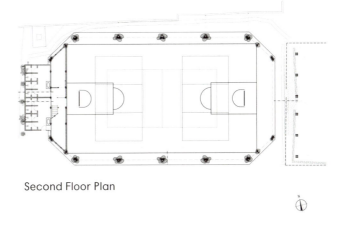

Second Floor Plan

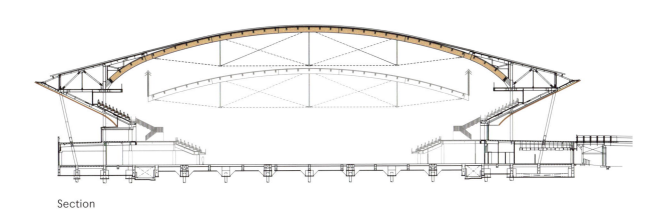

Section

Second Floor Plan

Third Floor Plan

Ground Floor Plan

First Floor Plan

OREGON FOREST SCIENCE COMPLEX (pp.128–133)

ARCHITECT(S): **MGA | Michael Green Architecture**
LOCATION: **Corvallis, Oregon, USA**
COMPLETION: **2020**
FLOOR AREA: **9,383 m^2**
WOOD: **Cross Laminated Timber, Mass Plywood Panels, Glue Laminated Timber**

GRAND WORLD PHU QUOC
WELCOME CENTRE (pp.136–139)

ARCHITECT(S): **Vo Trong Nghia Architects**
LOCATION: **Phu Quoc, Vietnam**
COMPLETION: **2021**
FLOOR AREA: **1,460 m^2**
WOOD: **Bamboo**

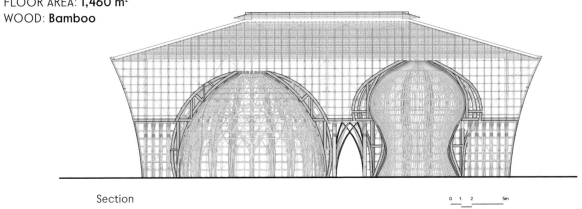

Section

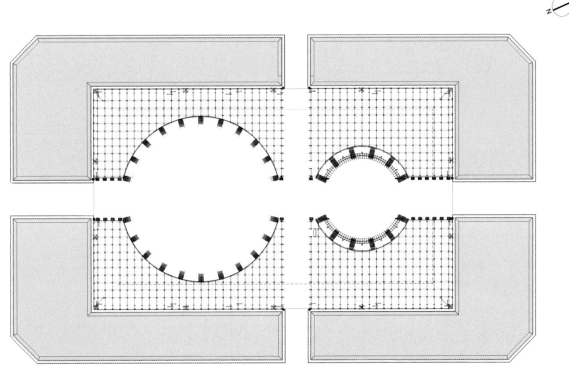

Ground Floor Plan

Apartment Floor Plan

Hotel Floor Plan

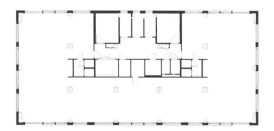

Office Floor Plan

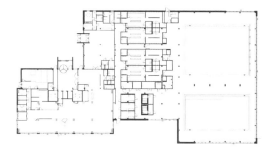

Ground Floor Plan

MJØSTÅRNET (pp.140-145)

ARCHITECT(S): **Voll Arkitekter**
LOCATION: **Brumunddal, Norway**
COMPLETION: **2019**
FLOOR AREA: **15,000 m²**
WOOD: **Local timber**

HOTEL MILLA MONTIS (pp.146–149)

ARCHITECT(S): **Peter Pichler Architecture**
LOCATION: **Maranza, South Tyrol, Italy**
COMPLETION: **2020**
FLOOR AREA: **3,500 m²**
WOOD: **Ash**

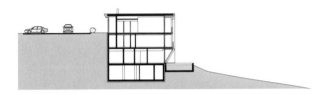 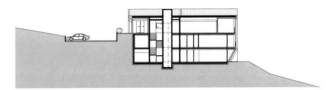

Sections

Ground Floor Plan

Second Underground Floor Plan

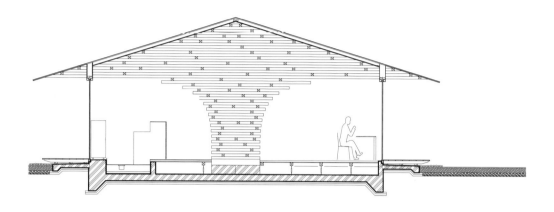

Section

Ground Floor Plan

COEDA HOUSE (pp.150–153)

ARCHITECT(S): **Kengo Kuma**
LOCATION: **Shizuoka, Japan**
COMPLETION: **2019**
FLOOR AREA: **173 m²**
WOOD: **Cedar**

FUCHSEGG LODGE HOTEL (pp.154–158)

ARCHITECT(S): **Ludescher + Lutz Architekten**
LOCATION: **Amagmach, Austria**
COMPLETION: **2020**
FLOOR AREA: **9,846 m²**
WOOD: **Hardwood, Ash, Oak, Maple, Silver fir**

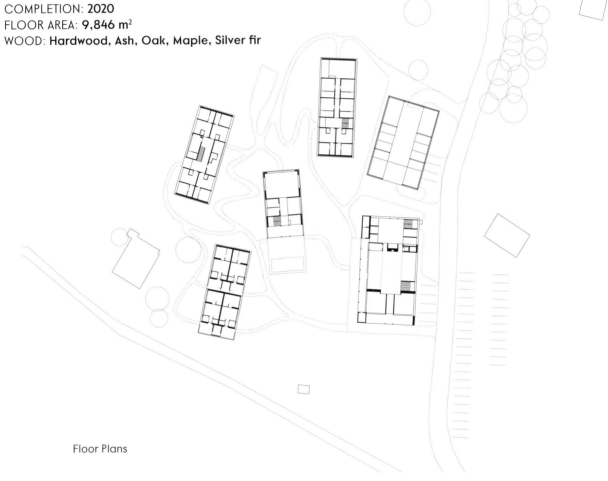

Floor Plans

Elevation

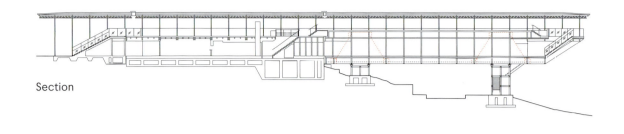

Section

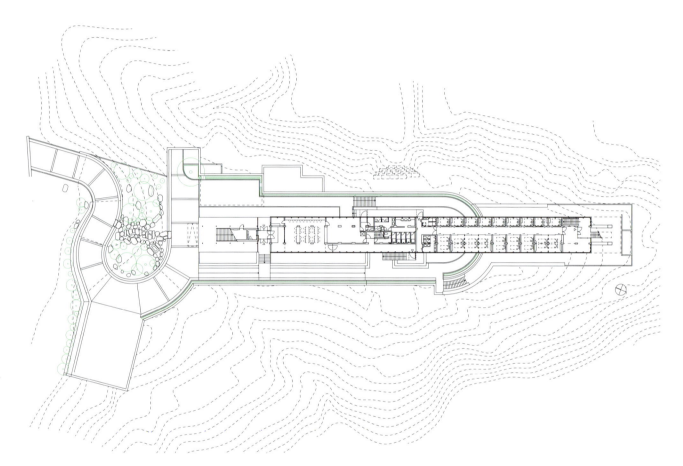

First Floor Plan

ZEN WELLNESS SEINEI (pp.160–165)

ARCHITECT(S): **Shigeru Ban**
LOCATION: **Awaji, Hyogo, Japan**
COMPLETION: **2022**
FLOOR AREA: **982 m²**
WOOD: **Timber**

THE FINANCIAL PARK (pp.168–173)

ARCHITECT(S): **Helen & Hard**
LOCATION: **Bjergsted, Stavanger, Norway**
COMPLETION: **2019**
FLOOR AREA: **22,500 m^2**
WOOD: **Cross Laminated Timber, Beech, Spruce**

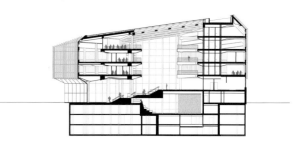

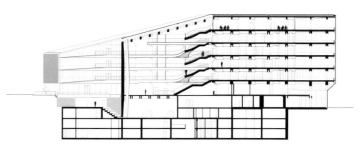

Sections

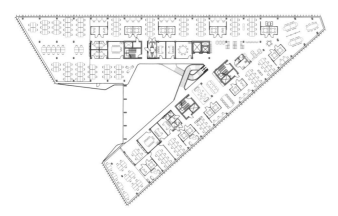

Fourth Floor Plan

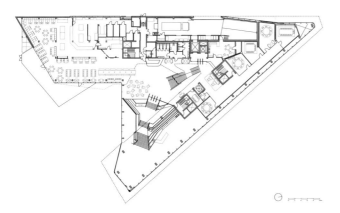

Second Floor Plan

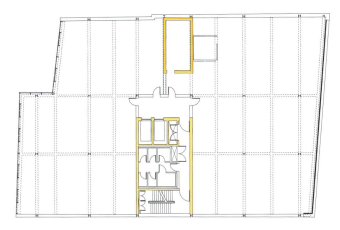

Typical Floor Plan

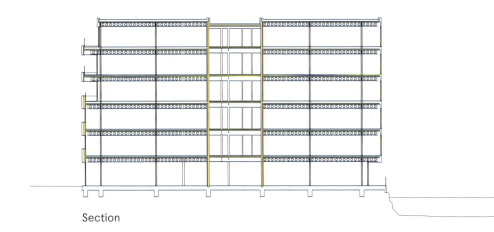

Section

6 ORSMAN ROAD (pp.174-179)

ARCHITECT(S): **Waugh Thistleton Architects**
LOCATION: **London, United Kingdom**
COMPLETION: **2021**
FLOOR AREA: **3,158 m^2**
WOOD: **Cross Laminated Timber**

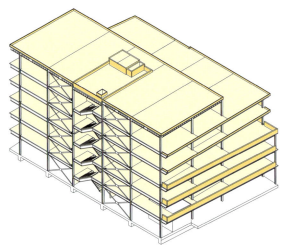

3D Isometric of Structure

CATALYST BUILDING (pp.180-185)

ARCHITECT(S): **MGA | Michael Green Architecture**
LOCATION: **Spokane, WA, USA**
COMPLETION: **2020**
FLOOR AREA: **15,329 m²**
WOOD: **Cross Laminated Timber**

Third Floor Plan

First Floor Plan

Ground Floor Plan

First Floor Plan

Ground Floor Plan

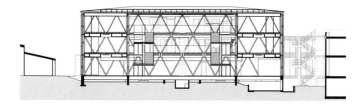

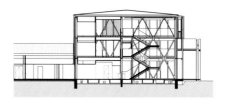

Sections

TE WHARE NUI O TUTEATA,
THE SCION INNOVATION HUB (pp.186–191)

ARCHITECT(S): **RTA Studio + Irving Smith Architects**
LOCATION: **Rotorua, New Zealand**
COMPLETION: **2021**
FLOOR AREA: **1,800 m^2**
WOOD: **Radiata Pine, Tasmanian Blackwood, Victorian Ash**

SWALES, JST HARRISBURG PRODUCTION ENGINEERING CENTER (pp.192–195)

ARCHITECT(S): **Ryuichi Ashizawa Architect & Associates / Arcari + Iovino Architects**
LOCATION: **Harrisburg, USA**
COMPLETION: **2021**
FLOOR AREA: **7,376 m²**
WOOD: **Douglas fir, Cypress, Cedar, White Oak**

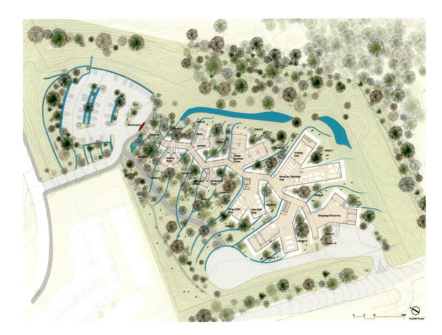

Plan

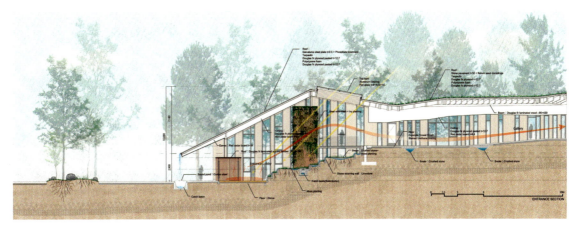

Section

229

INDEX

BUILDINGS

RESIDENTIAL ARCHITECTURE

14 LOGEMENTS HOUSING COMPLEX
p. 16

MTR
p. 34

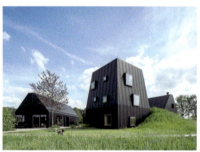
VILLA VUGHT
p. 22

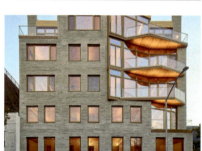
TIMBER HOUSE 670 UNION STREET
p. 40

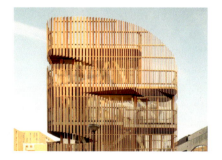
FREEBOOTER
p. 28

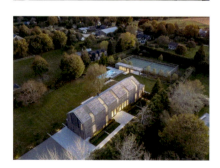
LATHHOUSE
p. 44

PUBLIC BUILDINGS

MAGGIE'S
LEEDS CENTRE
p. 52

MICROLIBRARY
WARAK KAYU
p. 66

ALTO TÂMEGA
TOURIST
INFORMATION
POINT
p. 58

COMMUNITY
LIFE CENTER
TRINITAT
p. 72

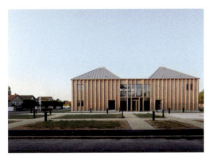

TAVERNY
MEDICAL
CENTRE
p. 62

CULTURAL VENUES

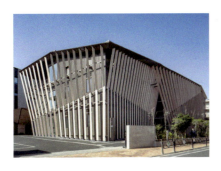

TOHO GAKUEN
MUNETSUGU
HALL
p. 80

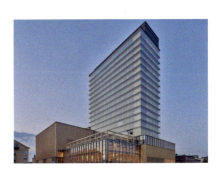

SARA
CULTURAL
CENTRE
p. 90

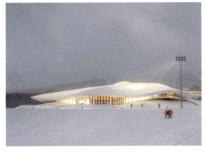

YABULI ENTRE-
PRENEURS'
CONGRESS
CENTRE
p. 84

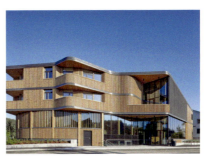

SAMLING
p. 96

EDUCATION & SPORT FACILITIES

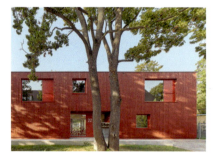

KITA IM PARK
DAYCARE
CENTRE
p. 104

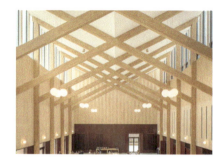

HOMERTON
COLLEGE
DINING HALL
p. 118

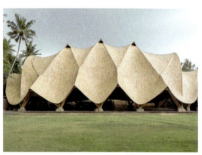

THE ARC
AT GREEN
SCHOOL
p. 110

THE ARIAKE
GYMNASTICS
CENTRE
p. 122

CANTEEN AND
MEDIA CENTRE
p. 114

OREGON
FOREST
SCIENCE
COMPLEX
p. 128

HOSPITALITY PROJECTS

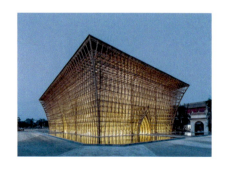

GRAND WORLD
PHU QUOC
WELCOME
CENTRE
p. 136

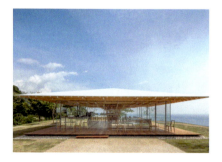

COEDA HOUSE
p. 150

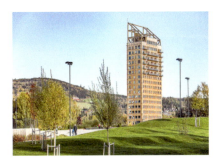
MJØSTÅRNET
p. 140

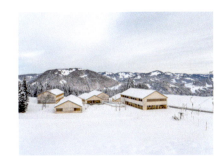
FUCHSEGG
LODGE HOTEL
p. 154

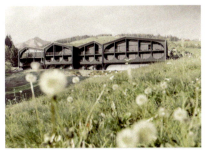
HOTEL MILLA
MONTIS
p. 146

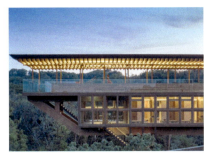
ZEN WELLNESS
SEINEI
p. 160

COMMERCIAL & OFFICE SPACES

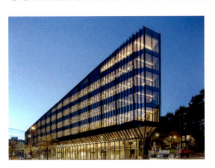
THE FINANCIAL
PARK
p. 168

THE SCION
INNOVATION
HUB
p. 186

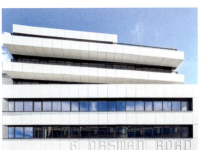
6 ORSMAN
ROAD
p. 174

SWALES
p. 192

CATALYST
BUILDING
p. 180

ARCHITECTS & WEBSITES

ALAIN CARLE ARCHITECTE
alaincarle.ca

AND-RÉ ARQUITECTURA
and-re.pt

ARCARI + IOVINO ARCHITECTS
aiarchs.com

BIRDSEYE
birdseyevt.com

BIRK HEILMEYER UND FRENZEL ARCHITEKTEN
bhundf.com

FEILDEN FOWLES
feildenfowles.co.uk

GG-LOOP
gg-loop.com

HAZ ARQUITECTURA
hazarquitectura.com

HEATHERWICK STUDIO
heatherwick.com

HELEN & HARD
helenhard.no

IBUKU
ibuku.com

IRVING SMITH ARCHITECTS
isarchitects.nz

KENGO KUMA
kkaa.co.jp

LUDESCHER + LUTZ ARCHITEKTEN
ludescherlutz.at

MAAJ ARCHITECTES
maaj.fr

MAD ARCHITECTS
i-mad.com

MARS ARCHITECTES
mars-architectes.com

MECANOO
mecanoo.nl

MESH ARCHITECTURES
mesh.nyc

MGA | MICHAEL GREEN ARCHITECTURE
mg-architecture.ca

NIKKEN SEKKEI LTD
nikken.co.jp

PETER PICHLER ARCHITECTURE
peterpichler.eu

RTA STUDIO
rtastudio.co.nz

RYUICHI ASHIZAWA ARCHITECT & ASSOCIATES
r-a-architects.com

SHAU INDONESIA
shau.nl

SHIGERU BAN
shigerubanarchitects.com

VO TRONG NGHIA ARCHITECTS
vtnarchitects.net

VOLL ARKITEKTER
vollark.no

WAUGH THISTLETON
waughthistleton.com

WHITE ARKITEKTER
whitearkitekter.com

WULF ARCHITEKTEN
wulfarchitekten.com

PHOTO CREDITS

pp. 2, 128–133: MGA | Michael Green Architecture, photography © Josh Partee; 7, 28–33: GG–loop, photography © Francisco Nogueira; 8: Kengo Kuma & Associates, photography © Mitsumasa Fujitsuka; 10, 13: Kengo Kuma & Associates, photography © Daici Ano; 12: © Kengo Kuma & Associates; 14–15, 44–49: Birdseye, photography © Michael Moran Photography; 16–21: Mars Architectes, photography © Charly BROYEZ; 22–27: Mecanoo, photography © Ossip Architectuur Fotografie; 34–39: Alain Carle Architecte, photography © Félix Michaud; 40: Mesh Architectures, photography © Frank Oudeman, 42–43: Mesh Architectures, photography © Matthew Williams; 50–51, 66–71: SHAU Indonesia, photography © KIE & team; 52–57: Heatherwick Studio, photography © Hufton+Crow; 58–61: AND — RÉ ARQUITECTURA, photography © Ivo Tavares Studio; 62–65, 238–239: Maaj Architectes, photography © François-Xavier Da Cunha Leal; 72–77: Haz Arquitectura, photography © Jose Hevia; 78–79: © White Arkitekter, 90–95: White Arkitekter, photography © Åke E:son Lindman; 80–83, 150–153: Kengo Kuma, photography © Kawasumi–Kobayashi Kenji Photograph Office; 84–85: © MAD Yabuli_by CreatAR Images, 86,88: © MAD Yabuli by ArchExist, 87, 89: © MAD Yabuli photo by aogvision; 96–101: Helen & Hard, photography © Ivan Brodey; 102–103, 118–121: Feilden Fowles, photography © 102–103, 118: Jim Stephenson, 119–121: © David Grandorge; 104–109: Birk Heilmeyer und Frenzel Architekten, photography © Zooey Braun; 110–113: IBUKU, photography © Tommaso Riva; 114–117: wulf architekten, photography © Brigida Gonzales; 122–125 Nikken Sekkei LTD, photography ©Ken'ichi Suzuki, 126–127: Nikken Sekkei LTD, photography © SS; 134–135, 160–165: Shigeru Ban, photography © Hiroyuki Hirai; 136–139: Vo Trong Nghia Architects, photography © Hiroyuki Oki; 140–141, 142, 144: Voll Arkitekter, photography © Ricardo Foto, 143, 145: Voll Arkitekter, photography © Øystein Elgsaas; 146–149: Peter Pichler Architecture, photography © 146–147 © Daniel Zangerl, 148 © Gustav Willeit, 149 © Jörgen Camrath; 154–159: LUDESCHER + LUTZ ARCHITEKTEN, photography 154–155 © Günter Stnadl, 156–157 © Studio Wälder, 158–159 © Elmar Ludescher; 166–167, 192–195: © Ryuichi Ashizawa Architect & Associates / Arcari + Iovino Architects; 168–173: Helen & Hard, photography © Sindre Ellingsen; 174–179: Waugh Thistleton Architects, photography © Ed Reeve; 180–185: MGA | Michael Green Architecture, photography © Benjamin Benschneider; 186–191: RTA Studio + Irving Smith Architects, photography © Patrick Reynolds; 196–197 © Nick Hillier / Unsplash; 230–231 © Ryunosuke Kikuno / Unsplash; 198–229: All plans, sketches and drawings with courtesy and copyright of the architects; 232–235: All credits as mentioned above.

Chapter openers: pp. 14–15: Lathhouse // Birdseye // Sagaponack, New York, USA, 2020; 50–51: Microlibrary Warak Kayu // Shau Indonesia // Semarang, Indonesia, 2020; 78–79: Sara Cultural Centre // White Arkitekter // Skellefteå, Sweden, 2021; 102–103: Homerton College Dining Hall // Feilden Fowles // Cambridge, United Kingdom, 2022; 134–135: Zen Wellness Seinei // Shigeru Ban // Awaji, Hyogo, Japan, 2022; 166–167: Swales, JST Harrisburg Production Engineering Center // Ryuichi Ashizawa Architect & Associates / Arcari + Iovino Architects // Harrisburg, USA, 2021

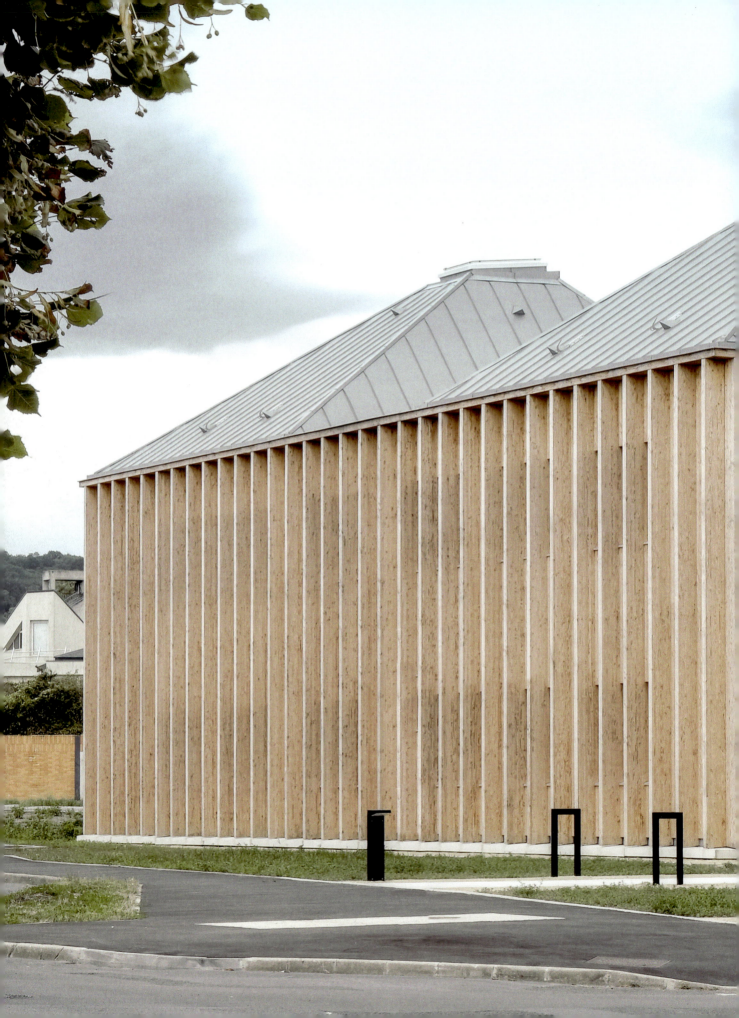

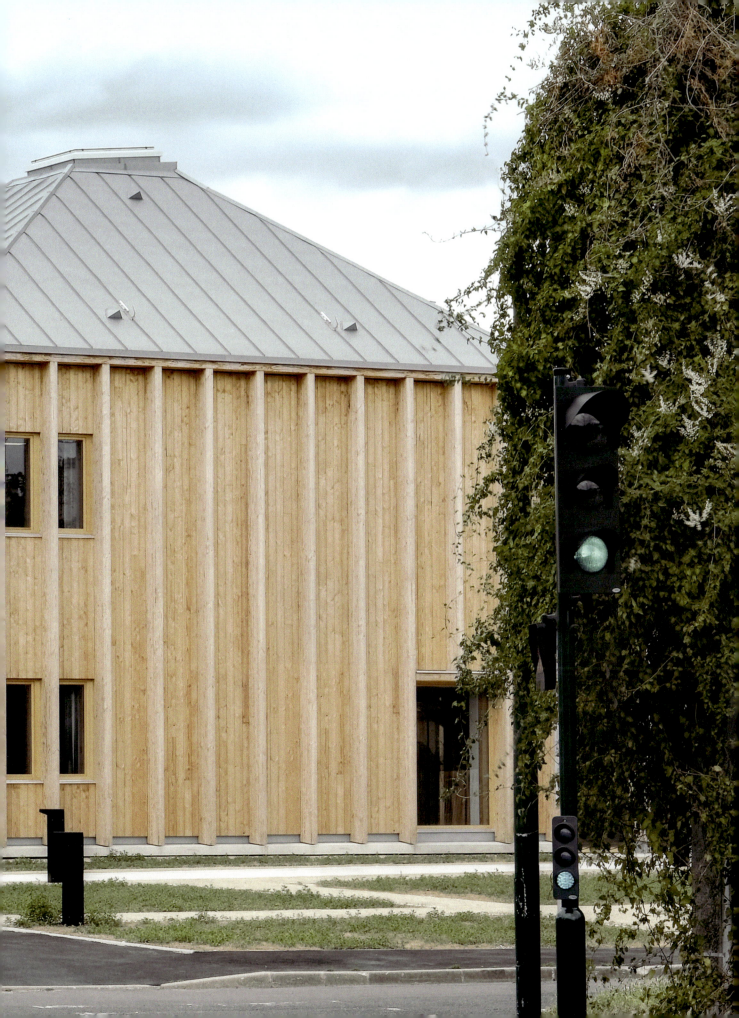

© Prestel Verlag, Munich · London · New York, 2023
A member of Penguin Random House Verlagsgruppe GmbH
Neumarkter Strasse 28 · 81673 Munich

Front cover: © MAD Yabuli by CreatAR Images
Back cover: top left © AND-RÉ ARQUITECTURA, photography
© Ivo Tavares Studio; top right © SHAU Indonesia, photography © KIE &
team; bottom: Alain Carle Architecte, photography © Félix Michaud

Library of Congress Control Number is available;
a CIP catalogue record for this book is available from
the British Library.

In respect to links in the book, the Publisher expressly notes that no
illegal content was discernible on the linked sites at the time the links
were created. The Publisher has no influence at all over the current and
future design, content or authorship of the linked sites. For this reason
the Publisher expressly disassociates itself from all content on linked
sites that has been altered since the link was created and assumes no
liability for such content.

Editorial direction: Sabine Schmid
Texts, design and layout: Agata Toromanoff
Copy-editing: Allison Silver Adelman
Production: Andrea Cobré
Separations: Schnieber Graphik, Munich
Printing and binding: Grafisches Centrum Cuno GmbH & Co.KG, Calbe
Paper: 135g Magnomatt

Penguin Random House Verlagsgruppe FSC® N001967

Printed in Germany

ISBN 978-3-7913-8924-0

www.prestel.com